VILLAGES OF THE PEAK DISTRICT

VILLAGES OF THE PEAK DISTRICT

DENIS EARDLEY

AMBERLEY

*I would like to express my grateful thanks to
John Hollinshead and Gillian Eardley for their help and support in
compiling this book.*

First published 2009

Amberley Publishing
Cirencester Road, Chalford,
Stroud, Gloucestershire, GL6 8PE

www.amberley-books.com

British Library Cataloguing in Publication Data.
A catalogue record for this book is available from the British Library.

ISBN 978 1 84868 728 8
Typesetting and Origination by Amberley Publishing.
Printed in Great Britain.

CONTENTS

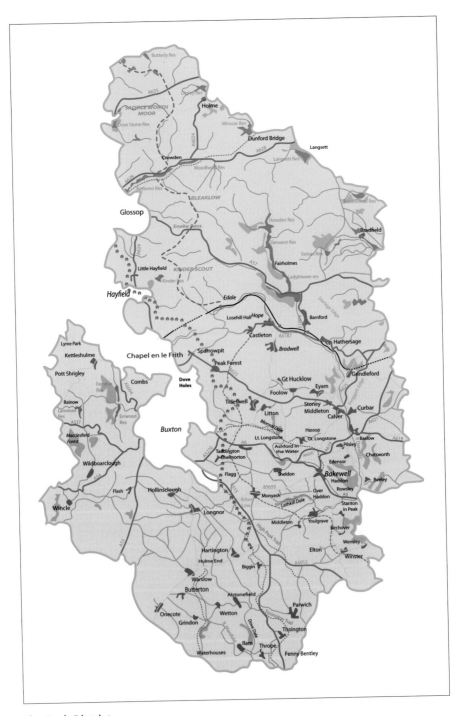

The Peak District

INTRODUCTION

The Peak District was Britain's first National Park when it was established in 1951, and is the second most visited in the world. Visitors come to enjoy its outstanding natural beauty, breathtaking views and the rich diversity of scenery and its ever changing landscape. They can walk on the bracken-covered moors, along the picturesque dales, and discover enchanting villages and historic towns each with their own unique character.

For convenience, commentators and mapmakers normally divide the National Park into two distinctive parts, the White Peak and the Dark Peak. The White Peak is a limestone plateau of green fields, white stone walls, attractive river valleys and some quite spectacular limestone rocks and cliffs. To the north of the limestone plateau and along the eastern and western edges lies the Dark Peak. This consists of an upland gritstone and shale area of grassland and heather covered moorlands, where the climate is often less hospitable, and sheep and grouse and other wild life dominate.

The older parts of the villages in the National Park frequently reflect the geology of the region in which they are found, by the type of building materials used. White slightly graying stone cottages and boundary walls in the White Peak and warm, brown gritstone walls and roof tiles in the Dark Peak. The small village of Elton is somewhat unusual as it is set on a division in the underlying rocks that runs along the main street. Limestone is on the north side and gritstone on the south. This produces an unusual effect with gritstone vegetation on one side and limestone on the other. The houses too reflect the division, with some built of gritstone and others limestone, or a mixture of both.

Some of the most attractive and beautifully landscaped villages were built as part of rich families estates, where although some of the houses have been sold off, they still retain their traditional charm. Probably the most visited is Tissington, one of the prettiest and most unspoilt villages in the country. Its pretty limestone cottages and well-tended gardens behind wide grass verges and backed by mature trees, give a feeling of peace and tranquillity. No planner designed it; the beauty of the village is the result of evolution.

Frequently referred to as the gem of the Peak, Castleton is one of Britain's most appealing villages, set in a magnificent location, with wonderful views in all directions. With its cluster of old gritstone cottages, hilltop castle and sparkling little stream leading to Peak Cavern, it attracts droves of visitors. There are though many less known fascinating villages and small towns that surround the National Park just waiting to be discovered.

The local economy is based on tourism, farming, quarrying and manufacturing. Lead mining has played a particularly important part in the development of many of the villages and towns in and around the Peak District. Wirksworth was the capital of the lead mining industry, which goes back to at least Roman times. The birth of the Industrial Revolution transformed Britain from an almost self-sufficient country, with an economy based on agriculture and cottage industries, into the workshop of the world. The importance of Cromford and the stretch of the Derwent Valley from Masson Mill to the Silk Mill at Derby was recognised in 2001, when it was awarded World Heritage Status.

Whether you are a first time visitor to the Peak District or a regular, you will find its local history, folklore and traditional customs intriguing. This was certainly the case for one visitor to Flash who was astonished to see a procession marching down the road carrying a large model teapot. Even more so as the marchers also carried banners referring to the teapot and were accompanied by a brass band. Another unusual event takes place at Castleton on, or around, the 29 May every year. This is when a 'King' and 'Queen' ride on horseback through the streets, the king's head completely covered by a garland in the form of an inverted basket decorated with flowers. The procession is accompanied by music and dancing. Progress tends to be slow as all the pubs in the village are visited, before the garland is finally hoisted to the top of the church tower.

This book sets out to make your visits that much more interesting, by helping you to plan ahead, to ensure you do not miss any hidden gems from your itinerary. Over 20 million people visit the Peak National Park every year and many of them come back time and again, which is the best possible recommendation.

NOTES

1. The village/town location descriptions are for use with recently published maps. Some older maps have different road numbers because of re-numbering.

2. All the facilities listed were in existence at the time of writing, but may change.

BAMFORD

(SK208835)

*On the A6013, between the A57 Sheffield to Glossop road and the A6187
Hope Valley road — Bamford Railway Station*

The superbly situated village of Bamford stands at the heart of the Dark Peak, eleven miles west of Sheffield and twenty five miles east of Manchester. It is surrounded by high impressive moorland scenery, with the gritstone edges of Bamford and Derwent on the northern side, and to the west, Win Hill. On the southern side the River Derwent passes through the village before the land rises again to moors.

Bamford is the sole surviving village in Derbyshire's 'Lake District.' The villages of Ashopton and Derwent were submerged when the Ladybower Reservoir was constructed. The Howden and Derwent Dams were built early in the twentieth century. The 1,000 or so navvies and their families were housed in corrugated iron shacks at Birchinlee. The locals called it Tin Town. Purpose-built houses were erected close to the reservoir, at Yorkshire Bridge, for the displaced villagers. One person refused to move. Miss A. Cotterill, of Ginnett House, whose home looked down on the former hamlet of Derwent, remained there until she died in 1990, at the age of 99, the waters of the reservoir lapping at the front garden steps.

Visitors from the south to the Upper Derwent Valley Dams tend to pass through Bamford on their way without stopping. If they did stop they would find this attractive little village has much to offer. At the centre is a pleasant, green triangle of land, where the Jubilee Stone commemorates Queen Victoria's Jubilee. Opposite the green, is a most unusual V-shaped stile, with a cut-out designed to allow a bucket of water to be carried from the trough at the rear. Over the road is what must be one of the most picturesque post offices in the county, with its bay window and leaded panes and comfortable seat outside the door. It was once Bamford's oldest public house, the Cheshire Cheese.

Bamford is a relatively modern place compared with many other Peak District villages, with most of its buildings dating from the early Victorian period to the present day. During the mid twentieth century, small housing

The 'Touchstones' Sculpture in the centre of the village

estates were built to the east of the main road through the village. The village is well served for refreshments with the Anglers' Rest and Derwent Arms, although the latter was recently looking for a new owner. At the village bakery you can sit outside with a cup of tea and a freshly baked Cornish pasty.

The railway station, to the south of the village, is a popular stopping point on the Hope Valley line that links Sheffield to Manchester. On the road just below the station the Peak Park has re-erected the Mytham Bridge toll gate which used to stand nearby. This was one of the toll gates on the first turnpike in the area — built in 1758 to link Sheffield to Sparrowpit.

Situated as it is in an area dominated by hills, with few fences in evidence and sheep in the ascendancy, it might be thought that the Industrial Revolution hadn't had much of an effect on Bamford. This is far from the case — a corn mill operated in the village in the first half of the eighteenth century. It was then converted to cotton spinning and doubling by local farmer and miller Christopher Kirk, who lost everything when the mill was destroyed by fire in 1791.

The Moore family re-built the mill, and created a weir to provide more power to their cotton mill and gradually recruited a substantial workforce. Having changed hands several times, it closed in 1965 as a cotton mill. For a

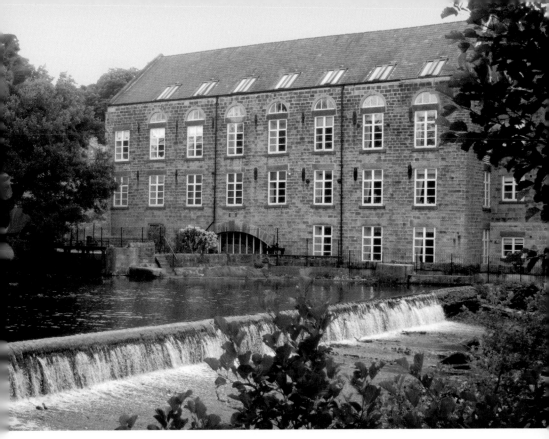

Bamford Mill

time the mill was used to make small electrical furnaces, but it has now been converted into high class accommodation, which looks out on the weir and one of the most unusual river crossings in the country.

In 1861, William Cameron Moore had the church and vicarage built at his own expense. Both are fine examples of the work of the noted Victorian architect, William Butterfield. Before 1860, Anglican services had been held in the National School, built nearly 40 years previously at the same time as the Wesleyan Chapel. Moore also gave generously towards the running of the schools and the Village Hall is named after him. He also had **Mill Houses built for his workers.**

Joseph Tagg is buried in the Roman Catholic Churchyard. A well-known local sheep farmer who helped found Hope Valley Sheepdog Trials, he lived at Yorkshire Bridge during his later years. He won a succession of prizes throughout the country with his sheepdogs and even sold one to an American for £1,000. This was probably the first time so much money had been raised for the sale of a dog overseas.

On the 12 December 1953, Tagg, aged 85, went out for the last time with his faithful border collie, Tip, and vanished completely. Despite an exhaustive

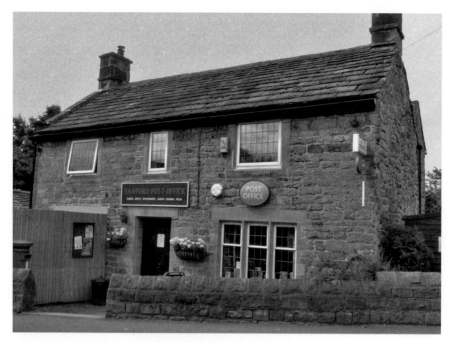

The former Cheshire Cheese public house

search, neither he nor his dog could be found. It was not until fifteen weeks later that Tagg's remains were discovered by chance, with the faithful Tip completely exhausted lying about five yards away. Somehow, Tip had managed to survive heavy snow, biting winds and freezing temperatures on one of the most hostile stretches of moorland in the country.

Tip was carried back to the rescuer's lorry and later transferred to a caring home, where she was carefully nursed back to health. Once the story became known, Tip became famous not only in this country, but abroad as well. A year later, in May 1955, she died. However, the hearts of those hearing the story were so greatly touched, that a memorial was erected at the western end of Derwent Dam, in memory of Tip.

The annual Well Dressings and carnival takes place in mid-July. However, the village is most famous for its sheep dog trials, which are held over the late Spring Bank Holiday weekend. For those wanting to explore, it is worth picking up the Bamford Touchstones Sculpture Trail leaflet, a walk of approximately five miles around the boundary of the village. There is even a sculpture to be found in the middle of the river crossing at Bamford Mill.

BRADFIELD

(SK267925 & SK264920)

At the far north eastern edge of the Peak District on unclassified roads to the north west of Sheffield

There are two parts of Bradfield conveniently named 'High and 'Low,' which accurately defines the two small settlements. Set in the midst of glorious wild, moorland scenery and the deep green valleys, a steep drop of half a mile separates the two. Bradfield is just a short distance from Sheffield, the only city in Europe to have large parts of a National Park within its boundaries.

Bradfield is the largest parish in England, with a population of around 15,000. The main centres of population apart from High and Low Bradfield are Dungworth, Loxley, Midhopestones, Oughtibridge, Worrall, Stannington and Wharncliffe Side in addition to a number of small hamlets and isolated dwellings. In total the parish covers an area of over 54 square miles, with a boundary of 42 miles in length.

Despite its close proximity to a major city the Loxley Valley has a surprisingly rural feel. The upper part of the valley becomes Bradfield Dale, where a series of reservoirs sit snugly in the valley bottom. This though was not always the case as on the night of the 11 March 1864, between 11.30 pm and midnight, the Dale Dyke Embankment burst, causing what is known as the Great Sheffield Flood. The torrent of water surged down the Loxley Valley through Sheffield and even towards Rotherham.

It was the worst disaster in England in the nineteenth century. More than 240 people died, 15 bridges were swept away and in only half an hour 4,500 homes were flooded lower down the valley. The damage was estimated at half a million pounds, a colossal sum in those days. The Damflask Reservoir was built after the great flood and is the lowest in the cascade of reservoirs known as the Bradfield Scheme. A memorial plaque in memory of the flood disaster, and those who tragically lost their lives, was dedicated in Bradfield Parish Church on 12 March 1989.

High Bradfield is famed for its magnificent views, none more so than from St Nicholas's Church, which celebrated its 900th anniversary in 2009. The

Cottages at Lower Bradfield

present building is over 500 years old, and holds a Saxon Cross, which was found at Low Bradfield, indicating a Christian place of worship has been in existence in the area long before the first stone built church.

In 1876, the oak eagle lectern, won a major award at the Philadelphia International Exhibition. It was carved in New York and presented to the church by a Canadian benefactor. The Norman Font may well have been a

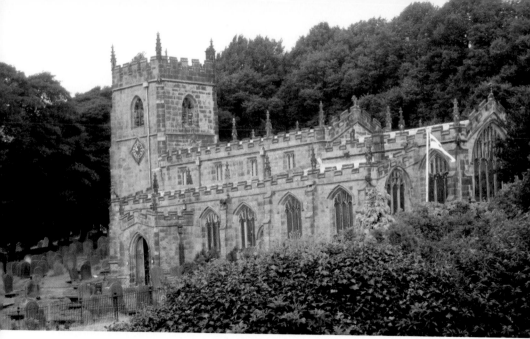

St Nicholas's Church at High Bradfield

gift to the church from the monks of Roche Abbey. The oak chest is one of the largest still in existence in this country and has been hewn out of a solid tree trunk. The hinged lid is the only join.

At the churchyard gates, stands the Watch House, an oddly shaped building of Gothic design, which is now privately owned. It was built in 1745 to enable a look out to be maintained for body snatchers who might wish to raid the churchyard. Payment was made at the time for corpses, which were used for research at Sheffield founded medical schools. Members of the family of the recently deceased kept watch from the building until natural decay rendered the bodies of no interest to the body snatchers.

To the west behind the church, up what is called Bailey Hill, at the edge of a wood are traces of a motte-and-bailey castle. It is undecided what it was used for; one suggestion is that it may have been a Chieftain's home. Even before then, Bradfield played an important role as a boundary between Romans and Celts.

The Old Horns stands at the top of the hill, a handsome stone building with terrific views from the rear. Almost opposite the pub is the Old Work House, built in 1769 to house the poor and homeless of the Parish. Now like all the rest of the buildings at High Bradfield, it fits perfectly into what is a picturesque scene.

At the bottom of Woodfall Lane lies Low Bradfield, with its pretty cottages. The Postcard Café and Stores, stocks a wide range of products as well as serving tea, coffee and light bites inside and out. Opposite the shop is the 'Cross Inn', converted to a private house some years ago. There are also several

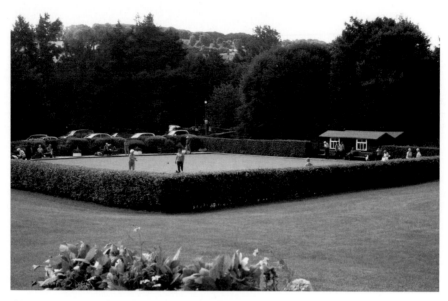

Ibbotson Memorial Ground, Lower Bradfield

three storeyed houses, which date back to the time when frame-work knitting was an important industry in the village.

The most striking feature of Low Bradfield is the Ibbotson Memorial Cricket Ground, with an accompanying bowls green and tennis courts. In the summer life revolves around the cricket ground, with cricket matches being played on every Saturday and Sunday and regular bowls and tennis tournaments. Situated adjacent to the ground is the Village Hall, which is the centre of village life throughout the year.

On the opposite side of the road to the cricket ground, is a large house named Burnside, which was the home of the Ibbotson family from 1865 to 1966. The Ibbotson family have in fact lived in Bradfield for at least 400 years. From their vantage point they have no doubt been able to keep an eye on the cricket in comfort, when on those cold summer days we are so often bedeviled with, sitting on the boundary edge can be a chilling experience.

After you have crossed the hump backed bridge at the bottom of the hill, there is an attractive little picnic site by the side of the stream. The road then begins to climb up Mill Lee Road, past the former Sunday School, which has been converted into offices for the use of the Parish Council. There can be very few facilities of this type that lookout on to such a gorgeous garden.

A short distance further up the road on a corner site is the Plough Inn, which has been considerably modernised and an extension added. The village also has its own brewery, not unnaturally called the Bradfield Brewery, which is based on a working farm and produces a range of distinctive cask conditioned real ales.

BRADWELL

(SK174811)

*On B6049 between the A6187 Hathersage to Hope road and the A623
Baslow to Chapel-en-le-Frith road*

Hidden from the main road, the centre of the village clings to the steep hillside. Tiny individually shaped cottages set at odd angles, among a profusion of narrow winding streets and alleyways, give the appearance of a picturesque Cornish fishing village, with just the sea and several thousand gallons of whitewash missing.

Local author and nineteenth-century chronicler Seth Evans, who wrote two books about Bradwell, famously described it in the following words. 'Its steep winding streets — if streets they can be called — and all sorts of queer little out of the way places running in and out in all directions, break neck, oblique, skew-tilted, beginning everywhere, leading nowhere, make the stranger feel that he is living in medieval times'. There were no planning regulations to worry about in those days and people simply built where they could find a space.

Bradwell had its origins in lead mining which has been practised in the area since the Romans. There was a Roman Fort at Navio, one mile to the north, at Brough. The fort was constructed at the meeting point of the River Noe and Bradwell Brook, to control the lead mining industry in the area. According to a local legend, some of the inhabitants of the village were descended from convicts, the Romans often using convicted prisoners to work in the metal mines.

The road is lined with steep cliffs for about three quarters of a mile as you approach the village from the south. This is Bradwell Dale, which is considered to be one of the most beautiful valleys in the county. On reaching the village, the lack of obvious long term parking facilities seems to invite the driver to press on towards Castleton and Edale. This is a pity, because although Bradwell is very much a working village and not a recognised tourist trap, it does have a lot to offer as well as excellent walking and beautiful scenery.

In its heyday, the village was one of the most important lead mining settlements in Derbyshire. Most of the inhabitants were involved, the men down the mines, or at the lead smelting works, the women and children washing and sorting the ore. There were several large mines on Bradwell

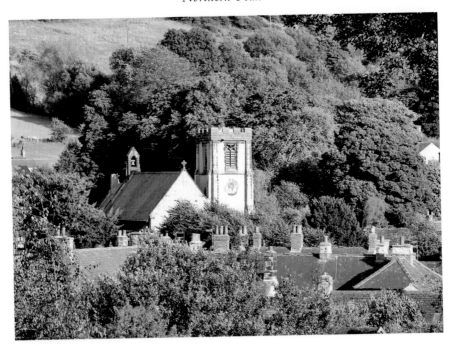

The Church of St Barnabas, Bradwell

Moor and numerous small ones in the hills round the village. Hungry Lane which leads back to the village from the neighbouring hills is said to be called that because it was the return route used by the miners at the end of the day, cold, wet tired and hungry!

The miners wore 'Bradder Beavers', a hat styled in the fashion of a military helmet, said to be the prototype of the 'tin hat'. On the top of the hat, a candle was placed to light the way down the mine. The hats became very popular and were used widely throughout Derbyshire, although originally designed for lead miners they were soon put to other uses and their popularity spread well beyond the county boundaries.

The demise of lead mining did not result in the collapse of the local economy as other forms of employment included silk weaving, cotton spinning, clog making. And more unusually, Bradwell became the local centre of the optical industry, producing telescopes, opera glasses and spectacles.

Some of the women worked in the cotton mill at Bamford, a twelve-hour day starting at 6am in the morning. They had to undertake the long journey twice a day, whatever the weather. In order to ensure they did not oversleep, a 'knocker-up' was employed to go round the houses in the morning. He carried a long pole, knocked on the windows, and called out the women's names.

Samuel Fox, the son of a shuttle maker, was born in Bradwell in 1815; he had an inventive mind and a capacity for hard work. He not only founded the massive

The village centre

steelworks at Stocksbridge, near to Sheffield, but gained worldwide recognition by designing the folding-frame umbrella. A benevolent man, he never forgot his home village, providing money to build a church, a site for the vicarage and setting up a trust fund for annual distribution to the poor and needy.

The building in 1868, of the church of St Barnabas, enabled the Anglicans to worship in their own village instead of having to go to the church in Hope. Many of the villagers though attended non-conformist services. The first Presbyterian Chapel (now Scout HQ) was built in 1662, for the 'Apostle of the Peak', the Reverend William Bagshawe, and other chapels and Sunday Schools soon followed. Methodism was strongly supported in Bradwell and John Wesley preached in the village in 1747. The former Wesleyan Sunday School, now a private house, is unusual, in that it is built over the Bradwell Brook.

An interesting custom for many years was for youths to stretch a rope across the road and not allow the bride and groom to get to the church before they had paid a toll. The money was then normally spent in the nearest hostelry, when no doubt a toast to bride and groom was drunk!

In 1807, lead miners working in Mulespinner Mine discovered Bagshawe Cavern. It takes its name from Lady Bagshawe, who together with her husband, owned the land and visited the mine soon after its discovery. The cavern has an extensive network of chambers some of which have not been fully explored. Arrangements can be made for parties to view the cavern.

A village street

Nowadays, the main source of employment is the Cement Works at Hope and the local quarries. In the village itself, Newburgh Engineering employs a good number of people; during the Second World War the company made munitions. Bradwell's, the ice cream manufacturers, make their award winning ice cream in the village and also operate a small shop.

The village is well served with public houses. It has its own Fire Station, opposite The Beggars' Plot. On Carnival Day, held on the Saturday before the first Monday in August, the procession starts from Beggars' Plot at the beginning of Well Dressing Week.

CASTLETON

(SK150829)

On A6187 Hope Valley road

Castleton is a delightful village that invites exploration with its cluster of old stone cottages and hilltop castle. The sparkling little stream leading to Peak Cavern takes you through the oldest part of Castleton. Along the main street are a large variety of gift shops, cafés, pubs and restaurants to suit all tastes.

Frequently referred to as the gem of the Peak, Castleton is one of Britain's most appealing villages, set in a magnificent location with wonderful views in all directions. Approaching from the southwest you descend into Castleton through the spectacular Winnats Pass with its forbidding appearance. In 1758 it was the scene of the horrific murder by five lead miners of a young couple journeying to the Peak Forest to get married. The crime was never solved until the last surviving miner confessed on his lingering deathbed. It was later revealed the other four miners had also met terrible ends.

William Peverel originally built Peveril Castle. He was a favourite knight of William the Conqueror who made him bailiff of the royal manors in north western Derbyshire. At that time the Peak Forest was rich in both game and minerals and the castle was ideal for protecting both. King Henry II built the stone keep almost 100 years later in 1176. It still stands today and can be viewed at close quarters by those prepared to climb the steep zigzag path leading up to the castle, made famous by Sir Walter Scott, in his novel 'Peveril of the Peak'.

Under the protection of the castle, the village grew up in a distinct gridiron formation, inside a protective Town Ditch, parts of which can still be seen. It was an important stopover for packhorses and, in later years, stagecoaches. The village takes its name from the castle, 'ton' being of Anglo-Saxon origin and meaning 'an enclosure'.

Castleton is most famous for its caverns of which only Peak Cavern is a true cave. Directly beneath the castle, it has a dramatic entrance and is said to have the largest cave entrance in Britain. It once contained houses and there is still evidence of soot from the chimneys on the roof. There is even a report in 1794

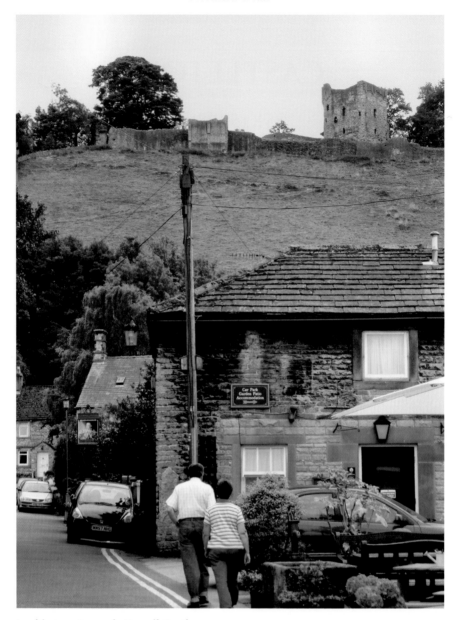

Looking up towards Peveril Castle

of an alehouse in the cave. The entrance was used for hundreds of years for rope making and some of the equipment still remains.

Blue John Cavern is famous for its semi-precious stone, Speedwell for its half-mile subterranean boat trip and Treak Cliff Cavern for its stalactites. The mining of Blue John stone is unique to Castleton. Pieces can be found all over the world including the White House and Vatican. The world famous cavern is

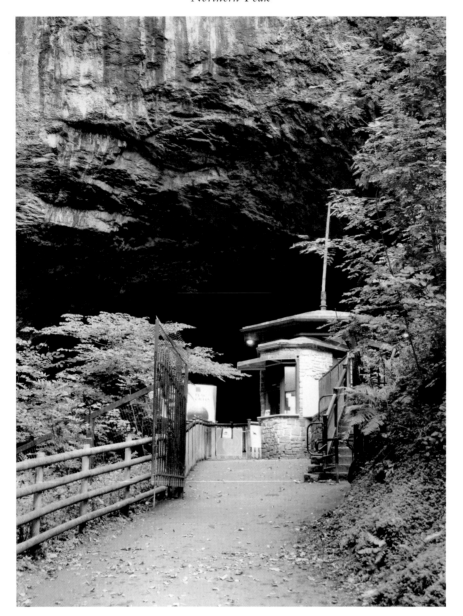

The path leading to Peak Cavern

of outstanding educational and geological interest and is open to the public.

Mam Tor looks down on Castleton from the south and is often called by the locals the 'Shivering Mountain', because its layers of soft shale between harder beds of gritstone frequently crumble, causing landslips. These have been sufficiently severe to permanently close the A625, which has been re-routed to Castleton through Winnats Pass.

There is an Iron Age Fort near the summit of Mam Tor from which superb views can be gained. By Treak Cliff is the Odin Mine, which in the eighteenth century produced large quantities of good quality lead ore; alongside is a crushing stone and circle, once used to dress the ore.

Cave Dale hidden behind Peveril Castle is the start of many walks. It is one of the most beautiful parts of Castleton with cliffs rising almost perpendicular at the start of the walk with the castle towering above. After reaching the head of the dale the route becomes more open with expansive views. From this point it is only a short walk to Mam Tor and some of the most breathtaking views in the country.

Oak Apple Day is Garland Day at Castleton and takes place on, or around, the 29 May every year. A 'King' and 'Queen' ride on horseback through the streets, the king's head completely covered by a garland in the form of an inverted basket decorated with flowers. The procession is accompanied by music and dancing. Progress tends to be slow as all the pubs in the village are visited before the garland is finally hoisted to the top of the church tower. The origins of the ceremony are uncertain, although frequently linked to the restoration of King Charles II who escaped the Roundheads by hiding in an oak tree.

At Christmas, the village takes on a magical appeal with pretty lights, decorations and an array of Christmas trees, which attracts visitors from far and wide. There is nothing else quite like it anywhere in the country, so it is worthwhile making a note in your diary to experience the festive magic of Christmas at Castleton in the heart of the Peak District National Park. At the weekends, Carol Services take place in both the Peak and Treak Caverns, but these are very popular and visitors have to book well in advance.

On the 2 April 2004, Castleton's new state-of-the-art information centre was opened to the public. The plans were drawn up following consultations with the local community and provide extensive community facilities. A museum has been incorporated into the building, which the Castleton Historical Society uses to feature a range of exhibitions about village life through the ages. The exhibition at the one million pound centre is superb, and fully does justice to one of the most beautiful villages in the country. The pot holing and climbing displays enable the visitor to get so close to the action, as if they are actually present.

The history of St Edmunds' Church is closely linked to that of the castle. Built in the twelfth century it was known as the 'Church of Peak Castle'. There is a Norman arch behind the pulpit and it still retains box pews. A treasured possession is a valuable Breeches Bible of 1611. In the market place, Castleton Hall is now a Youth Hostel and by an attractive old tree on the green stands a War Memorial in the form of a cross.

CHAPEL-EN-LE-FRITH

(SK055805)

Off the A6/A624 Buxton to Glossop road — Chapel-en-le-Frith Railway Station

The small town of Chapel-en-le-Frith is situated on a high ridge surrounded by hills, six miles to the north of Buxton, close to the border with Cheshire. It does not enjoy the best of reputations with those drivers from the industrial towns of the northwest who, when visiting the Peak District for the day, did stop in the town — not to look round or take refreshment; but because they were stuck in a traffic jam. Fortunately, in 1987 a bypass was opened that took much of the traffic away from the centre of the town.

For those who turn off by the King's Arms at the top of the town, they will be delighted. The eye-catching cobbled Market Place rises up from the main street, standing 776 feet above sea level, with a market cross, stocks and a number of colourful old inns setting the scene.

Originally known as Bowden, the town derives its present name from a Chapel of Ease, built in a clearing in the Royal Forest in the early thirteenth century; 'Frith' being the Norman French word for forest. A grant of the land to build the chapel was obtained, when according to the records the inhabitants of Bowden 'had become so numerous' as to make the building of a chapel desirable. The foresters cleared the land and built the chapel dedicating it to the martyred Thomas Becket.

The present church stands on the same site as the original and is the result of many frequent restorations. Over the doorway is a sundial; rectangular in shape it is set on a stone tablet rising above the porch. At the eastern end of the churchyard a gravestone displaying the carving of an axe and the initials P.L., is known as the Woodcutter's grave, and if it marks the last resting place of a thirteenth-century forester, it may be the oldest in the country. Inside the church, there are some fine box pews, Flemish-style chandeliers, a thirteenth-century stone coffin and several memorials.

A great scandal occurred in 1648, when Cromwell's men locked up in the church about 1500 prisoners of the Scottish Army who had fought at the Battle of Ribbleton Moor. The conditions were appalling, few could even lie down because of the overcrowding and they were left there for sixteen days before being released.

Church Brow

No fewer than forty-four died during this period and another ten were too weak to survive the forced march back to Scotland. The dead were buried in the churchyard and after that the church became known as 'Derbyshire's Black Hole'.

Human life in the area goes back over 3000 years, Bronze Age burial mounds and earthworks have been found nearby. The Romans made little impact and all that can be traced is a Roman Road. For many years, the area was a Royal Forest, where several small communities huddled together for protection. The forest itself never really existed in the truest sense of the word except to provide the basis of the vast Norman hunting preserve. In the main, the area was made up, as it is today, of open space rather than woodland.

The strategic location of Chapel enabled it to grow quickly and become one of the centres of power in the Royal Forest of the Peak. At a much later period in its history, the arrival of the Midland Railway gave the town a further boost, with the London to Manchester connection. All that remains today is the Manchester to Buxton line.

On the southwest side of the church is the town's most attractive feature, the cobbled Market Place, where the cattle market was once held. An open-air market now takes place there every Thursday. In the Ye Olde Stocks Café, is a mural by Claire Taylor, illustrating a typical market day in the late 1800s.

Apart from the fine old Market Cross and the town stocks probably dating from the Cromwellian period, a horse trough commemorating Queen Victoria's Diamond Jubilee is prominently sited in the Market Place. Among all the numerous objects to be found in Derbyshire that celebrate the Diamond Jubilee, this is one of the most practical.

The town church

Church Brow, a steep, cobbled street leads off the Market Street. It is lined with attractive little cottages that no architect ever planned, but that fit together in picture postcard fashion. It has been likened to Gold Hill, in Shaftesbury, the small hilltop town in Dorset on which Hovis based a successful advertising campaign.

The stocks in the Market Place

Vehicles descending to High Street risk running out of control — unless they have good brakes — something for which the town is justifiably famous.

Chapel-en-le-Frith has played an important role in the development of the automobile, with the massive Ferodo works to the west of the town bearing testament to that fact. Local man Herbert Frood first developed a brake block for horse drawn carts, before just over a century ago, turning his attention to mechanical vehicles. He invented a brake lining for buses and with the steady increase in the number of vehicles on the roads, he provided brakes for vehicles as well and his business rapidly prospered. The Ferodo works now produce vast quantities of brake linings for vehicles all over the world.

The King's Arms was a regular stopping place on the Buxton to Manchester Turnpike. In days when licensing laws were much stricter, The Roebuck had special dispensation to remain open until 4pm on Market Days, for the benefit of farmers, cattle dealers and their men. Many of the pubs that once clustered round the Market Place have long since disappeared, but a carved bull's head over the doorway of one large house rather gives the game away as to where the old Bull's Head public house was sited.

On Market Street, the building with a stone staircase at the side is the Hearse House, where the parish hearse was kept available for hire to anyone able to provide the horse.

Chapel-en-le-Frith Carnival takes place annually on the first Saturday in July, when the streets are colourfully garlanded, shopkeepers decorate their windows and a procession takes place through the streets. At the same time, the town holds its Well Dressings. Another form of entertainment is provided at the Playhouse Theatre, formerly a cinema, where the Chapel Amateur Players perform.

EDALE

(SK122859)

Off A6187 Castleton to Hope road — Edale Railway Station

Edale is a pretty village, but its stunning location is what brings visitors in their thousands all summer and at the weekends in winter. For many years, the Vale of Edale had remained isolated. Its location, surrounded by the glowering heights of Kinder Scout to the north, and a long ridge of hills to the south, made it difficult to reach. The River Noe just manages to find a space through a narrow gap in the hills on its way towards Hope.

Everything began to change when the railway arrived in the heart of the countryside. The Cowburn Tunnel cut through the rocks to provide the exit. Further east, the even longer Totley Tunnel, opens the route up to link Manchester and Sheffield. For those who do not use the train there is a bus service from Hope Valley. Car parking in the village centre is almost impossible, but there is a large pay and display car park near the Village Hall and parking for rail users at the railway station.

The right to roam the privately owned moor above Edale was severely restricted until the 1950s. Now that access to roam has been negotiated, subject to certain byelaws, the moors are very popular with walkers. But Kinder Scout, a plateau that covers five square miles and rises to a maximum of 2,088 feet, can be a very dangerous place. The weather can change quite suddenly from bright sunshine to thick mist, making it impossible to find your way without a compass. But for those who come unprepared to walk on Kinder and others who prefer more gentle exercise, the Vale of Edale offers a splendid alternative.

Tom Stephenson's classic long distance walk, the 'Pennine Way' has its official starting point at the Old Nag's Head, built in 1577, in the centre of the village. It follows the Pennine Chain for over 250 miles northwards, to the Scottish Border at Kirk Yetholm. Attracting some 10,000 walkers each year, it is a good test even for the most experienced walker. On the wall in the pub is a blank framed certificate awarded to those who complete the walk.

Fred Heardman, the one time landlord of the Old Nag's Head, known to his friends as 'Bill the Bogtrotter', set up the Edale Mountain Rescue

An Edale cottage

Team of volunteers. Many walkers had cause to be grateful to Fred and his friends, before the official mountain rescue service began. He also set up an information service, provided until recently at the Peak National Park Information Centre at Fieldhead. This has been replaced on the same site by the prestigious Moorland Centre. People still remember Fred for devising the demanding annual Four Inns Walk, which starts at the Isle of Skye Inn, near Penistone, north of Sheffield and ends at the Cat and Fiddle near to Buxton, calling at the Snake Inn and the Old Nag's Head. Sadly, three Rover Scouts died on the walk during bad weather in 1964.

Nowadays, Edale is a popular tourist attraction, but originally it was a loose confederation of five booths. These are huts giving temporary shelter to boothmen, while they kept watch over livestock. The booths eventually became the permanent settlements of Upper Booth, Barber Booth, Ollerbrook Booth, Grindsbrook Booth and Nether Booth. Grindsbrook Booth, the largest of the settlements, is more usually known as Edale.

In 1790, Edale cotton mill built at Nether Booth, on a site originally occupied by a corn mill and tannery, was one of only two such mills situated on the east of the Pennines. At one time up to eighty people worked at the

Looking towards Kinder Scout

mill. They were mostly women who walked over daily from Castleton, except in bad weather when they bought provisions and stayed the night. It ceased operations in 1934, and has been converted by the Landmark Trust into flats.

The Rambler Inn, near the railway station, plays host every fourth Tuesday night of the month to the popular 'Folk Train'. The train brings musicians and beer drinkers along the Hope Valley line, when music is played and songs are sung before the party alights at Edale. Although the scheduling of the journey is organised, the entertainment provided is impromptu.

The charming little parish church, built in 1886 is the third on the site, but prior to 1633, the village had no church and the villagers worshipped at Castleton Church. When someone died, the coffin had to be carried over the hills, for burial at Castleton, almost an impossible task in mid winter when the weather was particularly dire.

David Taylor, a wandering Methodist preacher and a colleague, having lost their way walking through a blinding snowstorm, saw a light shining in a solitary house. They knocked at the door and walked in. The occupier, John Hadfield, grabbed the sword he had used at the Battle of Prestonpans from the mantelpiece and prepared himself for battle. On seeing this, David

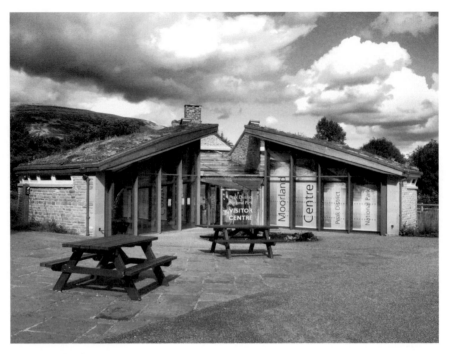

The Moorland Centre

Taylor stepped forward saying, 'Peace to this house'. Not only did this allay Hadfield's fears, but shortly afterwards prayers were said and he agreed to the house being used for Methodist services. A new chapel now stands in Barber Booth close to the original site.

There is a good variety of accommodation available in the area. On the walk up from the railway station and car park, a number of private houses offer accommodation, as do both pubs. At Champion House, the Peak Centre, provides residential accommodation for group activities and a short distance away at Nether Booth is a Youth Hostel.

The Old Nag's Head holds pride of place in the village, with Coopers Café providing an alternative for refreshment. The café occupies a location adjacent to a caravan and camping site. There is a small shop in the village, but that is soon left behind as the road narrows and turns into a track crossing Grindsbrook Bridge onto Kinder Scout and open country.

An event to look out for is Edale Country Day, which provides great fun and entertainment for all the family. The Edale Beer Barrel Race from the Snake Inn to the Nag's Head provides huge excitement for the competitor and spectators. Other events held in this active little village are Edale Jazz in the Field and the annual Church Fête.

FERNILEE AND GOYT

(SK017785 & SK014757)

On the A5004 Buxton to Whaley Bridge road

The ruggedly picturesque Goyt Valley, surrounded by heather clad moors, has been a popular place for visitors since Victorian times. The appearance of the valley changed dramatically in the 1930s when the Fernilee Reservoir was built and, some thirty years later, the Errwood Reservoir. Now the reservoirs provide leisure facilities, in a valley rich in industrial heritage and wildlife.

The tiny hamlet of Fernilee perched by the roadside, on the main road leading from Whaley Bridge to Buxton, is composed only of a pub, a few farms and houses. From here there is easy access for walkers to the Fernilee Reservoir and the Goyt Valley. The Cromford and High Peak railway used to pass through Fernilee, close to where the reservoir is now sited. At Whaley Bridge a short distance to the west, the railway joined up with the London and North Western line.

Traces of the existence of Neolithic farmers dating back to 3,000 BC have been discovered in the Goyt Valley, farming having always been a predominant activity. What is surprising is that this remote valley once had several other thriving industries. Goyt's Moss Colliery sited near Derbyshire Bridge was quite extensive. There were also several quarries in the valley, a paint mill and a Gun Powder Factory.

It is thought the Gun Powder Factory may date back to the sixteenth century and have supplied the ammunition for Sir Francis Drake to fight the Spanish Armada. The factory was positioned where the Fernilee Reservoir is now to be found. At the time, a network of tramways and a narrow canal were used to transport the explosive materials required to manufacture gunpowder. During the First World War the factory was very active but closed soon afterwards.

In close proximity to Goytsclough Quarry is what remains of the old Paint Mill. It operated in the nineteenth century, when a water powered wheel crushed locally mined barytes to a powder. This was then used to manufacture paint. Near the Derbyshire Bridge are the remains of dozens of old coal mining shafts, which provided coal for homes and for the local lime burning industry.

Packhorse Bridge

Errwood Reservoir

Until recent times the valley has also been an important trade route. The Romans built their roads in the area and the medieval tracks and hollow ways in the valley were once important packhorse routes. One of the packhorse routes came over the hills from Cheshire by the quaintly named landmark of Pym Chair, and then across the Goyt Valley to Buxton. According to a local legend, a highwayman named Pym used to lie in wait at Pym Chair and ambush the tired and weary jaggers leading the packhorses.

It was from Goytsclough Quarry that Thomas Pickford set up a family business mending roads. It progressed to such an extent that by the eighteenth century James Pickford was known as the 'London to Manchester Waggoner.' Today the business still thrives as one of the major removal and storage companies in Europe.

Packhorses were replaced when The Cromford and High Peak Railway was built in 1830. It linked the Cromford and Peak Forest Canals at Whaley Bridge. In the middle, it rose to over a thousand feet at Ladmanlow, and was considered to be an engineering masterpiece. Stretching for thirty-three miles in length, the line was fully opened in 1831, when it was used to transport minerals, corn, coal and other commodities from one canal to the other. The Goyt section was closed in 1892 after a new link to Buxton had been completed.

The Cat and Fiddle overlooks the valley from the A537, Macclesfield to Buxton road. The second highest public house in England, it stands at 1,690 feet above sea level, and is located in one of the wildest and most remote areas in the Peak District. Many are the tales told of the extreme weather conditions experienced; in 1892 it was apparently impossible to open the front door or any of the windows for seven weeks. Although the climate is now less severe, the pub is often cut off for short periods during the winter, when most of us have seen very little, or no snow at all.

The route into the valley from A537 is restricted for motor vehicles, which must be left at the Derbyshire Bridge car park. A one way system operating from Errwood to Derbyshire Bridge, apart from on Sundays, and Bank Holiday Mondays, during the summer season. The road is then closed in both directions from The Street to Derbyshire Bridge to traffic. Access is still permitted for emergency services, those who work in the valley, cyclists, walkers and horse riders.

On the western side of the Errwood Reservoir, lie the grounds and ruins of Errwood Hall, the former home of the Grimshawe family. Samuel Grimshawe, who had the hall built in the early 1840s, came from a rich merchant family from Manchester and was described in the census of 1851 as a 'Land Proprietor'. In the same year, he declared his conversion to Catholicism and converted part of an upper floor of the hall into a private chapel. The family became dedicated Catholics and were very generous in their support of the church; they also set up wayside shrines and a small chapel in the woods.

The last of the Grimshawe's died in 1930, and the hall was demolished when Fernilee Reservoir was built. Ruins of the hall still remain, the approach to which is particularly attractive when the rhododendron bushes that line the route are in bloom. The family cemetery can still be seen and traces of the small hamlet of Goyt's Bridge are still visible when the water level of the Errwood is low. Fortunately, the former Packhorse Bridge was removed when the valley was flooded and rebuilt, brick by brick, further up the valley.

In contrast to the vast expanse of moorland, the lower slopes of the river valley contain a variety of forest and woodland. The whole area is designated as a Site of Special Scientific Interest, and is home to many rich and diverse species of flora and fauna. It is a good habitat for wildlife conservation and a great place for visitors to enjoy the freedom of the countryside.

GLOSSOP

(SK035942)

At a meeting point of the A624, A6016 and A57 in north-west Derbyshire
— Glossop Railway Station

Situated in the far north-west corner of Derbyshire, in an area of outstanding natural beauty, Glossop is often referred to as the northern gateway to the Peak. There are though, not only the moors on Kinder Scout to explore, but also the great moorland wildernesses of Bleaklow and Saddleworth Moor. The terrain is frequently difficult and walkers and climbers often come to the area to test themselves, but for the less energetic there are plenty of easier walks.

The best place to view Glossop is from the Sheffield road, one of the highest and most desolate roads in the National Park, near where it emerges from the Snake Pass. From here you can look down on the town that nestles in a deep valley, surrounded by hills forming a natural amphitheatre.

There are two distinctive parts to Glossop, the busy, bright and modern town centre and the quieter unspoilt, former village of Old Glossop, on the north-east side of the town. The old village, once the centre of a vast, scattered, mountainous parish had a market and fair as far back as 1290 and grew around a market cross and parish church. Ancient buildings from the seventeenth, eighteenth and nineteenth centuries are tucked in along its narrow streets. Delightful Manor Park has been formed from the grounds of the former manor house owned by the Duke of Norfolk, which existed on the site in the sixteenth century.

Glossop is an ancient settlement, possessing evidence of occupation during Roman, Saxon, Norman and medieval times. In 78 AD, the Romans built a fort there, which was named Melandra. It was the most northerly of three forts in Derbyshire and at one time held 500 soldiers. It was burnt down and abandoned 62 years after being built, and all that remains are the foundations.

Anglo Saxon settlers farmed and hunted in the area. They named it 'Glott's Hop,' after 'hop' meaning a valley and 'Glott' who had a smallholding in the settlement, from where the present town derived its name. The abbey of Basingwerk, in Flintshire, received grants from William Peveril in the early twelfth century and encouraged settlement in Glossop, securing a market charter in 1290.

Glossop town centre

Early in the nineteenth century another village sprang up alongside the Glossop Brook. It was called Howardtown after the chief landowner, Bernard Edward Howard. Cotton manufacturing took place there on a rapidly increasing scale, so much so that the population increased six fold in half a century. The original wood-fulling mill, built in the 1780s was taken over by the Wood family in 1819.

This was a time of enormous expansion and prosperity, when the town developed as a textile manufacturing centre, largely producing cheap fabrics for colonial markets. The rapid expansion led to houses, schools and churches being built. By the middle of the century there were over fifty mills in existence in the town, together with the Partington Paper Works and the large print works run by the Potter family.

At the height of the Industrial Revolution, Howardtown Mills stretched for over a quarter of a mile and employed 1,500 workers. Howard was the family name of the Duke of Norfolk who owned most of the land.

The new town centre was developed around the Town Hall, which was erected in 1838, with a distinctive looking clock tower. Its arcaded ground floor is now used as a small shopping centre. A Market Hall was constructed

Norfolk Square

six years later, where markets are still held today. At the rear of the building are the impressive looking Municipal Buildings, which display the Borough Coat of Arms above the entrance.

A number of delightful sandstone buildings were built around Norfolk Square, which together with its lawns, trees and flower beds considerably enhanced the appearance of the town centre. Glossop Heritage Centre along with the Tourist Information Centre were looking for alternative premises in 2009, following the end of the lease on their former home at the top of Norfolk Square. Just across the road is the Partington Theatre; a modern sculpture of Hamlet made by the members has been placed in a niche above the doorway. The railway station in Norfolk Street has the Howard lion proudly standing guard over the entrance to part of their premises now occupied by a supermarket.

It may surprise visitors to find that Glossop Town Football Club was one of the founding members of the Football League. Perhaps even more surprising is that members of the Wood family, rich, local mill owners, who were great benefactors to the town, helped to establish Arsenal Football Club and have been directors of the club for over 100 years! The town cricket and

bowling club is used annually for Derbyshire County Cricket Club Second XI matches.

If you follow the excellent Town Trail, available from various sources in the town, you will pass the imposing Victoria Hall, with its Gothic tower. It was built and still serves as a public library and meeting place. Immediately beyond the chapel and the library an inscription on a gatepost indicates the entrance to the Howards' former estate office.

Howard Park with its Victorian swimming pool, little lake, humped back bridge and meandering paths, must be one of the prettiest parks in the Peak District. There is a statue at the entrance erected by the inhabitants of Glossop in memory of two members of the Wood family who donated the swimming pool. On the other side of the town, Harehills Park is quite different in character, with its Riverside Walk, taking you past converted old mill buildings. It was given to the town by Baron Howard, in memory of his son and other men who had been killed in the First World War.

High Street is tree lined and provides a wide diversity of traditional and individual shops. More shopping is available at the very popular indoor and outdoor markets and the famous Bank Holiday markets. Visitors arrive from all parts to watch the town carnival, with its abundance of colourful and decorative floats that move in procession through the town streets to Manor Park.

 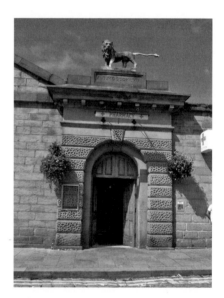

Above left: **The Partington Theatre sculpture of Hamlet**
Above right: **The Howard Lion**

GRINDLEFORD

(SK244778)

On B6001 two miles south of the A6187 Sheffield to Hathersage road — Grindleford Railway Station

Situated in a beautiful setting with wooded hillsides rising up above the River Derwent, the village of Grindleford occupies a desirable spot. It is a busy place where several roads converge and, before the bridge, a ford crossed the river that for centuries had been an important crossing point.

Grindleford is a 'modern' parish, formed as recently as 1987, out of the parishes of Eyam Woodlands, Stoke, Nether Padley and Upper Padley. This ended a lot of confusion as since the fourteenth century the development near the road bridge had been known as Grindleford Bridge, though ' Bridge' was dropped after the Second World War. The railway station, although in Nether Padley, was named Grindleford in the 1890s.

Rising steeply up from the Sir William Hotel in Grindleford is Sir William Hill, which reaches an height of over 1,400 feet on Eyam Moor. It used to be the Buxton to Grindleford turnpike. There are several theories as to how it was named, possibly the one that suggests it commemorates Sir William Cavendish who owned Stoke Hall may be correct.

On the other side of the valley, Totley Tunnel, opened in 1893, but it was a year later before passenger services started. It is Britain's second longest inland railway tunnel, three miles and 950 yards in length and took over four years to complete. When it opened, it caused considerable excitement in the Sheffield area opening up, as it did, the previously isolated Hope Valley. It linked the important cities of Sheffield and Manchester and in doing so unlocked the land in between for development. Grindleford was the first stop on the line and the cheapest after the tunnel and tourists flocked there to see for themselves the glorious land locked valley. Some liked it so much that they stayed and built their own houses in the area.

The arrival of the railway benefited the mineral extraction industry at Grindleford Quarry. The railway company used stone, but it most importantly provided an easy means of distribution to more distant places. Over a million

tons of gritstone from Grindleford was transported by train, for use in the construction of the Howden and Derwent Dams. All this activity brought prosperity to an area where the population was growing rapidly. The number of inhabitants quickly trebled due in the main to the increased availability of work in the area.

The ruins of Padley Hall lie along a track a short distance from Grindleford Station, past Padley Mill, now converted into a private house. All that remains of the hall are part of the foundations and the original gatehouse. Padley Chapel hidden away on the upper floor of the gatehouse survives today. It was used as a barn for over 100 years, before being restored in 1933.

On 12 July 1588, Padley Hall was raided and the two Catholic priests, Nicholas Garlick, Robert Ludlam and several members of the Fitzherbert family were arrested. It was not illegal to be a Catholic, but training abroad to be a priest was against the law. Harbouring a priest was a treasonable offence.

Nicholas Garlick, the son of a Yeoman from Glossop who had trained to be a priest in France, and Robert Ludlam, the son of a farmer from Radbourne, who had also trained in France, were taken to Derby and hung, drawn and quartered. John Fitzherbert of Padley and his brother both died in prison. A

The entrance to Totley Tunnel

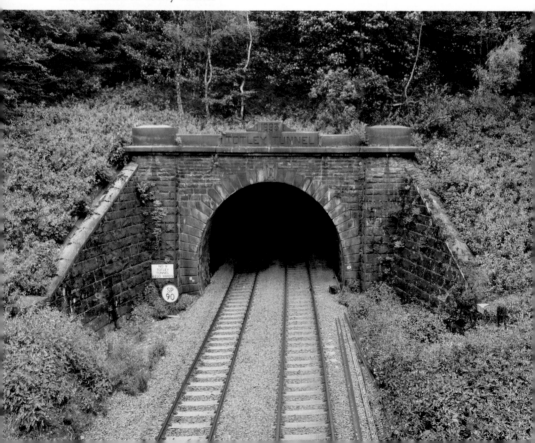

pilgrimage now takes place every year in July when a special service is held, in the chapel, in memory of the Padley Martyrs.

Facing Padley Chapel is Brunt's Barn, a volunteer conservation centre opened in 1981, in memory of Harry Brunt for his 'pioneering work for the National Park 1951-80'. A wild flower nursery that propagates an amazing variety of flowers is close by.

The increase in the population after the railway came to Grindleford, resulted in the enlargement of the Commercial Hotel, later re-named the Sir William. The Maynard Arms built in 1908, near to the railway station, also helped to cope with the extra inflow of visitors.

Grindleford Station Café is an excellent walker's café where groups can book early morning breakfasts at the weekend. There are various amusing notices dotted around so be warned do not use your mobile phone here — this is the place people come to get away from them! There are plenty of tables both inside and out. The café is the home of Grindleford Natural Spring Water. It is open all year.

On the western side of the bridge over the River Derwent is the Toll Bar Cottage, with the projecting window providing a good view in both directions for the toll keeper to keep a watch out for business. On the opposite side of the

Old Toll Bar Cottage

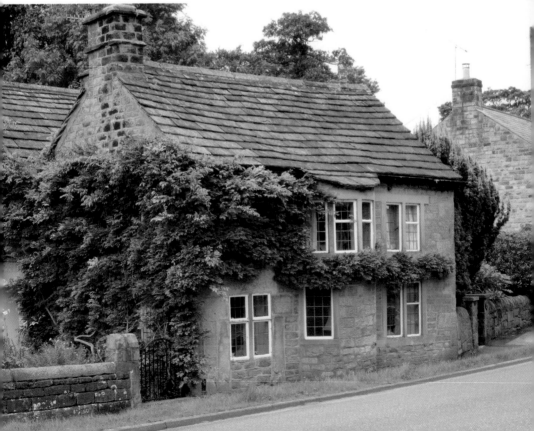

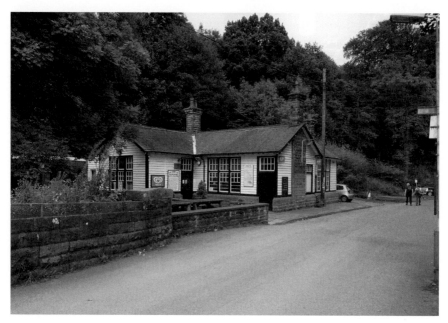

The Station Café

road an ornate cast-iron sign designed for the Peak and Northern Footpath
Preservation Society indicates the route to follow, and also informs you that
you are 427 feet above sea level. The lovely light and spacious St Helens
Church, consecrated in 1910, five years after the expansion of the Methodist
Chapel, is slightly higher up the road.

The 1977 Jubilee Gardens, by the bridge, is a pleasant place to sit and relax.
Across the road, activity that is more strenuous takes place on Bridgefields
sports ground. The large well-equipped Bishop Pavilion, apart from providing
sporting facilities, acts as the centre of community life in the village. Further
up the street, on the site of the former Red Lion pub, are a group of cottages
that carries its name. Over the road are the village post office and shop and
the Derwent Gallery, selling pictures of the Peak District.

On the beautifully wooded road to Calver, near the impressive Stoke Hall
a Grade II* listed building, is a stone quarry. The stone from this quarry is of
a pleasing pale buff colour and has been used in the construction of a number
of prominent buildings. Locally, St Helens Church is built of stone from the
quarry.

An important event in the village calendar is the annual Grindleford Show,
which has changed little over the years.

HATHERSAGE

(SK230815)

On A6187 Hope Valley road — Hathersage Railway Station

Hathersage today is a large good looking village with hotels, cafés and shops lining its long main street. It has strong literary connections as well as beautiful scenery, excellent walking and climbing country, all of which attracts droves of visitors. To the north, Stanage Edge rises up steeply and to the south the River Derwent flows, on its way to World Heritage status lower down the valley between Matlock Bath and Derby.

In the nineteenth century the scene was very different. Five chimneys belched out black smoke, Hathersage being the centre of the needle, pin and wire drawing industry. Brass buttons were also manufactured and in 1847 Samuel Fox designed his Fox Frame lightweight umbrellas. Those industries, along with their smoke, vanished around 1900 although four mills still remain but now with different uses. Button manufacture started at Dale Mill in 1720, the metal brought by packhorses from Sheffield before being returned in the form of brass buttons which were much in demand.

It was in mid 1700s that the rural quiet gradually began to be disturbed with the arrival of the wire drawing industry. Business built up gradually and it was nearly 100 years before it really took off, following the Great Exhibition when orders started to come in rapidly. Somewhat cynically, it was said that a wire drawer was easy to identify because he had several missing fingers. Even more serious were the working conditions for 'grinders' who seldom lived much over 30 years of age. The dust from the rapidly revolving millstones over which they toiled, got into their mouths and lungs until they contracted the dreaded 'grinders' disease'.

Conditions were gradually improved, particularly as a result of a Royal Commission investigating the working environment. The grinders, however, did not always take the precautions advised as they claimed these slowed productivity and reduced earnings. When the industry finally came to an end, Hathersage once again returned to its former peace and quiet.

Hathersage has strong literary connections. Charlotte Brontë's best friend at school was Ellen Nussey, whose brother was vicar of Hathersage. In 1845,

Looking down towards Hathersage from the church

Charlotte stayed at the vicarage with Ellen for about three weeks to prepare for the return of the vicar and his wife from honeymoon.

During her stay Charlotte took the opportunity to explore, walking on the moors and visiting many of the houses scattered around the area. Her famous novel *Jane Eyre* was set in Hathersage. She used the name of the landlord of the George Inn, a Mr Morton, who greeted her when she first arrived, as the name for her fictitious village.

Another famous character associated with Hathersage is the outlaw Robin Hood who is said to have been born at Loxley, only eight miles from Hathersage and many local places bear his name. On Stanage Edge is Robin Hood's Cave where he and his men often hid. The stream that runs through the village also bears his name. His faithful lieutenant, Little John, is reputedly buried in Hathersage churchyard, in a grave measuring 11 feet from head to footstone.

The grave was opened in 1784 and a thigh bone 30 inches in length exhumed, which would make the occupant over seven feet tall. For many years a great bow, arrows and a green cap hung in the church. In the porch is a large 600 year old stone said to have once marked Little John's grave. Yet

The former button factory

it is Nottinghamshire and not Derbyshire which has reaped the commercial benefits from the legend of Robin Hood and his merry men.

St Michael's Church stands on the hillside above the village and contains a fine collection of fifteenth-century brasses of the Eyre family. The churchyard is well tended and the Lych Gate particularly impressive. Close by the church is Camp Green which dates back to 850 AD; the circular mound was a fortification built by the Danes. At the bottom of Church Bank is a well-preserved example of a Pinfold that provided a secure lockup for straying livestock. It was the Pinders' responsibility to round up stray animals and not release them before the owner had paid a fine.

The present Scotsman's Pack Inn was built in the early 1900s, but there has been an inn on the site since the fourteenth century. A 'Scotchman' or 'Scotsman' is a name given to a pedlar, not necessarily from Scotland, which is how the inn derived its name. The George Hotel is another coaching inn, to the right of which, close by the footpath, is a nineteenth-century cheese press.

Set low in the wall about 50 yards above Dale Crescent, is an inscribed Gospel Stone, where the priest stood at Rogationtime to bless the crops. Just above at the entry to The Crofts, is an ancient milestone indicating '10 miles to Sheffield'. The railway station is a short distance down the Grindleford road.

On the southern side of the village, along Grindleford Road, a surprise is in store for many visitors in the form of a purpose built cutlery factory. The fact that the factory, designed by David Mellor, has been described by Sir Michael Hopkins as a 'minor masterpiece of modern architecture' out of what was once the gas works, will come even more as a shock.

Set discreetly back from the road, this highly functional industrial building hides its beauty away from the casual observer hurrying by on the busy road. It is only when it is approached up the gravel driveway and the whole site explored, that it is possible to fully appreciate the architectural value of the Round Building and the more recent additions.

The factory is internationally famous for its cutlery, designed by David Mellor. He also designed the national traffic light system, which is still in use to this day and a square pillar box for the Post Office, but this was not so successful. The Design Museum may be visited during the week, where a wide range of designs are on display from teaspoons to traffic lights. The café is equipped with all the finest David Mellor tableware and serves light lunches as well as specialist teas, coffees and cakes.

HAYFIELD

(SK037870)

On A624 road from Chapel-en-le-Frith to Glossop

The village of Hayfield sits peacefully on the edge of the Peak District, in the narrow valley of the River Sett, surrounded by some of the wildest hills in the Dark Peak. Its location makes it a very popular centre for exploring the area with good amenities for walkers and mountain bikers, many of whom use it as the starting point for the western ascent of Kinder. Contrastingly, the Sett Valley Trail, two and half miles in length provides easy level walking. It is used for recreational purposes by walkers, cyclists and horse riders and follows the former track of the railway line that linked Hayfield with Manchester as far as New Mills. The route forms part of the Pennine Bridleway National Trail between Hayfield and Birch Vale and is of outstanding natural beauty.

For many years Kinder was barred to walkers, being preserved as a grouse moor. The peace was interrupted on Sunday 24 April 1932 by the famous Kinder Scout Mass Trespass. This had been well advertised in the *Manchester Evening Chronicle* and involved some 400 people. The police were waiting for the leader, Benny Rothman, at the railway station but he avoided arrest by arriving on his bike. The walk started from Bowden Bridge Quarry, just to the west of the village centre.

On the moor the walkers were confronted by gamekeepers, who were unable to stop them walking across Kinder to meet up with other parties of ramblers who gained access from different locations. Five ramblers were later arrested and imprisoned for their part in the demonstration. As a result of the trespass, access restrictions were gradually reduced.

Things were much different in its industrial past, when cotton and paper mills, calico printing and a dye works made it a busy and anything but quiet place. It was wool that started the industrial expansion and the spinning and weaving of both wool and cotton became established in the seventeenth century. As the 1700s progressed Hayfield began to share in the great expansion of textiles, which was taking place in the North-West. Three storeyed weavers'

houses replaced the former thatched cottages; three woollen mills were built by the river and later in 1810, a dye works. The prosperity did not last and handloom weaving began to decline, although Hayfield still had woollen mills until the mid 1800s.

In 1868, the railway came to Hayfield and was soon busy with both passengers and goods, servicing all the mills in the Sett Valley, but business gradually diminished and it closed in 1970. At the former railway station a car park, information centre, picnic area and toilets are provided and trail users can visit New Mills. Spectacular New Mills! But many people who drive through the town by car are completely unaware of the secret beauty that lies below. The Torrs Riverside Park provides access to a dramatic gorge and an area of stunning natural beauty. The Park also contains the remains of what was an important industrial area, with the elegant Millennium Walkway winding its way for 125 yards through the gorge, high up among the canopy of trees.

Flooding has been a regular problem in the past and in 1818 after a disastrous flood, the parish church of St Matthew had to be re-built and the floor level raised. A curious feature of the building is that it stands on a stream which can be seen emerging from beneath the church.

The view from the former railway station

The Town Bridge, known locally as the Woolpack Bridge, built in 1837, is the third on the site, the first two having been swept away by floods. When the present bridge was re-built it was discovered the north side was built on quicksand. This problem was solved when someone came up with the idea of using huge bags of wool pressed down in the sand. The bridge is still standing, which is testimony enough to the soundness of the idea.

The Royal Hotel has a strange history. It was built in the eighteenth century as a parsonage, but incorrectly conveyed into the vicar's name. On his death in 1764, his family sold it and for forty years it was an inn. The new owner restored it to its original use, until in 1863, he disagreed with the choice of incoming vicar and it was converted back into an inn.

Arthur Lowe, the son of a railway worker, was born in Hayfield. He is best remembered for his role as Captain Mainwaring (also but erroneously referred to as Mannering) in the well known television programme *Dad's Army*. He died in 1982, aged 66, after collapsing from a stroke in his dressing room at the Alexandra Theatre, Birmingham. A keen cricketer, he often used to bring members of the cast back to play cricket in the village.

Overlooking the attractive little cricket ground is Fox Hall, an impressive three gabled seventeenth-century house. The lower storey of the former Town

The start of the Sett Valley Trail

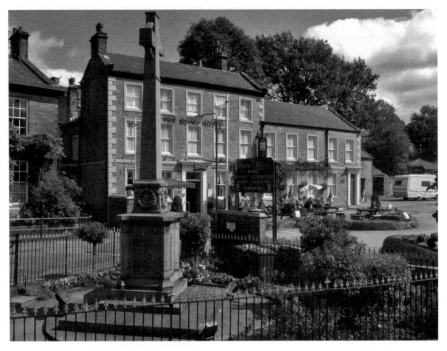

The War Memorial and Royal Hotel

Hall was once used as a prison, but many prisoners escaped up the chimney. The most dangerous, however, were handcuffed to the oven door! Beside the weir an attractive Memorial Garden has been created in the memory of three young people tragically killed in an accident at a Jazz Festival in 1983.

The Pack Horse Inn built in 1577, was a stopping off point for 'jaggers' and their trains of packhorses on the long journey to Holmfirth, or to the south. Built in the same era, the George was where the popular folk song 'Come Lasses and Lads' was first heard. The Bull's Head did not come onto the scene until 1788, when industry was booming and the first two woollen mills were built.

In Little Hayfield a mile to the north, Tony Warren created the television series *Coronation Street*. Pat Phoenix, who starred as Elsie Tanner, also lived in the village. Park Hall, a fine old house, is situated close by where Joseph Hague, who rose from rags to riches, once lived. He started work as an itinerant pedlar before becoming very wealthy and giving most of his money away. The annual Hayfield Sheepdog Trials and Country Show take place at Little Hayfield in September.

HOPE

(SK172835)

On A6187 between Castleton and Hathersage — Hope Railway Station

Superb scenery and excellent walking country surround Hope, which gives its name to the valley in which it lies. A village of great antiquity, it was once a centre of pre-historic trackways and later Roman Roads. The Romans most important fort in the Peak District was established at Navio, only one mile away from Hope. Nowadays, it offers the visitor the choice of welcoming pubs, shops, tea rooms and the opportunity to explore a village of great character with a fascinating tale to tell.

In 1086, at the time of the Domesday Survey, Hope covered two thirds of the Royal Forest of the High Peak and was one of the largest parishes in England. It was also one of the earliest centres of Christianity in the area and the church was the only one mentioned in North Derbyshire in the survey. As a consequence, people from a wide area around the village came to be married at the church for many years after the Norman Conquest.

A place of worship has stood on the site of The Parish Church of St Peter for over 1000 years; the present church having been in existence for in excess of 700 years. Light and airy inside, the church has much to interest the visitor. A very rare 'Breeches Bible', open in a glass case on the wall, displays the reference to Adam and Eve wearing 'breeches' rather than 'aprons'.

Outside the church there are numerous fascinating gargoyles round the roof, 'hideous' to some! A very worn, but recognisable carving of a Celtic Face is on the north wall of the Church tower. Close by, is the Eccles Cross that previously stood on Eccles Hill to mark a place of worship. On the southern side of the church, standing on either side of the path are a Saxon Cross and an old Market Cross. It is thought that the Market Cross originally stood in the Market Place, but after being broken was removed to the churchyard. The shaft only is all that remains of the Saxon Cross, which was found broken into two pieces.

On the northern side of the village, Win Hill and Lose Hill are very prominent features and there is an ancient legend about how they acquired

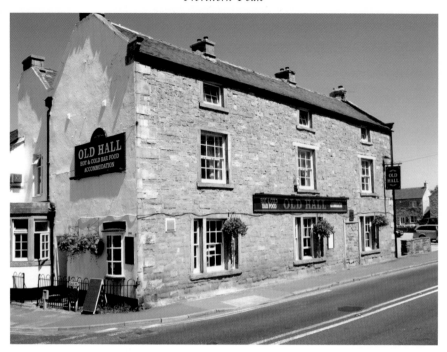

The Old Hall Hotel

their names from a battle in 626. Rivals King Edwin of Northumbria was camped on Win Hill and King Cuicholm of Wessex on Lose Hill. The army from Wessex was much the larger, so Edwin ordered his men to build a stone wall around the summit of the hill. When the battle commenced both sets of troops advanced, but the superior numbers soon started to push Edwin's forces back. Once the order to retreat came, the Wessex troops sensing victory, charged forward, only to be crushed to death by a hail of boulders heaved down the hill by Edwin's men to win the battle.

Hope Sheep Dog Trials and Agricultural Society celebrated its 50th anniversary in 1999, but Agricultural Shows go back to 1853. In 1944, the Hope Sheep Dog Club was formed with the sole aim of providing support for the Red Cross in the Second World War. After operating independently for five years, it merged with the Agricultural Society and the first joint show took place. The show is extremely popular and takes place on August Bank Holiday Monday every year. In particular the Sheepdog Trials provide a wonderful spectacle for both the country lover and city dweller.

Following the arrival of the Midland Railway in 1894, housing development expanded as business opportunities increased. Tourists came from Manchester and Sheffield along the Hope Valley line, often alighting at Hope Station to enjoy the scenery and to buy gifts and refreshments. The building of the Derwent and Howden Dams brought an army of construction workers and

The Parish Church of St Peter

their families into the area. They were housed in the temporary village of Birchinlee, known locally as 'Tin Town' in the Upper Derwent Valley. Many of the families stayed on when the work was completed and made Hope their home. Along Edale Road, opposite the farm shop is probably the last surviving building to have come from the temporary village of Birchinlee.

Hope Hall, now the Old Hall Hotel, was the home of the Balguy family. In 1715, after John Balguy had obtained a charter for a weekly market, a cattle and sheep market were held in the grounds of the hall. The market eventually closed down following the recent Foot and Mouth epidemic, with the land being made available for housing development.

All that remains of Hope Castle is an earthen mound that can be seen from Pindale Road. It pre-dates Peveril Castle at Castleton by about 100 years. By the bridge is a well-preserved Pinfold where stray animals were once kept. Further along the road are the Cement Works, the area's major employer.

On the southern side of the church, the old school is now available for hire for meetings, functions and the like. Adjacent is Loxley Hall, built in 1900, from a bequest — when instructions were left that a reading room should be provided with copies of current papers and periodicals and a fire lit as required for the benefit of the villagers. It currently houses pre-school activities. Daggers House, a former public house faces the War Memorial, on the other side of the road.

The Methodist Church

The village is well served with shops to suit the needs of local people and visitors alike. The Courtyard is home to a small number of shops and a pleasant modern café. Opposite is the Woodroffe Arms Hotel named after an ancient local family who can be traced back to the fifteenth century, and once held the title of King's Foresters of the Peak.

On the western side of the village the Education Service for the Peak National Park is based at Losehill Hall, and Hope Valley College, built in 1958, is on the Castleton Road. The Railway Station, for the popular Hope Valley Line, is on the other side of the village.

The Well Dressings take place in July each year, when everyone is encouraged to take part in the preparations for the event, visitors included.

NEW MILLS

(SK000854)

On the A6015 which links the A624 and A6
— New Mills Railway Stations (2)

Spectacular New Mills! But many people who drive through the town by car are completely unaware of the secret beauty that lies below. The Torrs Riverside Park provides access to a dramatic gorge and an area of stunning natural beauty. The Park also contains the remains of what was an important industrial area, with the elegant Millennium Walkway winding for 125 yards through the gorge, high up among the canopy of trees.

The area around where New Mills is established today was designated as part of the Royal Forest after the Norman Conquest. It was not until 1391 when a corn mill known as 'Berde', located near the site of the present Salem Mill, took the name New Mill, that the present town was born. The town marked the occasion by celebrating its 600th anniversary in 1991.

The ingenuity of Sir Richard Arkwright at Cromford in the 1770s, using waterpower to drive machinery, revolutionised spinning and weaving and it led to the eventual collapse of the cottage industry, which had grown up in the area. A rapid change took place with the implementation of the factory system for spinning and weaving driven by waterpower. The Torrs was an ideal place. Set in a natural gorge it had the joint waterpower of the Rivers Sett and Goyt. Rocky waterfalls and cascades allowed the construction of weirs to provide a controlled supply of water. The ledges along the riverbank, above the flood water level, were ideal to build on. The sandstone rocks at the side of the gorge meant the builders did not have to go far for their materials.

Soon New Mills became an important centre for 'finishing trades', bleaching, dyeing and the printing of cloth in the early 1900s. It was during this period that John Potts invented a method of engraving designs onto copper rollers, making it possible to print multiple colours by machine, an estimated 40 times faster than hand printing. This invention spread worldwide and was adapted for use on pottery as well as textiles.

The main problem for the mills set in the Torrs Gorge was accessibility, with narrow steep roads that put it at a disadvantage when steam power started to replace water. The next generation of mills were built on high ground on the other side of the gorge at Newtown, alongside the Peak Forest Canal and close to the railway station. The canal is now only used for recreational purposes and has a busy marina at Newtown. However, a railway service still operates from the station between Buxton and Manchester.

On the opposite side of the gorge New Mills Railway Station serves the Hope Valley and provides a regular service between Manchester and Sheffield. One railway line that New Mills did lose in 1970 was to Hayfield, along the Sett Valley. It is now a two and a half mile recreational trail, very popular with walkers, cyclists and horse riders.

In 1884, the problem of access between New Mills and Newtown, on opposite sides of the gorge, was solved with the building of the mighty Union Road Bridge, one of the highest road bridges in this part of the country. Despite this, it hardly seems as if you are crossing a bridge, because the high parapets hide the view of the gorge.

One of the best of the many good viewpoints of the Torrs Gorge is from the platform outside the Heritage Centre. The centre, housed in a converted

The Union Bridge

stone building, contains a finely detailed model of the town in 1884, when the Union Road Bridge was nearing completion.

Only a short distance down the steps from the Heritage Centre is the Torrs Millennium Walkway. The Derbyshire County Council's in-house engineers, not specialist bridge designers as might have been expected, constructed it. The walkway spans the otherwise inaccessible cliff wall above the River Goyt — part on stilts rising from the riverbed and part cantilevered off the railway retaining wall. It provides the final link in the 225-mile long Midshires Way. Most definitely, it is well worth making a special journey to New Mills to cross the gorge, as many people already have done.

Outside what used to be the town prison in Dye House Lane, is one of the most unusual notices that you are ever likely to read. It relates to Thomas Handford, who was never sober for the space of a whole week. He was out drinking with his friend Stafford, in the Cock Inn, next door to the prison, when his friend fell down dead. He walked out of the pub and resolved never to drink again. The notice entitled 'The Drunkard's Reform Cottage', tells the rest of the story:

A working man, a teetotaler for ten years, who was formerly a notorious drinker and a notorious poacher has recently invested his sober earnings in

The Millennium Bridge

the purchase of the town prison which he has converted into a comfortable dwelling house. Frequently an inmate of the prison whilst a drunkard and poacher, he is now owner of the whole and occupier of the premises. Thomas Handford 1854.

In a town where flat land is hard to find, workers' houses were frequently built in rows or groups on the steep hillside. There could be as many as four or even five storeys on the down slope beneath the main house on the top, creating an under-living. Even today, there are examples on Station Road and Meal Street, where one family occupies the upper half and the other the bottom half.

The Town Hall is on Spring Bank, with the Carnegie Free Library at the rear. Built in 1909, the library contained nearly 7,000 books. But the readers were not allowed to examine them; they had to choose a book from a catalogue list and check the indicator board to see if it was available. The selection completed, the number given to the librarian and she would hand the book over, with a reminder, 'Wash your hands'. On the opposite side of the street, a plaque with the words 'Constabulary' identifies where the police station once stood. Here six ramblers spent a night in the cells in 1932, before standing trial at Derby Assizes, following the mass trespass on Kinder Scout.

Carnegie Library

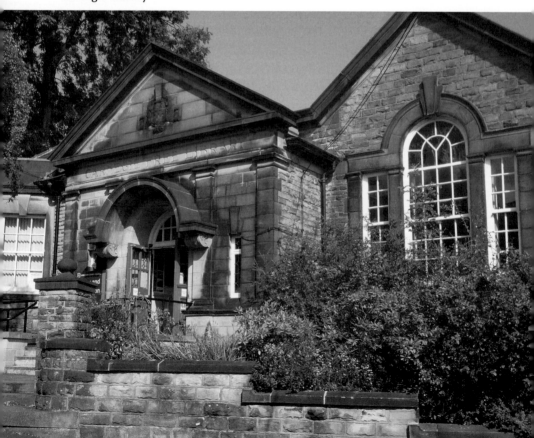

TINTWISTLE AND LONGDENDALE

(SK 024973 & SK982068)

On A628 Manchester to Sheffield road one mile north of Glossop

Tucked away in the northwest corner of Derbyshire is the village of Tintwistle or 'Tinsel' as it is called locally. Dating from Saxon times, it is situated towards the end of the stunningly, beautiful Longdendale Valley. This description can suddenly change when the weather alters, for this is Pennine country at its wildest on either side of the valley. It is part of the 'Dark Peak' named after its dark coloured gritstone, shale geology and vegetation. The heather covered moorland is the home to a wide variety of wildlife, much of which is now Access Land.

Tintwistle is on the boundaries of Cheshire, Yorkshire, Lancashire and Derbyshire and has panoramic views of glorious countryside looking up the Longdendale Valley. The landscape though has changed over the years following the building of reservoirs along the valley. Fortunately, Tintwistle Cricket Club, one of the oldest in the country, formed in 1835, had moved before the Arnfield Reservoir flooded its former ground. The club now plays on Speedwell in another part of the village.

Another major change, this time a paper one, came about as a result of the local Government Act of 1972 coming into force. Until 1974, Tintwistle Rural District was part of the administrative county of Cheshire, but as a result of the act, it became part of the High Peak District of Derbyshire. The inevitable consequence: the inhabitants found themselves living in another county without moving an inch.

The population of the village has changed remarkably over the years. It was only a small village when the domestic cotton industry arrived, which was followed by the establishment of cotton mills. Tintwistle along with Glossop was at the southern end of miles of cotton towns and villages that began in the northwest, in Central Lancashire. The opening of the mills increased the demand for workers so much that the population trebled between 1801 and 1851. The mills have now gone, but terraces of weavers' cottages still remain in the older part of the village.

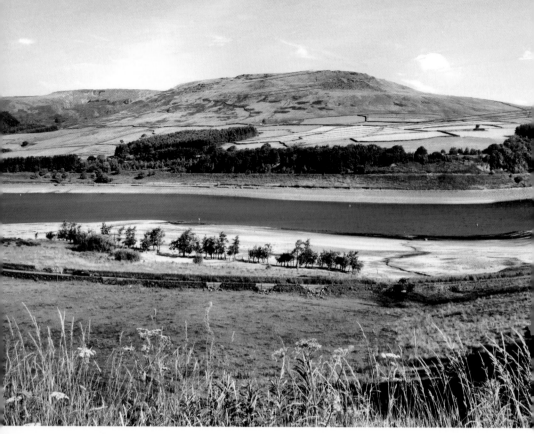

Longdendale Valley

The building of the Woodhead Tunnels in the Longdendale Valley created another surge in the population with an army of 1,500 navvies working on the site at one time. The building of the first tunnel, which was three miles in length, saw many accidents, some of them fatal. Started in 1839, it was completed in 1845. The second line completed in 1852, also led to considerable loss of live amongst the navies, much of it as a result of cholera. However, the establishment of the first rail link between Manchester and Sheffield brought prosperity and employment to the area.

A third larger tunnel replaced the first two single tunnels in 1954, to take the newly electrified line. The first two tunnels were then closed, but one was reopened in the 1960s to take electric transmission lines to avoid disfiguring the valley still further. Improving road communications and the expansion of road haulage services, with the corresponding loss of business to the railway forced the line to close for freight in 1981. Passenger services had been withdrawn eleven years earlier.

The population declined to around 2,500 after the departure of the railwaymen. This was not to last and another rapid change took place, with the arrival of the construction workers to build the reservoirs and the population

Looking towards Bottoms Reservoir

rose by another thousand. In total five reservoirs were constructed; Bottoms Reservoir, Valehoues Reservoir, Rhodeswood Reservoir, Torside Reservoir and Woodhead Reservoir. In addition Arnfield Reservoir, just to the west of Tintwistle was constructed. The Hollingworth Reservoir was abandoned in 1987 and has been incorporated in the Swallows Wood Nature Reserve. The reservoirs supply water to the area in and around Manchester. Altogether they took about 30 years to build.

Following the closure of the Trans-Pennine Railway, the Longdendale Trail, which runs for around six and a half miles from just beyond Hadfield Station to the entrance to the Woodhead Tunnel, was constructed. It is now used by walkers, cyclists and horses and runs parallel with the reservoirs in the valley, along a wide well surfaced track. The Trans Pennine Trail, an international walking route which stretches through Europe, from Liverpool to Istanbul, also utilises part of the trail.

Longdendale Valley provides a variety of recreational activities, apart from the trail, which include a sailing club on Torside reservoir, water skiing and fishing on Bottoms Reservoir. There are two official car parks at Crowden and Torside, where at the latter, a picnic area and information point has been provided. On the northern side of the valley, the busy A628, carrying convoys of vehicles across the Pennines, contrasts sharply with the peace and quiet of the valley.

Today, Tintwistle is divided into two by the A628, with part of the village lying within the Peak District National Park boundary and is designated a conservation area. The older part of the village is situated on the northern side of the road, the houses built on what bits of flat land could be found at the time. Some are said to date back to the sixteenth century, including the Bull's Head public house.

An interesting tale is told about the old smithy, when one day the blacksmith was forced at pistol point by Dick Turpin to re-shoe his horse. At the time the highwayman was being pursued by the King's officers after one of his hold-ups. He did not have the horse re-shod in the conventional manner, but bade the smith put them on back to front so that it would appear he was riding in the opposite direction!

Terraces of weavers' cottages still survive in Higher Square, Lower Square and Church Brow, near the impressive sloping green around the War Memorial. From this point there is a particularly impressive view over Bottoms Reservoir. Most of the buildings on the other side of the A628 are of the Victorian period or later. The adjoining village of Hadfield is known by fans of the cult BBC TV comedy series, *The League of Gentlemen*, as Royston Vasey.

YORKSHIRE BRIDGE & LADYBOWER RESERVOIR

(SK200850 & SK200860)

On the A6013, between the A57 Sheffield to Glossop road and the A6187
Hope Valley road

The tiny village of Yorkshire Bridge, in the Upper Derwent Valley, lies in the shadow of the dam wall of the Ladybower Reservoir. Its neat, regimented rows of houses were built to re-house the inhabitants of the former villages of Ashopton and Derwent. Both villages and the surrounding land having been submerged, when the reservoir was completed and filled with water.

The Upper Derwent Valley is often referred to as the 'Lake District of the Peak'. It is surrounded by magnificent countryside where water and woodland, topped by high moors, predominate. In recent years forestry has become an important factor and the sides of the valley have been clothed in conifers. Not surprisingly, the area has become so popular that over two million people visit each year. At certain times the road beyond Fairholmes is closed to help protect the environment and a mini-bus service is operated. Disabled badge holders are exempt.

Yorkshire Bridge has its own pub of the same name and the bridge spanning the River Derwent also bears the same name. The Yorkshire Bridge Inn, dates back to at least the 1826, and takes its name from an old packhorse bridge which was the last crossing point on the River Derwent before the Yorkshire border. Today Yorkshire Bridge is a tiny hamlet within the parish of Bamford consisting of three rows of gritstone cottages built on the sloping east bank of the Derwent.

Despite all the references to Yorkshire, you are still in Derbyshire; the boundary between the two counties is more than two miles away to the north east. The visitor centre at Fairholmes, situated further north below the wall of the Derwent Dam, tells the story of the 'drowned villages' and the birth of Yorkshire Bridge.

There were already two reservoirs in existence when the Ladybower was constructed; the Howden and Derwent were both completed by 1916. The 1.25 million tonnes of stones used in construction was transported to the site

by rail on a specially constructed narrow-gauge line from Bamford. In the 1930s, when Ladybower was constructed, it was re-opened as a timberline. The line was purchased by the Peak District National Park Authority in 1944, and is now a bridleway and footpath.

The Upper Derwent valley was a very attractive location for the storage of water, with its long deep valley and narrow points for dam building. This combined with a high average rainfall, low population level and heavy demand for water from the industrial towns that surrounded the Peak District, made the case for reservoir construction. The Derwent Valley Water Board was set up in 1899 to supply water to Derby, Nottingham, Sheffield and Leicester and the Howden and Derwent Reservoirs were constructed.

At that time the demand for water was satisfied and although plans existed for further reservoirs, no further action was taken. But demand did grow and the decision was taken to build one very large reservoir, to be called Ladybower. This entailed the flooding of the villages of Ashopton and Derwent and caused considerable unrest. However, the project went ahead and the villagers were moved to new houses at Yorkshire Bridge.

Ashopton Viaduct was built to carry the Snake Road to Glossop and the Ladybower Viaduct to carry the road from Yorkshire Bridge to the A57. The

Ladybower Reservoir

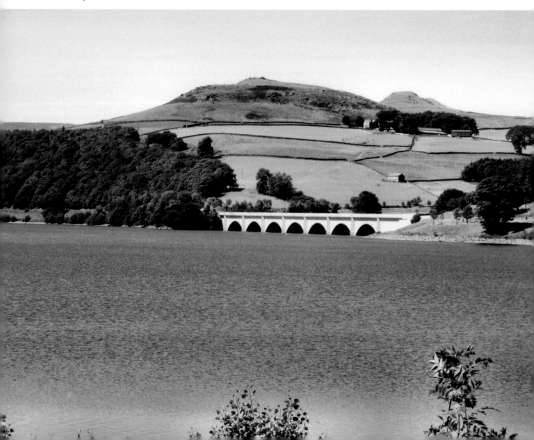

Yorkshire Bridge village

ancient Derwent packhorse bridge, which had a preservation order on it, was painstakingly moved stone by stone and rebuilt at Slippery Stones at the head of the Howden Reservoir. The graves in the churchyard were excavated and the bodies reburied in an extension to Bamford churchyard.

A few properties built on slightly higher land, including the Shooting Lodge and former Roman Catholic School, survived. Although the majority were demolished and flooded, the church spire was left eerily poking out above the water, but this too was blown up in 1947. The flooding having been completed, the opening ceremony was carried out on Tuesday 25 September 1945 by King George VI. In order to mark the occasion a commemorative monument was built close to the dam wall. One person though refused to move, Miss A. Cotterill of Ginnett House. She remained there until she died in 1990, at the age of 99, the waters of the reservoir lapping at the front garden steps.

Perhaps the best known inhabitant to have lived at Yorkshire Bridge was a sheepdog named Tip. Her master, Tagg, was a well-known local sheep farmer who helped found Hope Valley Sheepdog Trials, and during his later years lived at Yorkshire Bridge. He won a succession of prizes throughout

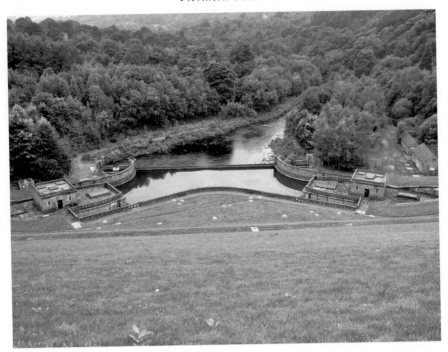

Ladybower Dam

the country with his sheepdogs and even sold one to an American for one thousand pounds, a lot of money in those days.

On the 12 December 1953, Tagg, aged 85, went out for the last time with his faithful border collie, Tip, and vanished completely. Despite an exhaustive search neither he, nor his dog could be found. It was not until 15 weeks later that Tagg's remains were discovered by chance, with the faithful Tip now completely exhausted lying about five yards away. Somehow, Tip had managed to survive heavy snow, biting winds and freezing temperatures on one of the most hostile stretches of moorland in the country.

Tip was carried back to the rescuer's lorry and later transferred to a caring home, where she was nursed back to health. Once the story became known, Tip became famous not only in this country, but abroad as well. A year later, in May 1955 she died. However, the hearts of those who had heard the story were so greatly touched that a memorial was erected at the western end of Derwent Dam, in memory of Tip.

The Derwent Dams were used during the Second World War to perfect the 'bouncing bombs' technique which in 1943, breached the Ruhr Valley Dams, in the heartland of industrial Germany. A plaque and memorial museum in the west tower of Derwent Dam retells the story of the Dambusters, which many will have seen on film.

ASHFORD-IN-THE-WATER

(SK196697)

Alongside the A6 Bakewell (2 miles) to Buxton road

The lovely village of Ashford-in-the-Water nestles on the banks of the River Wye as it slowly meanders its way south towards Bakewell. It lies on the route of the ancient Portway, one of the Peak District's oldest trackways which has been used for many centuries. The splendour of its setting attracts large numbers of visitors and over the years it has inspired the work of many artists and photographers.

Ashford, unlike most Peak villages, is set in a beautiful valley setting, rather than in a hollow on a plateau, or on the side of a valley like Youlgreave. Its mainly eighteenth-century cottages are built of smoothly textured limestone, light brown in colour, giving a warm and cosy feel to the village. At the time of the Domesday Book it was a Royal Manor, before eventually passing by succession to the Devonshire family. In the 1950s it was sold off to pay death duties.

There have been times in the past when the village has lived up to its name, and as recently as October 1998 most of the village was flooded. Debris, swept down the river as a result of heavy rain, became blocked at the Sheepwash Bridge and caused the Wye to overflow.

The beautiful low arched medieval Sheepwash Bridge, overhung by willow trees, is built on the site of the ford across the river. In the seventeenth century it was crossed each week by hundreds of packhorses, usually carrying malt from Derby. It has been widened at least twice and takes its name from the attached sheep pen. The sheep were thrown unceremoniously into the river and as they swam across, the shepherds ensured they got a good soaking to clean their fleeces prior to shearing. The bridge is no longer open to traffic and is a favourite spot where visitors can either feed the ducks, or gaze down into the clear waters to see if they can spot a rainbow trout!

Lead mining was carried out in the area, but the chief industry used to be marble polishing. Impure forms of limestone mined locally when polished, turned jet black; this was then cut and used for ornamental purposes. Henry

Sheepwash Bridge

Watson founded what were known as the Ashford Black Marble Works in 1748, at a site now acquired by the Water Board, the business having finally closed in 1905. The marble was very popular in Victorian times and was exported all over the world. Ashford church houses one of the finest examples of an inlaid tabletop with pieces of Ashford Marble.

In the nineteenth century a stocking industry was set up in Ashford and by 1829 there were 80 frames being worked. The part of the village where the machines were located was called 'Rattle' because of the noise created! One of the stocking frame cottages still remains on Hill Cross, which can be identified by its long upper floor windows. In Greaves Lane, Candle House stands on the site of the old candle making factory. The word 'greaves' was used by the workers to describe the dregs of melted tallow.

Holy Trinity Church was mostly rebuilt in 1868, but the tower is fourteenth century and there are also features dating back to the twelfth century of an earlier church. An interesting insight into seating arrangements in the church is contained in a document published in 1632, which states that men should sit on the south side: women on the north side of the church and the Minister's wife in the seat at the front of the pulpit.

'Virgin Crants' hang from the ceiling in Ashford Church

Hanging in the aisle of the church are four Virgin Crants, which were once carried at the funerals of unmarried girls. These are garlands made from white paper, cut to form rosettes, fixed to wooden frames, which were later hung above the pew where grieving relatives sat.

Out of all the charming houses in the village, the one with the finest location must be The Rookery. Lovely spacious lawns front this imposing residence

with its origins in the sixteenth century and just to make the picture complete the River Wye flows through the grounds in a great majestic loop. In 1941 it became the first home of the former Duke and Duchess of Devonshire.

Ashford's attractive little cricket ground is one of the most admired in the country. In recent years the local club has played host to a number of exhibition matches with Derbyshire County Cricket Club. The county's batsmens eyes light up when they see the shortness of the boundaries, in stark contrast to the sinking feeling in the stomachs of the Ashford bowlers.

On the old bridge near the cricket ground is an inscription carved simply in the stone 'M HYDE 1664'. This relates to a tragic incident when a man was blown off his horse and drowned in the river. Originally, the road on which the bridge stands was built to give access to the Corn Mill from the village. There has been a corn mill at Ashford since at least 1086, when its existence was recorded in Domesday Book. The present day building, parts of which go back 400 years, is passed by leats from the Wye on either side of the structure which used to have two water wheels.

The Parish Pump and The Top Pump are at opposite ends of Fennel Street. The pumps have been removed and a shelter was erected over both wells in 1881. A medieval Tithe Barn stands close to Sheepwash Bridge, as does the Riverside Hotel and Restaurant. At the far end of Church Street are the Parish Rooms where the Post Office is now housed; close by is the Ashford Arms and across the road the Village Stores and the Bull's Head and a small café.

On Trinity Sunday, Ashford celebrates the founding of the church. Following the service, there is a procession to bless the six wells that are dressed annually. Over the years Well Dressing has become deeply established in Ashford and is a highlight of the village year, with visitors flocking to see examples of this ancient local custom.

Holy Trinity Church

BUXTON

(SK060735)

*The A6 from Matlock/Chapel-en-le-Frith passes through Buxton
— Buxton Railway Station*

Visitors arriving in Buxton for the first time from the bleak moorlands cannot be blamed for pinching themselves in some disbelief as they emerge into a town with fine parks and grand old buildings. At well over 1,000 feet above sea level Buxton is the highest town in England for its size. Close by is the highest village in England at Flash; the highest railway station at Dove Holes; the second highest public house, the Cat and Fiddle.

The market place is in Higher Buxton, the older part of the town that rests on a small limestone plateau. Lower Buxton, the newer part of the town, nestles in a river valley. The river, the Wye, does the disappearing trick, being culverted under the town centre before emerging on the far side. Essentially, Buxton is a northern town at the southern end of the Pennine Chain, but county boundaries place it in the Midlands.

The main reason why Buxton has grown to its present size is due to the thermal springs it stands on, from where the water rises at a constant temperature of 82 F (28 C). According to the findings of a British Geological survey, the water that emerges fell as rain over five thousand years ago. On its way to the surface, the water filters through a bed of ancient limestone, finally reaching the light of day totally pure and crystal clear.

Given a more equable climate Buxton might well have rivalled Bath as the most prominent spa town in England. Even in these days when snow clearance is so much more sophisticated, we often hear of major roads leading to Buxton being blocked. It is not just during winter that the town has been in the news for falls of snow. On the 2 June 1975 snow prevented play in the county cricket match between Derbyshire and Lancashire at Buxton! But the harshness of the winter must not be over emphasised, as the climate is now getting milder. Whatever the problems created by the climate it has not stopped Buxton becoming one of the leading inland resorts in England, well worthy of a visit at any time of the year.

The Opera House

There is evidence of pre-historic settlers in the caves round Buxton, but it is the Romans who created the first real impact on the area. Precisely when they settled in Buxton is uncertain, but it was around AD 78 when forts were established nearby at Navio and Melandra. Attracted by the warm springs they built a bath on about the same site on which St Ann's Hotel now stands. The bath measured thirty by fifteen feet with a spring of warm water on the western side.

That this was an important settlement is obvious, judging by the number of roads that radiate out of it in all directions. An old Roman milestone was discovered at Silverlands in 1862 and can be seen in Buxton Museum and Art Gallery. It shows the mileage to Navio, the Roman fort at Brough. The Romans remained at Buxton in continuous occupation until early in the fifth century when they withdrew from Britain.

After the Romans left, little importance appears to have been placed on Buxton. A small shrine was built in about 1200 and dedicated to St Anne, the patron saint of cripples. People came in the hope that the waters would cure them, but Henry VIII put an end to such 'idolatry and superstition' and had the baths and wells locked up and sealed. They were re-opened in Elizabeth I's

St Anne's Well

reign and attracted royal patronage in the form of Mary, Queen of Scots. It was in the 1780s that Buxton really came to prominence as a spa. The fifth Duke of Devonshire using the profits he had made from his copper mines at Ecton in the Manifold Valley, embarked on a costly campaign to attract and accommodate more visitors in what was then only a tiny Peakland village.

The Duke employed the eminent, northern architect, John Carr, to build the Crescent, modelled on the Royal Crescent at Bath. It provided hotel accommodation, a house for the Duke, card and billiard rooms, and elegant Assembly Rooms approached by a distinctive curved staircase. The arcades were used for shopping.

On the northern side, where the thermal baths were located, the seat used to lower people into the bath can still be seen. The Pump Room opposite the Crescent was where visitors sat drinking the waters. At the rear, the drinking fountain is very popular and people can often be seen filling plastic containers to take away.

The Slopes, laid in a series of graded paths, were originally intended for exercise for those people coming to the spa for treatment. From the top they provide an excellent view of the Crescent and the buildings beyond that should not be missed.

The Great Stables, until recently the Devonshire Royal Hospital, now part of Derby University, are quite remarkable. Erected on slightly higher ground to the rear of the Crescent, they housed horses and their grooms. The two storey octagonal building was arranged round a circular exercise yard with the perimeter colonnaded to give a covered ride in bad weather. In 1859, it was converted into the Devonshire Royal Hospital; the central exercise yard was covered by what, at the time, was the largest unsupported dome in the world.

Buxton Opera House, designed by Frank Matcham in grand Edwardian style, was completed in 1905, but just over twenty years later it was converted into a cinema. Following a period when it had fallen into disuse, it was lovingly restored in 1979, and re-opened as an opera house. In the same year the Buxton International Festival of Music and Arts was born, which has developed into one of this country's largest opera-based festivals.

The town possesses a good selection of hotels and guesthouses, a wide range of cafés and restaurants and many shops of pleasingly individualistic character. Buxton Museum and Art Gallery is a past winner of the best archaeological museum of the year award. Buxton holds a carnival during Well Dressing week in mid-July. On the southern side of the town, Poole's Cavern is famous for the longest stalactite in Derbyshire and Go Ape! for its high-wire activities.

Solomon's Temple

CALVER

(SK242746)

Off A623 Baslow to Stoney Middleton road

The most attractive part of this little river valley village is hidden away behind the main A623 road. There are found charming stone cottages and smart modern houses existing in comparative harmony close by the ancient village Cross.

It was only after the first bridge had been built across the Derwent and lead mining became popular, that the village began to take shape from an isolated community of scattered dwellings. In 1778, a small mill was built close to the new bridge and this was soon followed by the building of a much larger water-powered cotton mill. The second building was destroyed and replaced by the impressive seven-storey granite building that still remains today. No longer used for industry, it has been converted into luxury apartments.

The Mill achieved national recognition shortly after the Second World War, when it was featured as 'Colditz,' the notorious German POW camp, in a popular television series. During the series the swastika flew high above the mill, but no one was fooled. This was not the case during the war itself, when lights were lit on the moors nearby, fooling the German bomber pilots into thinking that Sheffield lay below and releasing their loads harmlessly onto the moors.

Calver is one of a combined parish of three with Curbar and Froggatt, which are both situated higher up the eastern slopes above the Derwent. Calver is the oldest and largest, and is the only one of the three mentioned in the Domesday Book, when it was an outlier of the Royal Manor of Ashford.

The village is composed of three separate settlements, laid out in a roughly triangular fashion with Calver Bridge on the east. Calver Sough in the north and Calver itself fill the remaining area. The sough, which gives the area its name, dates back to the lead mining era. Underground channels were dug, called 'soughs,' to free the mines from flooding — the water flowing into a vast subterranean cavern.

A short walk past the entrance to Calver Mill leads to Stocking Farm, with its very dignified barn and interesting looking bell-tower. In the early nineteenth

century an upper room in the barn was used for religious services and, later, it was also utilised as a school. When All Saints Church was consecrated in 1868, services were transferred and a few years later, the barn lost its school and bell.

Calver Bridge News and General Store ceased trading in 2003 and is now an Art Gallery. It had for many years operated as the village post office and shop. Before modern transport had taken such a strong hold on every day life, the postmaster collected the mail in a wheelbarrow from Froggatt about one mile away.

The 'old' and the 'new' can be viewed from the Bridge Inn, a small friendly pub with two bars and large garden running down to the River Derwent, from where the village's two bridges can be seen. Further up the road the Derbyshire Craft Centre has on display a large selection of local and national crafts, plus a wide range of gifts, books and other items. There is also a popular café.

The post office with its VR post box, is now located in the former bakehouse on High Street, at the centre of the village by the Cross. Opposite, is the village cross, the base of which is very old. A stand pipe used to be attached to it, from where the villagers could draw water. It is surmounted by a lamp which was erected in 1977 to commemorate the Queen's Silver Jubilee.

Along Lowside, situated at the top of the hill, is the Derwentwater Arms that looks down on the small, but immaculately maintained village cricket

The Eyre Arms

ground. Calver Cricket Club is one of the oldest cricket clubs in the country and there is a record of Princess Victoria attending a match there in 1832, almost 30 years before the formation of Derbyshire County Cricket Club. The longest 'big hit' was made by George Walton, who is reported to have hit the ball from the cricket ground to Calver Cross.

On the Stoney Middleton side of the intersection of the A623 and the B6001, is the former Heginbotham Boot Factory, where steel toe-capped boots were once manufactured. Founded in 1884, it became a major industry in the area and was converted into a limited company in 1920. In the early days the firm ran two small factories in Stoney Middleton, before building a factory in two fields at Calver Sough. The invention and fitting of steel toe-caps for miners and similar trades where the use of the steel cap was beneficial, led to the sale of 40,000 pairs of boots in 1938. As demand reduced later in the twentieth century, boot manufacturing was transferred to Northampton. As a result the business eventually closed and the premises are now occupied by a factory shop.

At the rear of the shop is a well-stocked Garden Centre and by the side, tucked away out of sight, a beautifully maintained bowling green. On the other side of the cross roads is an outdoor centre with a café, where you can sit inside or out. The attractively ivy clad Eyre Arms is on the opposite side of

Calver Mill Gallery with 'Colditz' in the background

The village cross

the road and behind it a petrol filling station that is now the only source of grocery provisions in the village.

The Little Shop on Hassop Road, established in 1919, now sells snacks and ice cream. It is certainly worth looking inside to see the neat rows of jarred sweets on display — normally never less than ninety jars. Originally, it was the domain of Fishy Bill, whose fish were not always as fresh as he claimed. Unfortunately, he seemed to have no sense of smell, as if he did not sell all his fish on his trip round Calver one week he would offer them for sale the following week! He also sold ice cream, but sales reduced after he was seen washing his feet in the ice cream bucket.

CHELMORTON AND TADDINGTON

(SK113700 & 141711)

Taddington is off the A6 Bakewell to Buxton road and Chelmorton two miles to the south-west

Chelmorton is an ancient village, the highest above sea level in Derbyshire and at one time it was claimed to be the second highest in the country after Flash, in Staffordshire. It is also nationally famous for its medieval strip field system, set aside from the surrounding land for intensive farming. Stone walls enclosed the narrow fields, which ran parallel to each other and at right-angles to the main village street, behind the crofters' cottages. The fields were enclosed in medieval times, well before the Enclosure Award of 1809 and the early field pattern still remains.

The oldest part of the village was sited near the spring that emerges from Chelmorton Low. Charmingly named Illy Willy Water, the stream dictated the shape of the village street of which there is only one. The street ends suddenly with only an ancient trackway, now a footpath ahead, which climbs up towards the summit of Chelmorton Low. Twin Bronze Age burial mounds have been found at the summit of the Low, indicating early human habitation in the area.

Agriculture has been the dominant industry in the past, in the area around Chelmorton, but only a few farms now remain and these are mainly dairy farms. In recent years the village has undergone a rapid transition from that of an isolated rural community into a commuters' dormitory. Houses have been built and the redundant agricultural barns converted into comfortable dwellings. The village also has a history of lead mining, which provided a supplementary income for local farmers. A long rake climbs up from the churchyard boundary in the direction of Five Wells Farm. More recently, quarrying has been a source of employment for local people.

The Parish Church of St John the Baptist is situated at the highest point in the village and built in gritstone, which contrasts noticeably with most of the other buildings in Chelmorton that are mainly of white limestone with gritstone features. The church dates from the thirteenth century and was restored in 1574. In the porch are several early sepulchral coffin lids, some

The Parish Church of St Michael and All Angels

belonging to the twelfth century. Outside in the churchyard is the base of a broken Saxon Cross.

A weathercock tops the spire in the form of a locust, recalling that St John survived in the wilderness by eating locusts and honey. The church bells were rescued from the Derwent Church, flooded when Ladybower Reservoir was constructed. They were installed in 1952.

Facing the church stands the aptly named Church Inn, originally known as the Blacksmith's Arms, reflecting the dual profession of a previous landlord who was also reputedly its best customer! At the other end of the village, stands the oldest building in Chelmorton, Townend Farm built in 1634 by Isaiah Buxton. With its fine Venetian windows, enclosed courtyard and elaborate buildings, it is known locally as Chelmorton Hall. Other houses bear nineteenth-century dates but these may be rebuilding dates.

Taddington, now conveniently bypassed by the A6, has been returned to its former days of peaceful tranquility. It is a typical White Peak one street village with fine views from the top of Humphrey Gate. At over 1,100 feet, it is not quite as high as Chelmorton, about five miles away by road and two as the crow flies, but with a stiff climb for it still ranks as one of England's highest villages.

The Queen's Arms and Community Shop

It is an ancient village and evidence of settlers in the area has been revealed a mile and a half to the south west of Taddington, at Five Wells. There is a Neolithic Chambered Tomb, which at 1,400 feet is the highest site of its kind in Britain. The tomb was opened by Thomas Bateman, the famous archaeologist from Middleton-by-Youlgreave in 1846. Across the A6, in the same parish, archeological evidence suggests that the Celts grew oats in the Priestcliffe area. Arable crops are very rare in this part of Derbyshire due to the soil being generally too thin.

Generations of Taddington men have worked at quarrying, both for limestone and minerals. There is plenty of evidence of the efforts of former lead miners, with numerous hillocks and spoil heaps which disfigure the landscape around Humphrey Gate Quarry and over Taddington Moor.

The Parish Church of St Michael and All Angels, with its splendid broach spire is a dominating feature in the village. It dates back to at least the twelfth century, although a chapel may have stood on the same spot as early as the fourth century. It was rebuilt in 1350 and has been subsequently restored. Likened to Tideswell's 'Cathedral of the Peak' and described as 'One of the prettiest and best proportioned churches of the

Cottages on the village street, Taddington

Peak', its impressive lych-gate, provides a fine entrance to the well-kept churchyard.

An inscription on a stone fragment in the church porch bears the words, 'Here lyeth the body of William Heward, who departed this life, November 19, 1718, aged 218'. Taddington's climate may well be bracing with plenty of clear fresh air, but that is taking things a little too far!

Most of the houses at the top end of the village are modern in design, while those at the lower end of Taddington's long main street, built of random limestone pieces, are much older. The Queen's Arms opened, in 1736 as the Miner's Arms, when lead mining was in the ascendancy, was also a stopping off place for coaches, when the main London Road ran through the village. It is still an important meeting point for local people and visitors and now provides a home for the village shop.

Taddington Hall, built during the eighteenth century, is probably the oldest house in the village. It was at one time the home of two brothers, who made rope in the cellar. One night the brother responsible for finding purchasers returned home drunk and murdered his brother, whose ghost still haunts the building.

Situated just under half a mile west of the village on the A6 is the Waterloo Hotel, a former farmhouse and a popular stopping place for travellers on the Bakewell to Buxton road. It also gets its fair share of walkers of the Limestone Way, which passes the pub.

CHESTERFIELD

(SK380710)

On the A61 Sheffield to Alfreton road — Chesterfield Railway Station

Chesterfield is a busy, redbrick town with more than 250 stalls doing a lively trade on market days, a delightful cricket ground at Queens Park and an unusual church spire. Second only to Derby in population in the county, it is quite different in style and character to any of its neighbours in the Peak District.

It is the crooked spire, that does most to make Chesterfield famous and the first thing newcomers usually look for on arrival in the town. The spire to St Mary and All Saints Church started its life straight, but is now 9 feet 5 inches out of line and leans a tiny bit further every year. It gives the impression that it could fall down in the next strong gale, but having stood for over 600 years, it is quite safe for a long time yet.

Many fanciful reasons have been advanced for the spire leaning. The local legend being that the Devil having accidentally had a nail driven into his foot by a Bolsover blacksmith flew over the church, and in lashing out in pain, struck the spire. Another story is that it was caused by bell ringing, which considering the spire weighs 32 tons, must have required some very loud bells and immensely strong ringers! The experts say that the spire is crooked because the lead and timber used are incompatible. This caused the timber to warp because of the heat of the sun on the lead casing.

As the spire was being built at the time of the Black Death in 1349, a theory has been put forward that the original craftsmen may have died. As a result, less experienced men completed the job and they made the mistake of using green timber. Whatever happened, it has proved to be a masterstroke in increasing Chesterfield's name awareness and marketing potential in the tourism trade.

Chesterfield's early prosperity came as a market town serving the whole of North East Derbyshire. The area around the town was rich in minerals. Coal, ironstone and lead extraction increased the town's importance as a regional centre.

The real expansion of Chesterfield began with the Industrial Revolution. With its mineral resources it was in a prime position to exploit the town's geographical location, close to the centre of the country. Chesterfield Canal and later the railway opened up markets much further afield than North East Derbyshire.

In 1901, as the result of much needed boundary changes, Chesterfield was no longer restricted to a small central area, which had been a major factor in limiting its growth. Houses had been crowded together, in alleyways and yards, poorly constructed and with inadequate sanitation. The lifting of the restrictions allowed the town to expand and the demolition of sub-standard housing started. This went well into the twentieth century and it is only in recent years that Conservation Area status has been granted to the market place and its environs.

Originally, the market place extended further to the east, where the Shambles is today, but gradually permanent buildings replaced the temporary stalls. It was once the 'Flesh-Shambles', where the butchers had their market. Now, it is a fascinating area to explore with narrow medieval streets lined with shops and cafés. But everything would have been so much different, had the Borough Council's plans for re-development not met such stern local

Queen's Park Cricket Ground

The crooked spire to St Mary and All Saints Church

opposition; then the Shambles and Chesterfield's Market Place would have disappeared.

Along Irongate, a narrow lane in the Shambles, is the Royal Oak, one of the town's oldest public houses, a sixteenth-century timber-framed building. According to the notice board outside, it claims that it was first mentioned as an inn, in 1722 and prior to that was said to be a rest house for the Knights Templar, a band of Crusaders.

Chesterfield's spacious market place really catches the eye, so much so, that following its redevelopment, it received a prestigious European award in recognition of the design and exemplary workmanship. The brightly covered market stalls laden with goods are busy with shoppers on Monday, Friday and Saturday. On Thursdays, 'Flea Markets' are held. A farmers' market takes place on the second Thursday of every month and once a year a 'Medieval Market' takes place when the traders dress up in traditional costumes.

The Market Place Pump, erected in 1826, was a meeting point, where in the past, passionate speeches have been made and even riots started. Behind it, the Market Hall, built in 1857, did not initially fare very well, and came in for a lot of criticism, but over the years views have changed, and it is now accepted as an important part of the market scene.

Lovely Queen's Park is only a few minutes walk away, with its boating lake, miniature railway and children's play area. The jewel in the crown is its cricket ground, widely acclaimed by sports writers everywhere as one of the prettiest grounds anywhere in the world. First class county cricket was lost for a time, but following substantial ground improvements, Derbyshire County Cricket now play a number of matches at the ground every year.

From 1871, Chesterfield Town Football Club has played at Saltergate, but will move to a new ground in 2010. The team have usually played in the lower reaches of the Football League, but everything was different in 1997, when they had their moment of glory, reaching the FA cup semi-finals.

The Chesterfield Canal opened in 1777, giving the town easier access to other parts of the country, but it was soon superseded by the railway. In 1838, railway pioneer George Stephenson came to live on the outskirts of Chesterfield. He was involved in many successful engineering projects. An advocate of sound training, he was a strong supporter of providing good educational facilities in the town and engineering became one of the main industries in the area.

After Stephenson's death, the Stephenson Memorial Hall opened in 1879. The complex comprised of a public hall, lecture hall and numerous other rooms. It has had a number of users and now is home to the Pomegranate Theatre. Chesterfield Museum and Art Gallery occupy another part of the complex, where you can learn more about George Stephenson, the 'Father of the Railways'.

EARL STERNDALE

(SK090671)

From the North leave the A515 (2 miles South-East of Buxton) and follow the B5053 for two miles, before turning left signed for Earl Sterndale. From the South follow the B5053 to the village

Earl Sterndale is a pleasing, unspoilt, working village, lying at 1,100 ft above sea level, surrounded by some of the most picturesque countryside in the Peak National Park. Unlike almost anywhere else in the park, apart from Thorpe Cloud, it has what many first time visitors to the area expect to find 'Peaks'. The Peak District took its name from the Pecsacetans, 'the hill dwellers' who once lived in the area and not its mainly flat-topped hills, which tends to confuse the newcomer.

The two dominant hills on the western side of the village, Parkhouse and Chrome, are conical in shape. They originate from former reef knolls, or coral reefs formed under the waters of a lagoon millions of years ago. High Wheeldon to the south east of Earl Sterndale is conical, but not so markedly as the other two hills.

High Wheeldon was given to the nation, as a memorial to the men of Derbyshire and Staffordshire, who gave their lives in two World Wars, by the family of a Buxton man who had been a tireless worker during his lifetime for conservation. It is now in the hands of the National Trust. Fox Hole Cave, on the hill, was excavated in the 1970s, revealing a range of Stone Age implements and the remains of animals hunted by the men of that period.

The village is surrounded by a number of farms, which include 'Grange' in their titles, a reminder that during the Middle Ages much of the land was owned by Basingwerk Abbey. Farming is still an important industry in the area as is quarrying; the quarries hidden away behind the eastern ridge scar large areas of the landscape and attract much criticism as a result. On the other side of the argument they provide employment for many of the people who live in Earl Sterndale and elsewhere in the area, who otherwise would probably be unemployed.

St Michael's Church has had a somewhat unusual life. In Norman days it was a chapelry of Hartington, but during the eighteenth century fell into

disrepair. It was rebuilt in 1828, but disaster struck again in 1941, when it became the only church in Derbyshire to be struck by German incendiary bombs, probably intended for a huge high explosives dump, in a quarry near Buxton. This tragic event in the history of the church was recorded by local humorist Tom Wise, in the following words:

The Sterndale Blitz

They bombed our church them Germans did
In nineteen forty one
And left it there without a lid
Exposed to wind and sun
And when at last the war was o'er
And Hitler was the loser
We knelt, praying as of yore
Thanked God they missed the boozer

Farm on the outskirts of the village

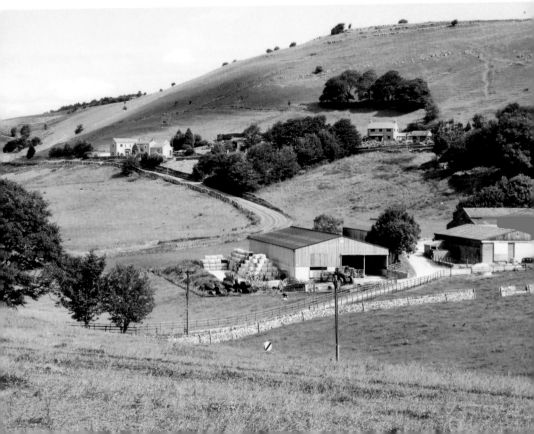

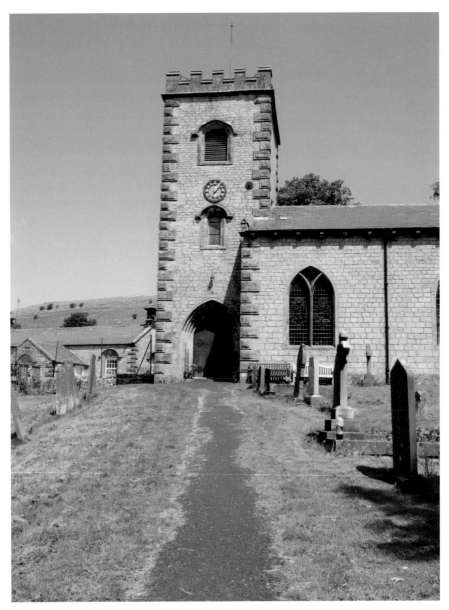

St Michael's Church

Ten years later the church was rebuilt and rededicated and its Saxon font restored by an expert craftsman from London.

The sign at the village pub, the Quiet Woman, carries the immortal adage 'Soft Words Turneth Away Wrath' which is below the picture of a headless woman. The story goes that a former pub landlord's wife, known as 'Chattering Charteris' nagged so much that she even started ranting in her sleep. At last her husband could

The sign at the Quiet Woman public house

stand it no more and cut off her head. The approving villagers even had a 'whip round' to pay for the headstone; the remainder of what was collected going to the perpetrator of the crime!

Over 400 years old, the pub is a magnificent unspoilt rural inn. It retains its original beams, there is an open fireplace and you are likely to see notices on the wall advertising for sale eggs, hay and silage and the like. One notice of different type warns 'The fire is for the comfort of all patrons, not just the few who think the rest need protecting from the heat'. The pub has won several awards and been mentioned every year but one since 1976, in the Good Beer Guide and attracts beer lovers from near and far who want to soak up its traditional atmosphere. In a macabre way it seems appropriate that Headless Ale, brewed in Leek, Staffordshire, is now available at the pub to help meet the needs of thirsty customers!

There is a thriving school in the village, which holds some classes in the church, a large village green and a Methodist Chapel. A GR post box is inset in the wall of a house, but sadly there is no post office. Along the attractive row of cottages leading out of Earl Sterndale to the east, is Woodbine Cottage. It was once the home of Billy Budd, who fought in the Afghan War of 1880. He marched from Kabul to Kandahar, wearing no boots, his feet wrapped in cloths. A remarkable effort considering the towns are approximately 350 miles apart.

The strangely named hamlet of Glutton is a quarter of a mile to the west of Earl Sterndale, at the foot of a rocky little dale at the edge of the parish. How it got its name is uncertain, but one story is that Bonnie Prince Charlie's men stole cattle from Cronkstone Grange and gorged themselves at a massive feast. In the 1870s a cheese factory was built near the bridge, and Glutton became well known for its cheese, until production ceased in the early 1960s. The factory produced Wensleydale cheese for Express Dairies.

Important archaeological finds were made in nearby Dowel Cave, which was used by the earliest known settlers in the White Peak. The cave dwellers lived by hunting, prey being plentiful in the area.

The village Wakes are held on the Friday nearest to 11 October. Tradition has it that the person, who is most drunk on the Friday before the Wakes, is elected mayor for the year.

EYAM

(SK218764)

Off the A623 Baslow to Chapel-en-le-Frith road

Any tourist visiting the beautiful village of Eyam for the first time, not knowing of its tragic history, rapidly becomes aware by reading the plaques on the walls of buildings. The people of this village once endured an epic struggle. In a period of just over 12 months, from September 1665, 260 people died from the plague out of a population of about 800. This has resulted in Eyam becoming one of the most visited villages in the Peak District.

The plague started when George Vicars, a tailor, was lodging in one of the cottages next to the church. A packet of cloth arrived, but as it was damp after its long journey from London, he spread it out in front of the fire to dry. This released fleas concealed in the parcel, which were carriers of bubonic plague germs. The death of George Vicars was sudden, others soon followed, and the villagers started to panic.

Some families fled, but as the disease seemed to be abating during the winter, others remained, only for the plague to intensify during the following spring. The Rector of Eyam, William Mompesson and his predecessor Revd Thomas Stanley persuaded the villagers to shut themselves off from the outside world to avoid the spread of the disease. Some refused and left the village, including the Bradshaws of Bradshaw Hall. Those that remained accepted strict quarantine arrangements to help prevent the spread of the disease. Neighbouring villages left provisions at agreed pick-up points. On the outskirts of Eyam a path leads up through the woods to Mompesson's well. Here provisions were left by neighbours in return for coins soaked in vinegar in a pool at the edge of the well. Another pick-up point was the Boundary Stone, on the Stoney Middleton side of the village.

Mompesson closed the church and held open air services in Cucklet Delph, to reduce the chance of infection. When the plague finally was over, whole families had been wiped out and only one sixth of the population remained in Eyam. The plague had been contained within the agreed boundary set by the people of Eyam, but at a dreadful cost. From the early 1900s an annual

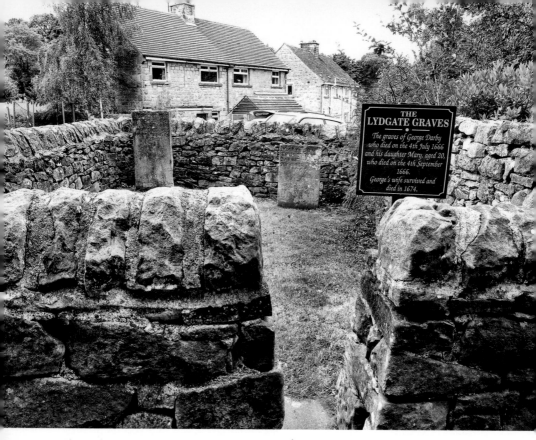

The Lydgate Graves

Plague Commemoration service has been held on the last Sunday in August and the following Saturday there is a carnival and sheep roast. In more recent years Well Dressing as also been held at the end of August making this a very popular time for visitors.

The church is dedicated to St Lawrence and has been used for worship since Norman times. In the churchyard is a Celtic cross well over 1,000 years old, probably once used as a preaching cross. Close by is the tomb of Catherine Mompesson, who bravely stayed with her husband during the plague, but did not survive the epidemic. Only a few other plague victims are buried in the churchyard; as the plague took hold families agreed to bury the dead close to where they died to contain the infection.

The tombstone of Harry Bagshaw, who played cricket for Derbyshire, has on it stumps in disarray, bails flying and an umpire's finger upraised in dismissal.

Lead mining in the area dates back to Roman times and reached a high in the eighteenth century. By the beginning of the next century, however, lead extraction had become less profitable and more and more miners turned to an alternative source of income. Surprisingly, this came mainly from the

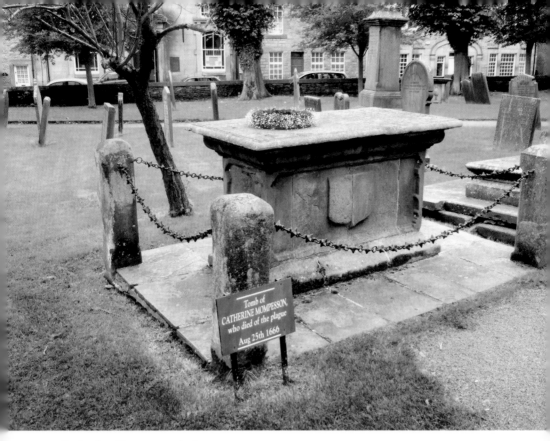

Catherine Mompesson's Grave

spoil heaps discarded by the lead miners, with the discovery of the uses to which fluorspar and barytes could be put. Quarrying was also important and limestone extraction in the area continues to this day.

Manufacturing has been important in Eyam in the past and manufacturers have adapted to changing trends with a great deal of skill and initiative. After the cotton spinning industry hit problems, silk-weaving looms were introduced. This brought prosperity to the village in the nineteenth century. Ralph Wain, an illiterate silk worker, invented a process that repeated the design on both sides of the fabric. Unfortunately, he sold the invention to a firm in Macclesfield, who patented it and reaped the rewards. Another example of innovative thinking came when Eyam set up one of the first public water supply systems of any village in the country. Using natural springs a series of stone troughs were set up and water piped through the village.

The decline of silk manufacturing led to the introduction of shoe making. Soon three factories were in production as well as a small cottage industry making shoes. In the mid-1900s around 200 people were involved — children's shoes and slippers being a speciality. Cheap foreign shoes eventually forced the closure of the last shoe-making factory during the latter years of last century.

Eyam Hall was built in 1671, on land bought from a survivor of the plague, by Thomas Wright for his newly married son. It has remained in the Wright family ever since. This fine old house is now open periodically to the public for conducted tours. The out buildings round the attractive courtyard have been turned into craft shops, together with a café and gift shop. Opposite are the village stocks, where at one time you might have found a lead miner imprisoned by the Barmote Court for a mining offence.

At the other end of the village, the barbaric sport of bull baiting used to take place and the Bull Ring is still on view in the square. The Miners Arms, a lovely seventeenth-century pub with a cosy public bar, beamed ceilings and stone fireplace is located nearby. It was once the meeting place of the Barmote Court where lead mining disputes were settled and is said to be haunted by several ghosts.

Standing near to the Townend Factory, at the west end of the village, is Marshall Howe's Cottage. He was the self-appointed sexton, who buried the dead during the plague and raided their homes as a way of payment. The Olde House, built in 1615, one of the many ancient buildings in the village, was once the home of the poet Richard Furness. In Rock Square is Margaret Blackwell's House. She recovered from the plague by accidentally drinking hot bacon fat!

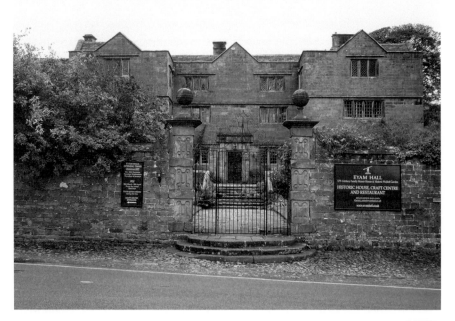

Eyam Hall

FOOLOW

(SK191768)

*Off the A623 between Stoney Middleton and Wardlow Mires,
one mile from Eyam on an unclassified road*

The small upland Derbyshire village of Foolow, with its light grey stone houses, is one of the most picturesque in the whole of the Peak National Park. Pretty limestone dwellings cluster round the well turned-out village green, the centrepiece of which is the duck pond. Visitors often stop there to picnic and watch the ducks swimming on the pond and admire the idyllic scene. Those who carry cameras with them will not be able to resist taking a few images to capture the moment. It is no wonder that pictures of Foolow appear in so many tourist guides.

It was not like this in the days when Foolow was predominantly a farming community. The cattle were brought in for milking and drank from the mere, often making the green muddy and covered with hoof marks. Nowadays, animals are no longer driven into the village to drink at the mere and the ducks have taken over! There is even an official duck crossing warning sign as you come round the corner opposite the village's only public house.

The green is surrounded by some fine seventeenth- and eighteenth-century cottages. Also prominent are the bay windowed Manor House and its handsome out buildings, and the Old Hall, split into two residences. The village cross now stands on a plinth in the centre of the green and bears the date 1868, when it was moved from where the chapel gates are positioned. In front of the cross is a bull-ring that once stood by the roadside. Behind the pond there is an ancient well enclosed on three sides by a stone wall.

On the limestone uplands, water used to be a rare commodity before piped water arrived. Foolow, having several natural wells, was attractive to settlers. Travellers in medieval times, between the established settlements of Eyam, Stoney Middleton and Tideswell, would no doubt also use the wells to quench the thirst of the animals they were driving.

Foolow is on the edge of the White Peak and is surrounded by small fields enclosed in a network of limestone walls, which gleam white in the sunshine.

The duck pond. Inset: Duck crossing!

On the North West side of the village is Tup Low, where there is a Bronze Age tumulus and at Long Low a cairn built of limestone blocks set in a circle. When excavated it was found to contain ninety human remains.

The discovery of rich veins of lead along Eyam and Hucklow Edges to the north of the village, and the Watergrove Mine to the south, led to the opening up of lead mines. In the early eighteenth century, the population of Foolow was considerably greater than it is today. With the decline of lead mining the villagers returned to farming, but there are no longer any working farms in the centre of the village.

The Bull's Head still survives; it is last of five pubs that once helped to quench the thirst of hard drinking lead miners. It has been licensed for well over 200 years, although not always under the same name. Until a few years ago it used to be called, the Lazy Landlord, which at the time was said to be an appropriate description of the landlord. Now the name has been changed back to the Bull's Head and the former landlord has departed. In recent times the pub has been sympathetically refurbished and is a wonderful example of how a traditional old English country pub should look. It has stone flagged floors and an oak panelled dining room.

The Bull's Head Inn

The delightful little Anglican Church of St Hugh, across the road from the pond, was originally a smithy. The foundation stone for the church was laid in August 1888, the official opening taking place just before Christmas the same year; since then several extensions and improvements have taken place. Local people have made many donations to the church including the brightly coloured tapestry kneelers. They are the work of members of the congregation and are mostly dedicated to the memory of loved ones. Labels underneath the kneelers indicate who they have been donated by, who they are in memory of and who undertook the work.

Almost side by side with the Anglican Church, but a little further back from the road, stands the Wesleyan Reform Church of 1836. It has a particularly imposing Truscan porch entrance and pointed lancet windows.

Piped water only arrived in the village in 1932. Prior to that, villagers had to fetch and carry buckets of water. The sewage system came later in the twentieth century and soon afterwards newcomers started to move into the village, attracted by the superb location and improved amenities. Now no longer the centre of a farming community, development in the village is tightly controlled by The Peak Park Planning Laws.

Farms still survive outside the village, and on the south western side at Brosterfield Farm there is a camping and caravan site for visitors. It is for the walking and beautiful scenery that most people come to Foolow, to explore the high escarpment behind the village and the many footpaths in the area. For those who want something different they can always visit the Derbyshire and Lancashire Gliding Club, which is situated nearby.

There is a pleasant circular walk to Eyam, passing through tiny Linen Dale in the early stages of the walk. Eyam has a tragic tale to tell of the terrible sacrifices made by its inhabitants. Plaques on the walls of buildings in the village and Eyam Museum tell of the epic struggle. The return journey takes you along Tideswell Lane, lined by limestone walls, passing through Linen Dale again, before returning along the road back to Foolow.

The old custom of Well Dressing was revived in the village in 1983. Two wells are erected on the village green on the Saturday prior to the last Sunday in August and blessed the same day.

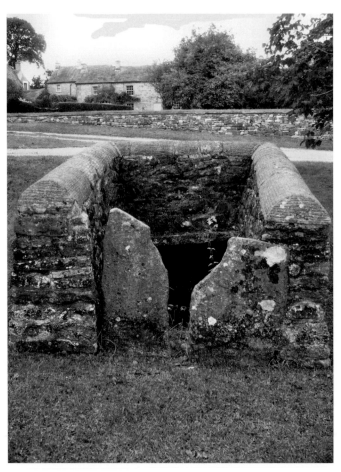

The village well

GREAT LONGSTONE

(SK200717)

On a minor road off A6020 from Ashford in the Water, one mile from Monsal Head

Sheltered by Longstone Edge from the cold north winds, the attractive limestone village of Great Longstone winds its way along a minor road linking Monsal Head and Hassop. Its comparative isolation from major tourist routes is probably the reason that it has remained relatively undiscovered by the visitor. But the situation is changing: no longer is it a one street village — much discreet development has taken place and newcomers have moved in. And with the opening of the Monsal Trail to walkers and the increase in leisure time, more people now visit the village to enjoy its quiet charm and hospitality.

The villages of Great and Little Longstone, separated by about half a mile, have many fine eighteenth-century cottages, built during an era of prosperity from lead-mining and shoemaking.Like so many villages in the White Peak, Great Longstone owes its existence primarily to lead mining. The presence of water where limestone and shale meet was most likely the deciding factor in where the village was located. Good farmland was another attraction, as miners supplemented their incomes from their underground activities by keeping livestock.

The carvings in St Giles church of a milkmaid and a miner accurately reflect the two main sources of wealth in the village during past centuries. It is not just lead, which has been mined; chert was extracted in the late 18th and early 19th centuries. More recently, fluorspar has been worked mainly on the Stoney Middleton side of Longstone Edge, which for the most part provides a fine viewpoint for the surrounding countryside. Unfortunately, the intensive quarrying for lead and, more recently, fluorspar has left the slopes on the northern side somewhat less impressive.

Miners are a tough breed of men, but they objected in Napoleonic times when the serving of call-up notices to join the army was thought unfair. It was every parish's duty to provide a fixed number of conscripts. When lots were

Longstone Hall

drawn at Hope, miners from Great Longstone, Castleton, Bradwell, Tideswell, Eyam and other villages marched on Bakewell, where the justices were sitting. They took with them picks, forks, shovels and anything else that they could lay their hands on. On arrival, they made a great bonfire and ceremonially burnt all the call-up papers.

In the 1860s, Great Longstone found itself on the London-Midland railway line between St Pancras and Manchester. Its pretty little woodland station, the last stop before crossing Monsal Dale Viaduct, still stands, but now only passed by walkers, cyclists and horse riders. At the rear is Thornbridge Hall, a minor stately home.

Monsal Trail runs for eight and a half miles from Coombs Road Viaduct, one mile southeast of Bakewell to the head of Chee Dale, about three miles east of Buxton. But not without diversions, to avoid tunnels, one of which occurs on the route from Great Longstone to Monsal Head, where there is a magnificent view.

Despite the controversy over the building of the Monsal Dale Viaduct, it is now considered an important feature of historic and architectural interest. When the railway line closed after 100 years, and plans mooted to demolish

The medieval market cross

the viaduct, there was a widespread protest. The answer came in 1970, with the award of a preservation order.

Less than half a mile from Monsal Head is the village of Little Longstone, with its charming cottages with their well-kept gardens. Built wholly of stone it has a popular pub, the Packhorse Inn and a seventeenth-century Manor House. The Longson family have lived in the village for over 800 years; a record few can equal anywhere.

Another half mile along the road and you are in Great Longstone. A line of trees guides you towards the village green, where there is a medieval market cross. Markets were held here to sell local produce and an annual fair took place during Wakes Week. Nearby, The Crispin Inn is a large comfortable old pub situated in the centre of the village and named after the patron saint of shoemakers, which provides a reminder of the former village trade.

Across the road from the Manor House is Longstone Hall, the most impressive looking building in the village. It was surprisingly re-built in brick in 1747 by Thomas Wright, when every other building in the village was built of stone. Sir Richard Levinge made the same choice at Parwich Hall, which all seems very strange in an area where stone predominated. Part of the old house built in 1600 still remains. The Wrights, one of the oldest families in Derbyshire, owned the hall for over 400 years, and although it is no longer in their ownership, they are still represented in the village.

The foundations of St Giles Church date back to the Normans. It is an interesting old church with a splendid fifteenth-century roof with fine moulded beams. A tablet in the church commemorates Dr Edward Buxton. Although retired from practice he returned, at the age of seventy-three, to provide a service to the villagers when a typhoid epidemic affected every house but one in the village. He did this without asking for a fee and everyone in Great Longstone survived. He prescribed 'wort': a beer before the processes of fermentation is complete, which was brewed every day at a farm in Church Lane.

The good doctor lived at Church Lady House, a late medieval building, which contains at least one cruck frame. It is said to be haunted by a lady dressed all in black. The adjacent building was once a barn belonging to Church Lady House, which was later used for a variety of purposes, including a period as a theatre. It is now a private residence.

At the bottom of Moor Lane is the last surviving village pump. Close by, the cottages that occupy Bullfinch Square are said to be former lead miners' homes. The new White Lion is on the eastern side of the village, near the Village Hall. The hall is well used by the many active community groups in the village. The vicarage re-built in 1831, was previously a public house called the White Lion Inn.

LITTON

(SK166751)

*One mile south of the A623 Baslow to Chapel-en-le-Frith road, turn
left shortly after passing Wardlow Mires, when travelling east to west.
Alternatively approach through Miller's Dale and turn right on the outskirts
of Tideswell*

There is a sense of spaciousness about Litton; a wide grass verge runs down
the side of the street of this attractive upland village, situated almost 1,000
feet above sea level. An old world village pub and a small triangular green
complete with ancient wooden stocks makes up the idyllic picture.

The houses are of good quality, mainly built in the eighteenth century,
and are of considerable charm and character. This was the time of a boom
in the lead mining industry and with it came increased prosperity, enabling
the more fortunate to spend more time and money on the construction of
property. Hammerton House (1768) and the Clergy House (1723), which face
one another across the road are particularly good examples of the quality of
workmanship, along with Sterndale House hidden away behind the Red Lion.
The oldest, Holborn House, dates back to 1639.

A combined school, church and library were built in 1865, on a rather grand
scale in the centre of the village by Canon Andrew, Vicar of Tideswell. Sixty-four
years later, independence came when Miss Penfold gave the newly constructed
Christ Church to the village. Standing on the outskirts of the village, along
Tideswell Road, the church was consecrated for the use of an Anglican Church.
Now only the school remains in the premises built by Canon Andrew.

For its 125th anniversary, the school revived the local tradition of Maypole
Dancing during Wakes Week. The tradition has been continued except for
1997, when due to a torrential downpour, a Victorian Music Hall singalong
was held in the school instead. The children also dress one of the two wells
on display during Wakes Week. Well Dressings take place in Tideswell
simultaneously, with the Tuesday of Wakes Week being given over to Litton,
when there is a fair in the village and various other events and attractions.
Tideswell a somewhat larger village is situated one mile to the west.

The village centre

Following the closure of Litton's only shop, the post office was re-housed in the Village Hall, but the villagers were not keen on the new arrangements. After some market research they found there was sufficient demand to sustain a shop. Next, they formed a friendly society, each villager buying a ten-pound share, found some derelict premises in what had once been the village smithy, obtained additional funding to that already raised by their own efforts and converted the premises into a shop, post office and meeting place for the community.

The Litton Community Shop opened for business on 26 September 1999, and was the first village owned and run shop in Derbyshire. During that year, the shop project won a Peak Achievement Award from the National Park Authority. The shop is mainly run by volunteers. It has been such a success that in 2003 it was expanded. A wide range of goods are sold at supermarket prices and where possible locally produced products are stocked. A newspaper delivery service is operated and visitors can sit outside and enjoy a cup of tea or coffee and a piece of homemade cake. This excellent and successful venture might be worthy of consideration by other Peak District villages and others who have lost the services of their village shop.

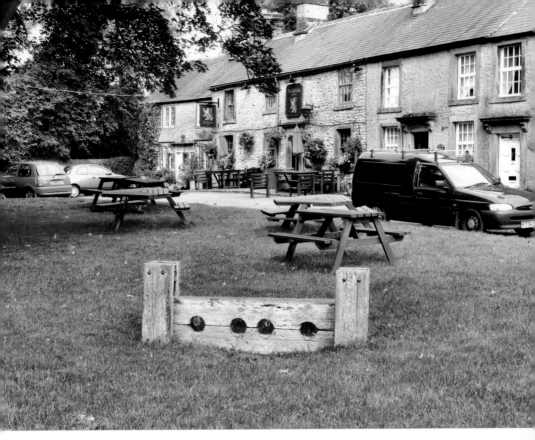

The stocks in front of the Red Lion

William Bagshawe, the non-conformist minister who later became known as the Apostle of the Peak, was born in Litton. Early in 1652, he was appointed as Vicar of Glossop, where he happily went about his work for the next ten years. Then the Act of Uniformity resulted in the ejection of 1,700 of the clergy from the Church of England. Bagshawe refused to conform and went from house to house and village to village, preaching the gospel. To make matters worse, his family partially disinherited him because of his beliefs.

In the reign of Charles II alone, it is estimated that 8,000 non-conformists died in prison. In constant fear of fines and imprisonment, Bagshawe had to act with caution. Every Sunday morning and afternoon he attended the parish church at Chapel-en-le-Frith, but in the evening he took services at his own home, or at someone else's. He visited Glossop once a month and established other congregations at several villages scattered round the area, travelling mainly on horseback. The Act of Toleration was introduced in 1689; he signed it and spent the rest of his life at Ford Hall, publishing several volumes of practical divinity.

The Village Hall faces The Green. It was given to Litton in 1907 and originally designated as a Working Men's Club. The school and a variety of

The village green

organisations now use it, including two doctors. During the Well Dressings the hall is used to serve refreshments to visitors. Further along the street, the nineteenth-century Methodist Chapel started life two centuries earlier as a farmhouse.

The Red Lion, a seventeenth-century free house, is an absolute gem made up of three cottages. It has a cosy and relaxing feel. Log fires burn merrily away in the winter, beneath beamed ceilings, the walls and shelves adorned with a miscellany of interesting items.

Litton Mill is located about two miles away on the southern side of the village in a beautiful spot by the side of the River Wye. It had an infamous reputation and is where Robert Blincoe arrived as a child from a London poorhouse. He later wrote a harrowing tale of the cruelty and inhuman treatment meted out to the mill workers, many of whom never saw their families again. In fact, it is reputed that burials were made at several locations in an attempt to cover up the number of deaths. Happily, in 1815, Ellis Needham the mill owner was declared bankrupt and the mill was taken over by a succession of owners. The building, having been rebuilt following a fire, has been converted into living accommodation.

MILLERS DALE

(SK141734)

Off the B6049, that runs through Tideswell, linking the A6 and A623

Millers Dale is a tiny hamlet, set in the heart of the Peak District, sharing its name with the dale in which it lies. The scenery in this part of the Wye Valley is magnificent, with the impressive Ravenstor Cliff only a short distance down the road, on the route to the once infamous Litton Mill. The richness of flora and fauna along the dale sides has resulted in the area being designated a Site of Special Scientific Interest and Derbyshire Wildlife Trust has several nature reserves in the area.

It was once a major junction on the Midland Railway Line, and Millers Dale was one of the largest stations on the line. The original station, opened in 1863, had three platforms, two on the main line for trains between London and Manchester; and a bay for the branch line to Buxton, where passengers for Buxton joined or left trains on the old Midland Railway. A further two platforms were added when the second viaduct was opened in 1905. It was one of the few stations in England to have a post office on the platform.

Farmers from all over the Peak converged on the station every morning in time to catch the 'Milk Train' which conveyed two thousand gallons daily to the bottling plants in Sheffield and Manchester. In addition hundreds of day-trippers arrived during the summer months, anxious to enjoy the clean country air of the Peak District, returning to the station in the evening refreshed by their experience. Millers Dale remained one of the busiest stations on the line for over one hundred years.

The railway closed in 1968, and the line remained unused for twelve years before being taken over by the Peak National Park. The track has been converted into a walking route, known as the Monsal Trail. It stretches from Wye Dale, near Buxton, to Coombs Road, near Bakewell. Most of the tunnels have been closed, but alternative routes have been provided. The station car park at Millers Dale is convenient for those walkers who come by car to explore the magnificent scenery of the Wye Valley. The station

itself now houses a Peak Park Rangers Centre and information boards at the station and along the trail have been provided to provide information for visitors.

The Limekilns to both the east and west of the railway station were formerly used for commercial purposes. Quicklime had long been produced in small kilns mainly for agricultural use, but with the expansion of industry demand increased, especially from chemical businesses. Limestone was extracted from the quarries near the station and coal was brought in by the train and burnt with the limestone to produce quicklime. This was then taken on the way to its destination by rail. The last kiln closed in 1944.

Walkers can content themselves with a gentle amble down the Monsal Trail from Millers Dale, check out some of the neighbouring villages or take a walk on the high limestone plateau. For the more energetic the fearsome overhanging cliff at Ravenstor is a place where expert climbers test out their skills as well as in nearby Chee Dale.

Corn mills once operated in profusion along the banks of the Wye, powered by the water from the river. There has probably been a mill at Millers Dale for over 900 years. Domesday Book indicates that a mill existed in this part of the valley at that time.

Cottages at Millers Dale

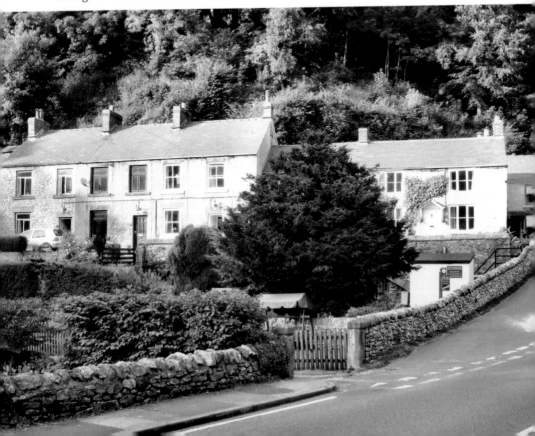

Miller's Dale Meal Mill closed in the 1920s and remained derelict until it was demolished some fifty years later, to allow for the sinking of a borehole to supply water to the Chapel-en-le-Frith area. Stone from the original walls was used to house the bore-hole and its machinery. The 150 year old water wheel was restored and placed adjacent to the pumping station. Stone walls enclose the whole site, and an information board has been supplied plus a comfortable seating area.

The Corn Mill at the western end of the hamlet, just beyond the viaduct, housed for a number of years a firm called Craft Supplies. They have become known internationally amongst woodturning enthusiasts and provided courses and demonstrations. The firm have now relocated to Bradwell.

At the eastern end of the dale is Litton Mill, a small hamlet grouped around a former cotton mill on the River Wye. The mill originally opened in 1782, became notorious for the inhuman behaviour of Elis Needham, the owner, towards his child labourers. Many of them were orphans both local and from as far away as London.

As a result of the cruel treatment meted out, a significant number of the children died and were buried in the churchyards at Tideswell and Taddington. Robert Blincoe was one boy who survived and he wrote a harrowing tale of

The footbridge at Millers Dale

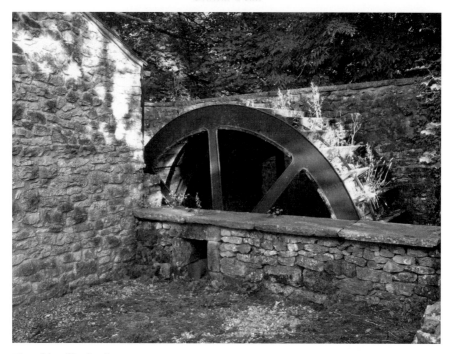

The old mill wheel

the cruelty and inhuman treatment handed out to the mill workers. It is said to have helped promote the Factories Act of 1833 and may have even have influenced Charles Dickens when he wrote *Oliver Twist*.

There are still a number of former railway cottages standing by the river as well as the impressive ivy clad Anglers Rest public house. It has been in the licensing trade since 1753 and apart from providing a pleasant dining room and bar, also caters for those with muddy boots with a Hikers Bar.

Ravenstor House, a large Victorian country mansion, was given to the National Trust in 1937 by Alderman J.G.Graves of Sheffield. Together with the House came 64 acres of land, including a one mile stretch of the River Wye and Tideswell Gorge, all of which are leased to the YHA. The house is open all year round as a Youth Hostel.

The square towered parish church of St Anne, which stands beside the Buxton to Tideswell road, has a date of 1879 on the clock tower. It was built in Victorian Gothic style and designed to serve as both school and place of worship, by the Vicar of Tideswell, Canon Samuel Andrew of Tideswell.

MONYASH

(SK150665)

On the B5055 Bakewell road, about one mile from the
A515 Ashbourne to Buxton road

Situated in limestone country at the head of beautiful Lathkill Dale is the sturdy little village of Monyash. The attractive green, together with the village pub and café form the centre of the village, where visitors like to sit outside and relax. Four ancient trackways, now converted into metalled roads, radiate from the green, lined by houses and buildings of all sorts and sizes.

The availability of water from a bed of clay about 100 yards square, on the edges of which rose 23 springs, was almost certainly the major factor why people settled here. Relics of an ancient flint tool factory, perhaps Derbyshire's first industry, have been found locally, most of them now being housed in Sheffield City Museum. The Roman road known as 'The Street' passed the village on the western side.

Only Fere Mere, once the village's source of drinking water, remains of the fives meres that originally existed to retain water in what was otherwise a dry limestone area. Before Cow Mere was covered over, farmers used to drive their livestock to drink according to an agreed schedule with other farmers. Meres are round ponds, usually with concrete bases, the making of which was once an important industry in Derbyshire.

Formerly an important lead mining centre for the High Peak, Monyash had its own Barmote Court. This sat at the Bull's Head at Easter and Michaelmas to settle mining disputes and to hear complaints of theft, trespass and grievances of lead miners. Judgements were made based on custom and precedent handed down over the years.

In order to encourage the growth of the lead mining industry a charter was granted in 1340 to hold a weekly market and a fair. A village market is now held, on Spring Bank Holiday weekends, on the green, where the old market cross still stands, the base made up from the former village stocks. But the importance of Monyash goes back much further. People from pre-historic times have been attracted to the area as evidenced by the stone circle

at nearby Arbor Low, the ancient trackways and burial mounds. The stone circle at Arbor Low is huge and consists of a ring of stones surrounded by a grass bank and a ditch. No one knows for certain if the stones originally stood upright.

Just over one mile from Monyash, on the popular walkers' route to Lathkill Dale, lies One Ash Grange. This is where the Cistercian monks of Roche Abbey in Yorkshire once had a farm and manor. According to one ancient tale, it was where Monks who had been unruly were sent as a punishment! Later it was the home of John Gratton, the Quaker preacher, and is now the site of one of the Peak District's network of camping barns. From here the path drops steeply to Lathkill Dale, a National Nature Reserve, whose clear waters are reputedly the purest in the county.

The parish church of St Leonard's dates back to the twelfth century. Encircled by tall lime trees planted in the eighteenth century by the Reverend Robert Lomas, it is one of the prettiest in the county. Unfortunately, it is not the limes the vicar will be remembered for, but the tragic end to his life. One dark and stormy night when he was returning from Bakewell the worse for drink, he fell off a cliff into Lathkill Dale and was killed. The cliff from which he fell is now known as Parson's Tor. It is said that a local person predicted this

Fere Mere

terrible event after he had witnessed the Revd Lomas and a crowd of drunken lead miners attack a Methodist preacher who was addressing a meeting. The villager was so upset at what he had seen that he forecast the vicar would die a dreadful death.

Monyash was a stronghold for the Quaker movement for over 100 years, and in 1668, John Gratton the most famous of the Midland Quakers, came to live in the village where he remained for forty years. Apart from being imprisoned for his faith, he suffered grievously at the hands of his fellow men. As this extract from a book about his life relates '...I got on top of a the wall and spoke to the people, but a company of rude fellows set on to stone us, the stones flew above my head and rattled in the tree, yet hit me not. But a woman that happened to sit near me, a great stone hit her and wounded her...' The Quaker Meeting House in the village is now used for other purposes.

A research project, the Integrated Rural Development Plan, was undertaken between 1981-84, in the village to create new business opportunities, community initiatives and to improve the environment. This project appears to have been very successful judging by the improvements that have taken place since then. There is now a new Village Hall, opened in 1986 by the Duchess of Devonshire, and a children's play area; the old toll bar has been

The Old Toll Bar

saved from dereliction and the Quaker Chapel repaired. Perhaps the most impressive achievement came in 1989, when impatient with the cramped conditions at the local school, the villagers raised the money required and did most of the work themselves to provide an extra classroom and store.

Most of the houses in the village were built during the eighteenth or early nineteenth century. The Bull's Head, partly built in the seventeenth century, is probably the oldest. It is a fine old village pub with beamed ceilings and it has an imposing coat of arms above the stone fireplace. Next door, the former blacksmith's shop has been converted into tearooms that are very popular with walkers. Inside musical instruments adorn the walls.

Jack Mere has been covered over and converted into a car park. Opposite Fere Mere is Chandler's House where candles once were made for mining and domestic use with tallow supplied by local butchers. The wide grass verges near here were used as a ropewalk, and much later to stack incendiary bombs during the Second World War before transportation to an ammunition site.

**The Bull's Head
public house**

SHELDON

(SK175687)

Off B5055 Bakewell to Monyash road

Sheldon is a lovely upland village perched high above the River Wye. It is situated three miles west of Bakewell off the A6, with the villages of Ashford-in-the-Water and Monyash only a short distance away. It has one street with a mixture of old houses and farms on both sides. Mature trees and attractive greens add to the charm of this Conservation Village. After the award of Conservation status, the villagers requested the restoration of the elongated greens. The main emphasis was to reverse the deterioration of the greens and improve the street scene.

The views just outside the village of the Wye Valley and the lower part of Monsal Dale are excellent. A good place to enjoy a panoramic view is close by the children's play area, where many visitors use the picnic tables provided. On the hillside that descends steeply from Sheldon to the River Wye, lie Shacklow Woods a huge expanse of trees, which are particularly noted for their beauty in the autumn as the leaves turn golden brown.

The village is recorded in the Domesday Book, but the building of the present dwellings came mainly when lead mining was enjoying a prosperous time in the locality. Most of the stone built houses date from the eighteenth century, but not the pub. The Cock and Pullet was built in 1995, and must be one of the Peak District's newest pubs. Nobody would think so, as with beamed ceilings, an open fireplace and ancient fittings it fits in perfectly with the rest of the village. It is named after the cockerels and pullets that used to run around in front of a barn where the pub is now situated. The village's previous pub, the Devonshire Arms, which stood next door, closed in 1971, and is now a private house.

Lead mining flourished around here in the eighteenth and nineteenth centuries; as a result a number of Cornish miners migrated to Sheldon. This increased the village population by 25 per cent according to the census in 1861. Magpie Mine stands one third of a mile south of the village, from where it can be seen standing darkly silhouetted against the skyline. It is

The Cock and Pullet public house

about 1,050 feet above sea level. Footpaths approach it both from Sheldon and the Monyash to Ashford-in-the-Water road. Members of the public may visit it for external inspection at any reasonable time. It is now scheduled as an ancient monument, and is the most complete example of a lead mine remaining in the Peak District.

Magpie Mine has a recorded history from 1739, but dates back much further and is said locally to be over 300 years old. Protracted troubles broke out in the 1820s and 1830s between the miners of Magpie, Maypitts and Red Soil mines. The dispute revolved around a vein of lead, and at various times the miners broke through into each others workings. Often when this occurred one side would light a fire underground and try to smoke the other out. Tragically, in 1833, three Red Soil miners were suffocated to death by a fire lit by the Magpie miners.

Following a year in prison and a lengthy court case at Derby Assizes, five Magpie miners were acquitted of the charge of murder owing to conflicting evidence and the lack of intent. The three widows of the Red Soil miners reputedly put a curse on the mine and, supposedly, a ghost was seen there in 1946. A party of speleologists, who were exploring the mine, reported seeing a

Magpie Mine

man with a candle who disappeared without trace. They also captured on film a mysterious apparition apparently standing on nine feet of water!

In 1842, there were two deaths at the Magpie Mine and during the next 50 years the mine was dogged by problems caused by flooding and fire. In 1880, the company operating the mine even changed its name to the Magpie Mining Company, probably in the hope of ridding itself of the curse!

After a period of inactivity, several attempts were made to revive the mine, the last in the 1950s. However, in 1958, the constant battle with flooding and falling prices forced the closure of the mine. The mine now receives far more visitors than anticipated in 1962, when the tenancy of the Magpie Mine Cottage was taken over as a Field Centre, by the Peak District Mines Historical Society. There is usually someone present at the mine at weekends to provide visitors with information, and it is open to the public during the Heritage Weekend, in September. Further information regarding the mine may be obtained from the Peak District Mining Museum at Matlock Bath.

The Parish Church of St Michael and All Angels at Sheldon was erected in the nineteenth century. The demolition of a former chapel of ease, which stood in the centre of the village and was reputedly the smallest chapel in

Looking towards the Ashford Road

Derbyshire, supplied most of the materials. In 1753, an unusual wedding is said to have taken place between a boy of fourteen and an eighty year old widow, who came to the altar on crutches! The church was refurbished in 1983, when the bell was made to ring again. Although small, the church is quite striking with a particularly attractive timber ceiling.

The Hartington Memorial Hall was presented to the inhabitants of the village in memory of William John Robert Cavendish, Marquess of Hartington, Major of Coldstream Guards who was tragically killed in action in Belgium on the 10 September 1944. Had he lived he would have become the Duke of Devonshire, instead of his younger brother Andrew. Only four years later William's wife was killed in an air crash. She was the sister of John F. Kennedy, the late President of the United States of America.

The green opposite the former Devonshire Arms has its own mysterious legend. In 1601, villagers said that they had seen a duck fly into a tree and disappear. Some 300 years later when the tree was felled and its trunk cut into planks, the imprint the shape of a duck could be seen. This has led to the suggestion that this is where the term 'duck-boards' originated!

STONEY MIDDLETON

(SK230753)

On A623 Baslow to Chapel-en-le-Frith road

Anyone describing Stoney Middleton as a quiet and peaceful place is likely to attract strange looks and the expectation that men in white coats will soon arrive to take them away. That's the view from those people who have only driven through the village. For those that have taken the time to explore the back streets of this fascinating old village a different view will prevail.

The A623 from Chesterfield to Chapel-en-le-Frith divides the village in half, with the houses clinging to the hillside where any space can be found. On the western side of the village, the cliffs rise almost vertically and this is where aspiring mountaineers come to test their skills. Further to the east, the land begins to flatten out a little, but Stoney Middleton must have one of the steepest High Streets in the country. This was the route through the village before the present road along Middleton Dale was opened in 1840.

Lover's Leap is a prominent limestone cliff that overhangs Middleton Dale. It acquired its name after an incident in 1762, when a young woman by the name of Hannah Baddaley, attempted to commit suicide by throwing herself over the cliff top. Her lover, William Barnsley, had jilted her, and she had decided to end it all. Miraculously her billowing petticoats acted like a parachute on the way down, until they were caught in brambles protruding from a ledge. This saved her life and all she suffered were a few cuts and bruises. However, this story does not have a happy ending: Hannah died two years later of natural causes, still unmarried. The details of this event are recorded on an information board outside the former Lover's Leap Café, now an Indian Restaurant that marks the location of the leap.

Industry has played an important part in the life of the village, ever since the Romans discovered lead here. Stoney Middleton has at one time or another been involved in businesses as diverse as lead mining, smelting, quarrying, boot and candle making. Today, quarrying on a large scale is carried out on the outskirts of the village.

St Martin's Church

The Roman Baths in The Nook still have warm thermal springs, where Roman soldiers once liked to bathe. Although there is no irrefutable proof of this, Roman coins have been found in the vicinity. As Stoney Middleton was undoubtedly rich in lead, and the Romans surface mined and smelted the ore wherever deposits could be found, they may have been actively involved close to the village.

For many years after the Roman occupation, the springs with a constant temperature of 63 degrees, attracted the infirm. Lord Denman had the medieval bathhouse demolished and re-built in an attempt to increase its use amongst his tenants and employees. The Parish Council and the Peak Park Planning Board have recently restored the building.

Stoney Middleton Hall, hidden away behind the church, was the home of the Denman family for many years. Thomas Denman, who acquired the hall following the death of his uncle, became Lord Chief Justice of England in 1832, a position he held for 18 years. Part of the hall gardens have now been converted into an attractive housing development.

In a delightfully secluded square is St Martin's Church, surrounded by

Lover's Leap

picturesque cottages and with a stream running alongside. Like the thermal springs, the church is dedicated to the Patron Saint of Cripples and Soldiers. It has a fifteenth-century tower at the front leading into an octagonal church that is claimed to be one of only two in the country.

The construction of the road through Stoney Middleton in the 1840s created the need for a new Toll House. It was built to an octagonal design to match the

Top: **The waterfall in the Grove Garden**
Above: **The Roman Baths**

church. After it was no longer used for its original purpose, it was converted, in the mid-1920s, into a fish and chip shop, which it still remains today. It is now a Grade II listed building, the only fish in chip shop in the country to hold this distinction.

Alongside is the Grove Garden, given to the community for relaxation purposes by the Grove family. Look carefully after passing the garden and you'll be able to see a small waterfall partially hidden away amongst the vegetation. Lennon's Boot Factory, the last manufacturer of safety boots in this country is to the rear. Further up the steeply rising hillside is the Wesleyan Reform Chapel.

At the foot of High Street, behind the Village Cross, stands the Moon Inn. It was originally called 'The Old Moon,' before it was moved across the road to its present site. As a consequence, it was then called 'The New Moon' prior to adopting its present name. In coaching days, the 'old' pub was the principal posting station between Manchester and Sheffield where horses were changed.

The Moon Inn is now the only pub left in the village. There were fifteen pubs in the village at one time and according to legend a wealthy young couple 'Alan' and 'Clara' called at the Royal Oak one day for lunch on their way to Peak Forest to get married. Sadly they were robbed and murdered in the Winnats Pass by five miners. The saddle used by Clara was kept at the Royal Oak for many years and can now be found in the Peak Cavern Museum at Castleton.

At the foot of High Street is the well-known Castlegate Farm Shop, ran by John Hancock combining a butchery business, delicatessen and bakery. Further up the street, Stoney Middleton Primary School faces Pine View where the butchery business of L. W. Hancock & Son operates. The Hancock family have been in the business for about 175 years.

The annual Well Dressings take place every July, when two wells and a children's well are dressed. A wide range of supporting events also takes place on the first Saturday and the WI provides teas. The event is always well attended and the money raised is used to support local causes.

TIDESWELL

(SK152754)

One mile south of the A623 Baslow to Chapel-en-le-Frith road

A large, very well kept, upland village of considerable character, Tideswell is ablaze with colour in the summer with hanging baskets and flower tubs everywhere. In recent years, Tideswell has won both the Derbyshire Best Kept Village Award and the East Midlands section of the Britain in Bloom Contest on several occasions. It has been said that Tideswell is 'too big to be a village and too small to be a town'. The population of around 2,000 has remained relatively static over the last 200 years and the street scene has remained much the same, even if the use of some of the buildings has altered.

Standing at approximately 1,000 feet above sea level on a limestone plateau, Tideswell dates back to the Romans and beyond. There has been evidence of Neolithic settlements found in the area. But it is thought to be named after Tidi, a Saxon chief who lived here in the seventh century. Another less likely explanation is that the name came from the 'tiding well' on the Manchester Road, which because of a natural siphon in the rock did 'ebb and flow'. A new drainage system finally put a stop to this unusual feature.

William the Conqueror gave Tideswell to William Peveril of Castleton, and from the thirteenth century it was an important hunting centre and was referred to as the 'King's Larder'. In 1250, it was granted a market charter and although the market has long since ceased, it still has the air of a busy town. It has a wide main street and a magnificent parish church, often referred to as 'the Cathedral of the Peak', that would not be out of place in a much larger town.

The church, dedicated to St John the Baptist, with its superb pinnacled tower, has dominated the village for over 600 years. Rebuilding started in 1346 and it was fifty years before the work was finally completed. The Black Death that swept the country interrupted work for a lengthy period in the early stages. Inside, the church is spacious and lofty, with many fine carvings, brass and stained glass windows. A good number of the carvings are the work of Advent Hunstone, who was encouraged by Canon Andrew, the vicar, to

switch from the family stone masonry business to woodcarving. This he did to great effect and much of his and his family's work is seen in churches far beyond Derbyshire.

Songs of Praise, the popular television programme visited Tideswell during October 2002, but it is for the singing exploits of Singer Slack the village is best known. Samuel Slack, born in 1757, was a noted bass singer. He was

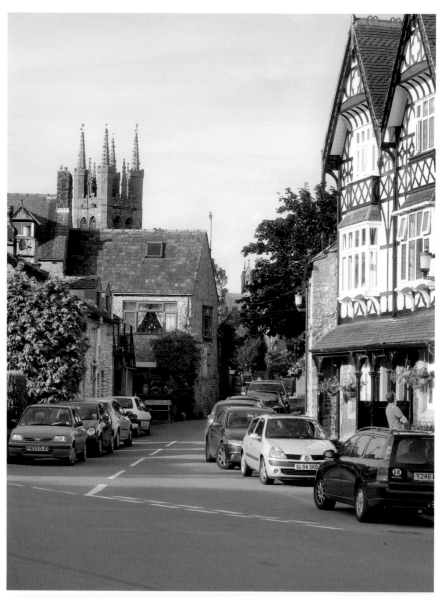

A Tideswell side street

commanded to sing before George III, and as a young man he competed for a place in the College Choir at Cambridge. After he had sung, there was a stunned silence and none of the other contestants took the opportunity to sing after such an awesome performance. Such was the high opinion of Singer Slack that he was invited to lead the choir in Westminster Abbey. He declined, preferring to sing with his friends in the village.

Bagshaw Hall

One interesting story of Slack's exploits tells the tale of how he lay down in a field to recover from a slight over indulgence at the pub, only to be aroused by a snorting bull. Restored to sobriety, he jumped up and gave such a loud bellow that the animal took fright! A scare of a different kind was given to King George III, when he saw a group of Tideswell lead miners paraded in front of him in London. He reportedly said 'I don't know what effect these men will have on the enemy, but good God they frighten me!'

Amongst the village's maze of alleyways and lanes are many buildings of architectural interest. None more so than Tideswell Grammar School, founded in 1559 by Bishop Pursglove. Eccles Hall and Blake House, both notable Georgian constructions, provided accommodation for staff and pupils. The school closed in 1927, and the library takes up part of the area where students used to live.

Bagshaw Hall overlooking the old market place, where cattle, sheep and pig fairs, were once held, was built in 1872 as the Odd Fellows Hall. With its giant pilasters and commanding position, it certainly attracts attention. Opposite is the building that for a short period operated as Tideswell College after the closure of the Grammar School. At the top of the slope near the hall is Laburnum House, formerly the House Of Correction. Prisoners were allowed to do odd jobs in the village to pay for their accommodation.

On St John's Road is the Bishop Pursglove C. E. (Aided) Primary School and next to it, an immaculate sports centre catering for football, cricket, tennis and bowls. Set back off Commercial Road is the George Hotel, an eighteenth-century coaching inn, dating back to 1730, which still provides excellent hospitality for travellers. The arched Venetian windows are particularly attractive, a style popular in coaching days. In the 1920s the landlord operated a charabanc service, drawn by two horses, to meet the trains at Millers Dale Station.

Tideswell, traditionally a home for craftsmen, now provides work for local people on its industrial estate. In addition, M. Markovitz Ltd., established shortly after the Second World War, has opened an impressive kitchen, bedroom and bathroom centre also incorporating a stove, tile and cooker section.

At the other end of the village, even more surprisingly, is a piano and musical instrument showroom, established in 1983, that at one time displayed more than 50 pianos from all over the world. Add to that, a Fossilist and Petrifactioneer's shop and it can be readily seen that Tideswell is full of surprises.

The village is renowned for its annual Well Dressings, which start on the Saturday nearest to the 24th June each year and continues for a week, with a carnival, parades and fun for all the family. Upholding the musical tradition of the village, Tideswell Male Voice Choir gives an annual concert in the church during the summer and is in much demand for concerts all over the Peak District.

BAKEWELL

(SK218685)

On the A6 Matlock to Buxton road

Set in an excellent location on the banks of the River Wye, in the heart of the Peak District, is the picturesque old market town of Bakewell. At the weekend and during the summer, it throngs with visitors who come to browse round its many shops, to enjoy refreshment at one of the numerous restaurants, pubs and cafés in the town. Others just enjoy a stroll round this historic little town with its fine old buildings and lovely river walks.

When in 1951, the Peak was the first of the national parks to be set up in England and Wales, Bakewell — the only sizeable market town in the park — was the logical choice as the administrative centre. From its offices at Aldern House, it controls an area of 542 square miles and covers Staffordshire, Cheshire, West and South Yorkshire and Greater Manchester as well as Derbyshire. The population when the park was set up was only 38,000 and has not changed drastically since that day.

The town is particularly busy every Monday, which is market day, when the stalls and the livestock market, in normal circumstances, do brisk business. Until recently, the livestock market occupied a position near the centre of the town, before moving to its controversial new building on the other side of the river away from the town centre.

The strong connection with agriculture is further emphasised every August when the town hosts the largest tented agricultural event in the UK, which is also one of the oldest and is often known as the 'Little Royal'. The first Bakewell Show was held in 1819 and apart from breaks for the First and Second World Wars and for foot and mouth in 1883 it has been held continuously. Despite foot and mouth, it was held in a modified format in 2001.

Less than 200 years ago, Bakewell presented a completely different picture, with narrow streets and timber framed properties, many of which had thatched roofs. The modern layout of the town only came about in the nineteenth century. Rutland Square was created and the Rutland Arms replaced the Old White Horse Inn.

The Bakewell Pudding Shop

It was at the Rutland Arms, in about 1860, where the hotel cook misunderstood her instructions and produced the world famous Bakewell Pudding. Instead of stirring the egg mixture into the pastry, she spread it on top of the jam, which has to this day proved to be a stroke of genius in creating name awareness for the town. The Bakewell Pudding Shop is an interesting place to visit, with information panels and exhibits to view as well as the chance to sample a delicious Bakewell Pudding, not 'tart', as some mistakenly call it nowadays. In 1811, Jane Austen, who wrote *Pride and Prejudice* is said to have stayed at the Rutland Arms and incorporated it in her writing. The hotel has even named a suite after her to commemorate the visit.

The site, on which All Saints Church stands, has been used for worship since Anglo-Saxon times and contains the largest and most varied group of medieval monuments in the United Kingdom. Inside the church, there are many references to the 'Manners' and 'Vernon' families, the story of the elopement of John Manners and Dorothy Vernon being one of the Peak District's most romantic tales.

The Olde House Museum is well worth seeking out, hidden away as it is behind the church. Originally a Parsonage, it was later converted into six

Wye Bridge

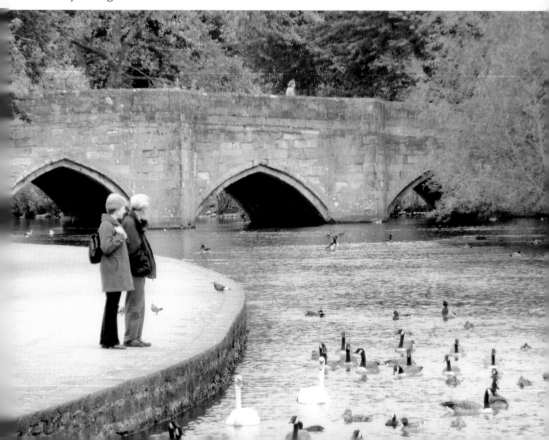

cottages by Sir Richard Arkwright; another four cottages were accommodated in the adjacent barn, to house his workers at Lumford Mill. It is now one of the best-preserved fifteenth-century houses in the country, but only fifty years ago it was nearly demolished, the local council having served a 'Demolition Order'. There was an outcry locally and the house was eventually saved and restored to its former glory by the Bakewell Historical Society. It is now a fascinating folk museum worth climbing up the hill to visit.

The five-arched bridge across the River Wye is one of the best-known landmarks in the Peak. It dates from 1200, is among the oldest in the country, and now designated as an Ancient Monument. From here, you have the choice of two short river walks. The first is to go upstream through meadowland known as Scots Garden passing Holme Hall, a small Jacobean Manor, built in 1626. Then cross the packhorse bridge, which is by the side of the sheep dip. The bridge was frequently used by packhorse leaders arriving from the Monyash direction, thus avoiding paying tolls in the centre of the town. The walk returns along the A6 to Bakewell. Alternatively you can walk southwards along the banks of the River Wye, where rainbow trout wait to be fed, down to the impressive looking sports ground then retrace your steps.

The Castle Inn, a cosy sixteenth-century pub, is situated by Bakewell's medieval bridge. For over 100 years horse markets took place in the yard, its three present day garages being used as stables. Inside, the Castle Inn has stone floors and a beamed ceiling.

Across from Rutland Square, at the far end of Bath Gardens, is the Bath House. This was for years the home of the famous Derbyshire geologist, White Watson, who acted as a bath superintendent. The Duke of Rutland, who owned the premises, tried to establish Bakewell as a spa town, similar to Buxton and Matlock. The 'warm' water from the natural spring, at only 15 degrees centigrade, was much colder than that of its rivals and the venture failed.

Further along the street is The Old Market Hall, which was built as an open-sided market hall. Since those early days, it has seen many uses: as a washhouse, dance hall, library and restaurant. Now it serves as a Tourist Information Centre and holds several interesting exhibitions. The M and C museum contains a fascinating collection of historic motorcycles and motor memorabilia, which has been assembled by two local enthusiasts. It is only open to the public on a limited basis and is a must visit for motorcycle lovers, but the colourful and interesting display will also appeal to many people who have never even ridden a motorbike.

BASLOW

(SK255723)

On the A619 Chesterfield road where it meets the A621 from Sheffield and A623 to Chapel-en-le-Frith

Baslow is a busy little village, delightfully situated in the Derwent Valley, located where limestone country of the 'White Peak' meets the millstone grit of the 'Dark Peak' at the heart of the Peak District. Chatsworth House is only a short walk away to the south, with Baslow Edge rising to the north, from where the short steep climb is rewarded with fantastic views. The village is full of interest and well endowed with pubs and places to eat for the many tourists who visit.

Nowadays, the Devonshire Bridge, built shortly after the First World War, carries most of the traffic across the river. But it is the Old Bridge, close to the church built in 1603, which attracts most interest from visitors with its impressive stone arches. It replaced a wooden bridge that all able-bodied men in the village were required to watch on a rota basis, to ensure the weight restrictions were not broken. Anyone caught breaking the rules was fined. The tiny watchman's hut still remains, no doubt reduced in size by the heightening of the road. At one time it offered a shelter of sorts to Mary Brady, a local beggar, who often slept rough inside.

The bridge has always played an important role in the history of Baslow, providing an easy route over the moors to Chesterfield and the North Sea ports. Prior to the erection of the first bridge the ancient trade route crossed a ford near where the bridge now stands. It is the only bridge across the Derwent never to have been destroyed by floods. To get a better look at the fine workmanship beneath the arches there is a path you can walk down to the water's edge by the side of the church. This is also an excellent place to watch wildlife and perhaps spot a trout in the river.

St Anne's is both a beautiful and unusual church — one clock tower has Roman numerals and is dated 1759 and the other has 'Victoria 1897' on its face to mark Queen Victoria's Golden Jubilee. Inside the church by the door, in a glass case, is a dog whip, which in the seventeenth and eighteenth centuries

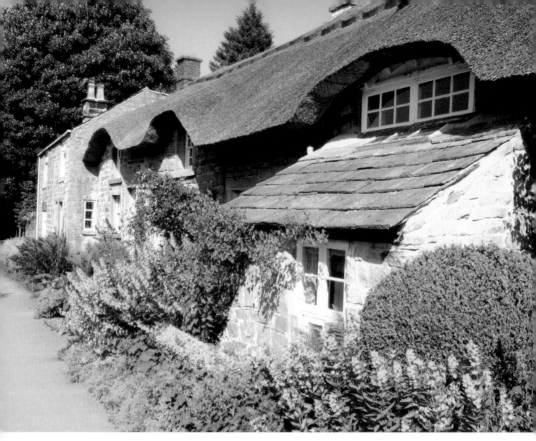

Thatched cottages on the path to Chatsworth Park

was used by the official 'dog whipper' to keep stray dogs in order during the service. The whip has a thong three feet long, which is still in excellent condition and is bound round the handle with leather. Some historians also claim that it was used to maintain order among worshippers and to wake up those who snored during the service! Across the road from the church is a group of shops housed in a handsome block of buildings.

As the road network improved, it became easier for wealthy people from Sheffield and other cities to visit the country for health or recreational reasons and for fifty years Baslow Hydro was the dominating feature in the village. Although falling short of spa status, the Hydropathic Hotel was set in spacious grounds with a croquet lawn, tennis court and bowling green all surrounded by gardens set out like a miniature park. There were nearly 100 bedrooms and in the 1890s an annexe was added providing a further 20 or so bedrooms. Until the First World War it was a profitable enterprise, but then trade dwindled and it gradually fell into disrepair before closing in 1936 and being demolished. All that remain are two stone gateposts.

Baslow Hall stands in landscaped grounds just off the A623 north of the village. It was built in 1907 for Revd Jeremiah Stockdale, vicar of Baslow for

48 years and it became the home of electrical pioneer Sebastian de Ferranti in 1913. Ferranti was a 'Do It Yourself Man' with a passion for electricity. He experimented with central heating and other electrical appliances in addition to fitting double-glazing. Sadly, his efforts at battery poultry farming had disastrous consequences for the chickens who were electrocuted. It is now a hotel and restaurant.

In 1862 Lieutenant-Colonel E. M. Wrench took over a medical practice in Baslow. He was a surgeon who had served in the army in both Crimea and India and was a great patriot. In 1866, he built Wellington's Monument on Baslow Edge; the ten feet high cross can be seen over a wide area. In Chatsworth Park he carved an inscription on the face of what is now known as Jubilee Rock to commemorate Queen Victoria's Golden Jubilee. The rock was previously known as the Elephant Stone. Queen Victoria would not have been amused! For her Diamond Jubilee, Lieutenant-Colonel Wrench refaced Baslow's church clock.

Nether End is the most popular part of the village with its hotels and little shops set around Goose Green, where people can sit in comfort and relax. From here the parklands of Chatsworth are approached over the seventeenth-century Packhorse Bridge and past a row of pretty thatched cottages. Chatsworth House is only a mile away and many visitors to Baslow prefer the

The watchman's hut

Cottages near to Packhorse Bridge

gentle stroll through the park to a more vigorous climb up to the edge. From the A623 at the northern end of the park, the estate is entered, for official purposes, through the Golden Gates. Following an accident a few years ago, when an out of control lorry demolished them, the gateway had to be rebuilt.

The massive boulder standing in solitary confinement on Baslow Edge is known as the Eagle Stone. According to legend, it took its name from the god, Aigle, who it appeared, had a habit of throwing boulders around. In the past, no local lad was considered fit to marry until he had shown his fitness and agility by climbing to the top of the stone.

Along the Bubnell road is a group of cottages that were used for weaving and at one time for making felt hats. Further to the west is the seventeenth-century Bubnell Hall, the home of the Bassett family for several generations. One member of the family is said to have fought with King Richard in the Crusades. Baslow Hall which stands on the opposite side of the river is a copy of Bubnell Hall.

BEELEY

(SK265674)

On the B6012 through Chatsworth Park, to the east of Chatsworth House

Anyone compiling a list of the most picturesque villages in Derbyshire would have to include Beeley. It is a pretty, unspoilt village sheltered by Beeley Moor with wonderful views in all directions. Arthur Mee wrote in his guide to Derbyshire, 'At the gate of Chatsworth's glorious park and set among the hills, Beeley has wonderful views whichever way we turn … hidden from those who rush by. Its roads go up and down and twist and turn as they take us by houses of old grey stone, by cottage and school and old grey hall, by a little green with a lovely lime, to ancient church with sturdy tower close to the gabled vicarage.'

The delightful Beeley Brook further enhances the village scene as it chatters its way cheerfully alongside the road over several small waterfalls, past the Devonshire Arms to a meeting with the River Derwent. Tastefully extended, The Devonshire Arms, with its oak beams and real fires, fits in superbly with this gem of a village. It boasts some celebrated patrons, as the writer Charles Dickens and King Edward VII both stayed at the inn. At the junction of the Chatsworth and Chesterfield roads, directly opposite the pub, stand three cottages built in a triangular pattern with very unusual Dutch-gabled roofs; the style is reminiscent of Edensor, another Chatsworth Estate village.

Surprisingly, many travel books featuring the Peak District do not mention the village, but refer only to Beeley Moor. On the heather clad moor, some 1,200 feet above sea level, are over 30 pre-historic barrows and cairns. It is Hob Hurst's House, an unusual Bronze Age Barrow, that attracts most attention. A small ring of five stones stands on a mound surrounded by a rectangular bank and ditch. When the barrow was excavated in 1853, scorched human bones were found and two pieces of lead ore. Various legends have sprung up including one that refers to 'Hob' as a kindly goblin who made his home in this barrow and gave assistance to the local community.

In a rather remote area on Beeley Moor, Park Gate is one of the lesser well-known stone circles in the Peak District — the circle consisting of ten stones

in a ring. The moor has long been famous for its grouse-shooting and in more recent years for the notorious 'carbon-copy' murders for which Michael Copeland was tried and convicted.

The pretty, almost secluded village of Beeley that we see today could have been very different in appearance. The old road to Chatsworth used to go through the heart of the village. It left by Pig Lane, so named because of a group of pigsties by the side of the road and crossing James Paine's Single Arch Bridge. Before the completion of the bridge in 1761, traffic crossed Mill Bridge, near the old ruined mill buildings in Chatsworth Park. Fortunately for Beeley, it has had a bypass for over a hundred years, effectively shutting out all the hustle and bustle of the Chatsworth traffic hurrying along the winding road. Most motorists hardly give the village a passing glance, which even to this day remains quiet, peaceful and relatively undiscovered.

It was only after the third Duke of Devonshire had bought Beeley Hill Top in 1747 that his successor embarked upon a grand plan to develop and landscape Chatsworth. Beeley then started to become part of the estate. Land and buildings were purchased as they came on the market, but this task took some time and was completed by the sixth Duke. Many of the properties have been sold off into private ownership in recent years as they became surplus to requirements.

St Anne's Church

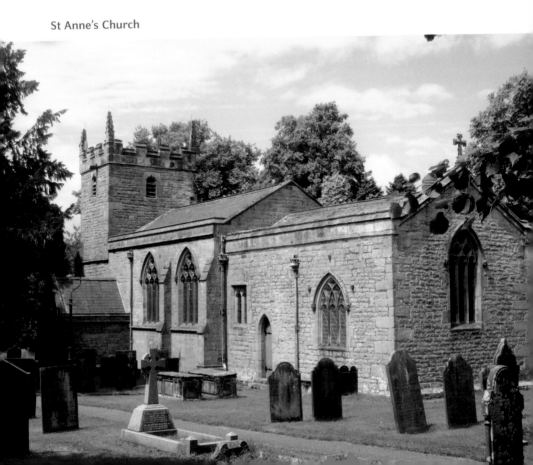

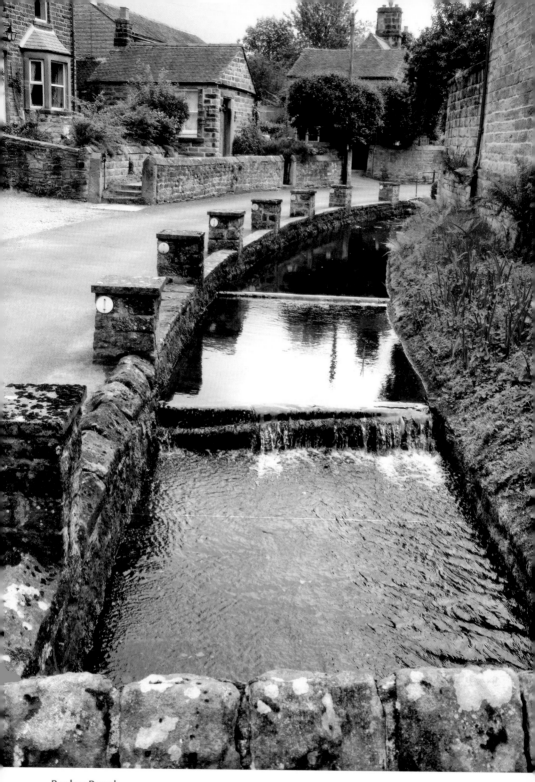

Beeley Brook

Looking down towards the Devonshire Arms

Beeley had acquired its present shape and size by 1800. With the exception of a small group of properties built in recent years on the Chesterfield Road, it has remained remarkably unchanged for over 200 years. The same does not apply to the use of the buildings: the school, schoolhouse, post office and reading room are all now private houses. Dukes Barn built in 1791, to house the estate carts used to carry coal from Rowsley Station, is now a residential study centre.

What makes the village so beautiful is that almost all the farm and domestic buildings are built from the same honey coloured sandstone, quarried locally, close to Fallinge Edge. The local stone quarries once gave employment to a large number of men. The two quarries at Bruntwood produced stone not only of good appearance, but also of such hardwearing quality that it was used in many of the principal buildings in Manchester. Nearer to home, good quality gritstone, mined up on the moors was also used in building Chatsworth House.

The ancient church of St Anne, close to the gabled vicarage — now a private house, is one of the oldest in Derbyshire. Its considerably mutilated round headed doorway dates back to the middle of the twelfth century. In the churchyard, the star attraction, at least as far as age is concerned, is a gnarled old yew — once a massive tree — said to be older than the church.

Beeley Old Hall is easily recognisable by its stout chimney. It was thought to be the original Manor House of the village until 1559, when John Greaves of the 'Greaves' bought it. Manor House status was then transferred to the 'Greaves' later known as Beeley Hill Top, where the arms of King James I can still be seen above a bedroom mantelpiece. It is one of the oldest houses in this part of Derbyshire, thought to date back to 1250. Both houses reverted to farmhouse classification in the seventeenth century.

Opposite Beeley Old Hall stands Norman House, once the home of the 'Norman' family who brought industry to the village in the form of a lead-smelting mill and a tanning yard. The Norman family who also owned farms at Fallinge and Doewood were of an entrepreneurial nature and had a small lead-smelting mill on Smelting Mill Brook between Beeley and Rowsley, and a tanning yard on Beeley Brook in the village. Coal pits on Beeley Moor fuelled the lead-smelting furnaces.

BIRCHOVER

(SK239622)

Off the B5056 a linking road between A515 — Ashbourne and A6 — Bakewell

The White Peak village of Birchover rises gently along a west facing hillside, the main street lined with some unusual and spectacular cottage gardens that give pleasure to the eye, particularly in summer when the flowers are in full bloom. The gardens provide an annual highlight on the social calendar in July when the residents open them to the public during Birchover Open Gardens Weekend and visitors flock to see the spectacle. Stalls and refreshments are available in the village and a flower display arranged at the church at this popular event. Needless to say a walk round Birchover at any time of the year reveals an abundance of attractive, well maintained gardens.

From the outskirts of Stanton Moor, on the eastern side of the village, the main street passes the majority of Birchover's fine old cottage buildings, which shelter under a tree-lined ridge. They were built between the seventeenth and the nineteenth centuries of attractive pinkish stone from Stanton Moor quarries. The buildings face in all directions as they struggle to find level ground, which all adds to their charm. More recent development has taken place on the lower side of the street, where great care has been taken to ensure it harmonises with the rest of the village.

Despite its rural setting, Birchover has been home, in the past, to a thriving quarrying industry on Stanton Moor. The area is very rich in mineral deposits, and lead mining, quarrying for stone, and spar mining has provided local inhabitants with a valuable source of employment over the centuries. Birchover stone from Stanton quarries has provided the raw material for the construction of many notable buildings, including the Tower of London, Windsor Castle and the Houses of Parliament.

It seems likely that the village was originally sited at Uppertown on the road to Winster, where the farm standing beside the road used to be an inn. The Norman church and the village are no more, the stones used to construct them scattered round field walls and cottages in the neighbourhood. The stocks are still there outside Uppertown Farm; they were restored in 1951 by Mr J. C. Heathcote, but may not be in their original position.

The view from Winster Road

The Millennium Stone

Birchover was the home of J. P. and J. C. Heathcote, father and son who were both noted amateur antiquarians. Between them, they excavated the tumuli on Stanton Moor and built up a fascinating private museum in the old village post office. When Percy Heathcote died, the collection was transferred to Sheffield West Park Museum.

On the corner, at the bottom of the street, stands The Druid Inn, its restaurant given a score of ten out of ten in a *Sunday Times* article in 2002. The Inn is named after the Druids, who are said to have practised their rites on Rowtor Rocks nearby. At the base of the rocks stands a large cave with socket — holes at the entrance and evidence of a carved altar piece in the interior, with a niche for a lamp beneath, which all add credence to the legend. During the eighteenth century, Bronze Age pottery and Romano-British artefacts were found in the cave.

Rowtor Rocks certainly fascinated the Reverend Thomas Eyre, whose private chapel and vicarage, Rowtor Hall, once stood at the southern edge of the rocks. He carved seats in the rocks, so that he and his friends could sit and enjoy the view and according to tradition he sat in his seat on the rocks when

he was composing his services. Following the death of the Revd Eyre in 1717, Rowtor Hall fell into disrepair and was eventually demolished in 1869 and the present 'Old Vicarage' was built shortly afterwards. The original chapel still stands, although much rebuilt and is now administered by the Church of England.

The Birchover Millennium Stone, sited by the roadside on the western side of the village, represents the former industry of millstone production in the area. Millstones were made out of local gritstone and exported all over the world. The stone has a circular core and a carved motif on the base, which is a copy of a Romanesque carving discovered in a wall at Uppertown, where a church built in the late eleventh century, or early twelfth century, used to exist.

The Village Hall opened in 1907, originally for 'men only', when newspapers were provided to broaden the horizons of the male readers alone! In 1999, following a comprehensive refurbishment, computer equipment was installed in the Reading Room, which was used as an official centre of the BBC's Webwise campaign to provide taster sessions on the internet to local people. The hall is in regular use for a variety of community events.

Entertainment in the village was provided by the Brass Band, who before they disbanded prior to the outbreak of the Second World War, won third prize in a band contest at Ormskirk. After that, they were proudly known as the Birchover Prize Band. Some of the shine was taken off however when it was later found that there had been only three entrants in the competition!

Higher up the hill is the Red Lion, erected in 1680, on the site of a farm, which at that time was probably used as an alehouse. An unusual feature just inside the main entrance of the pub is a 30 feet deep well with a thick glass cover. Outside the Brimsbury Well was originally used as a milestone and drinking trough for horses.

A helpful information panel, by the side of the toilets in the main street, provides a map and notes about the village, to assist visitors in identifying the main places of interest. Both visitors and local people alike will appreciate the well-stocked village shop higher up the road.

On a triangle of grass, at the top of Uppertown Lane is the stone covered tank that used to be the village's main source of water. Facing it on the opposite side of the lane is the former Pinfold, where stray animals were kept until their owners reclaimed them. The former Wesleyan Reform Church's date stone obligingly provides both the year the building was originally built, 1857, and the date it was re-built, namely 1908.

CARSINGTON AND HOPTON

(SK253534 & 260533)

Now bypassed by the B5305 Middleton-by-Wirksworth to Ashbourne road

The picture postcard village of Carsington and its equally attractive neighbour, Hopton, are inseparably linked. They lie in a wooded valley with Carsington Pasture rising steeply to one thousand feet to the west, behind a row of attractive little cottages that line the roadside. Both villages share the same church and school. The houses in each village almost overlap on the narrow shared road, and they are both in the same parish. Even the Domesday Book listed both villages as outliers of Wirksworth, some two and a half miles away.

A considerable change to the landscape took place a few years ago with the construction of Carsington Water. The reservoir built at a cost of 107 million pounds, increased Severn Trent's raw-water capacity by 10% to meet the growing demand for water in Derbyshire, Nottinghamshire and Leicestershire. Water is first pumped from the River Derwent at Ambergate Pumping Station. It is piped to Carsington Water when the river level is high and stored in the reservoir.

Conservationists fought a long hard battle against the site chosen for the reservoir. Now a bypass takes much of the traffic away from the narrow winding pavementless village road. Carsington Water has exceeded all expectations as a tourist centre. Thankfully all this has been achieved without life in Carsington and Hopton seeming to have changed very much. More walkers, however, pass through the village on their way round the reservoir, which helps keep the village pub busy.

Recent excavations made as part of the reservoir construction reveal that Romans were once present in the area. Many archaeologists think that Carsington was Lutadarum, the centre of the Roman lead industry. In more recent times the village was an important lead mining centre and Carsington Pasture is still littered with disused lead mines. Mining was still in existence in the twentieth century with barytes extracted at the Golconda Mine until 1953. Miners' Lane, situated on the corner of the road as it bends away from Carsington, was the route the miners used to get to work.

Carsington Water

Carsington Water, officially opened by HM the Queen in 1992, instantly became one of Derbyshire's most important tourist attractions. The original estimate of three hundred thousand visitors per year was soon revised to over one million. Further evidence of the popularity of the reservoir came when the East Midlands Tourist Board awarded it the 'Visitors' Attraction of the Year' in 1993.

Only a short easy walk from the Visitor Centre Car Park is the wildlife centre where you can watch Carsington's birdlife in warmth and comfort. Posters on the wall help identify the birds for those who are not experts. The weight of the turf-covered roof holds the building together without need of screws or nails. Along the bank side towards Carsington Village are further bird-hides where a fascinating hour or more may be spent seeing how many different species of birds you can spot.

Severn Trent has planted half a million trees and shrubs in woodlands, copses and hedgerows; the result has been not only to enhance a beautiful landscape, but also to create many new habitats for wildlife. This was recognised in 1995, by the receipt of the Forestry Centre of Excellence award for using 'The Highest Standards of Woodland Management' at Carsington.

The small Church of St Margaret's at Carsington fits into the scenery perfectly — pretty but not dominating. There is evidence that a church

Hopton Hall

existed as far back as the twelfth century and it is interesting to note that in 1971, a gravedigger dug up the skeletons of a man, woman and child, probably of Anglo-Saxon origin, giving rise to further speculation of the date of the first church. An unusual item in the church register records the life of Sarah Tissington who was born in the village in 1664 without arms, but despite this severe handicap learned to knit with her feet. A church flower festival takes place in second half of May every year, which is very popular with visitors.

The Gell family who lived at Hopton Hall for nearly 500 years were the dominating influence in the area. The Hall, sold in 1989, hides behind a red brick crinkle-crankle wall on the eastern side of Hopton. The wall traps the rays of the sun to assist fruit growing. The Gells built the school and had a considerable influence on the development of the church. Sir Philip Gell organised the building of the Almshouses in Hopton, above which a stone tablet declares that the buildings were for '2 poor men and 2 poor women of Hopton and Carson', the latter being the old name for Carsington.

At Hopton Hall, visitors can indulge themselves early in the New Year by viewing the spectacular display of snowdrops in the grounds of the hall. The grounds were first opened to the public earlier this century, and since then

St Margaret's Church, Carsington

visitor numbers have increased dramatically, making it one of Derbyshire's most popular winter attractions. Proceeds from the snowdrop displays are used to raise funds for the ongoing restoration of the gardens.

Partly hidden, across the road close to the corner of the crinkle-crankle wall, is the Ice House. It is a circular gritstone building with a domed roof, set well into the ground so that only the roof and tunnel are visible. This was used by the Gell family to store food in pre-refrigerator days. It was built around 1700 and has now been listed for protection.

Further along the road, in Carsington, is the Miners Arms, which was originally popular with thirsty lead miners and now with walkers. It is the only pub on the well trodden circular walk around Carsington Water. On the lane behind the pub is a small village green, where the remnant of a medieval cross stands on a more modern base. The cross formerly stood in the grounds of Hopton Hall. Further down the lane is the school, which dates from 1726. A tablet on the wall indicates that the school was given by Mrs Temperance Gell for twenty poor children of Hopton and Carsington.

CROMFORD

(SK295564)

Off the A6 from Belper to Matlock — Cromford Railway Station

Few people who journey through Cromford realise that it was the first purpose built industrial village and that it encompasses the site of the world's first successful water-powered cotton mill. From Cromford its revolutionary methods spread across the rest of the world.

Its creator, Richard Arkwright, the semi-literate son of a Lancashire tailor, rose from obscurity to become the first commoner ever to be knighted for his contribution to the industry. As a result of his achievements, Britain was transformed, from an almost self-sufficient country with an economy based on agriculture and cottage industries, into the workshop of the world. The importance of Cromford and the stretch of the Derwent Valley from Masson Mill to the Silk Mill at Derby was recognised in 2001, when it was awarded World Heritage Status.

Cromford was nothing more than a tiny hamlet when Arkwright arrived in 1771. He had to attract workers and to do this he built most of the village, much as we know it today. With the houses he built all the facilities which were necessary to village life in those days, even setting up a market. It is a village of contrasts, with its lower half resting by the gently flowing River Derwent and the upper climbing steeply up Cromford Hill to Black Rocks, where there are outstanding views. Majestic as the scenery undoubtedly is, it is not that which attracts visitors from all over the world to Cromford, but to examine the area where Arkwright built his cotton mills.

The village has some of the best examples of industrial housing in Britain, standing as an international monument to the Industrial Revolution. The three storeyed houses in North Street are among the finest examples of Industrial Archaeology to be found anywhere. Cromford's ancient buildings are now protected by a Conservation Order, which encourages enhancement and repair. In the market place, the Greyhound Hotel, built by Arkwright, has been renovated recently and is surrounded by an interesting collection

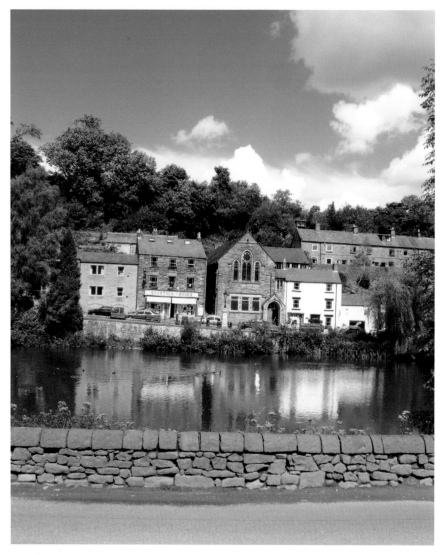

Scarthin

of shops. The intriguingly named Mystical Crystals is the leading supplier of natural crystals and minerals in the area.

At the rear of the Greyhound is a large mill pond, which together with a series of ponds along the Bonsall brook, was built to ensure a constant head of water for the wheels of the mills to drive the machinery. Overlooking the pond, and reached by a narrow one way road from the market place, is the old mining settlement of Scarthin. At the bookshop you can reputedly buy a book 24 hours per day and get a cup of coffee and a meal during more normal hours.

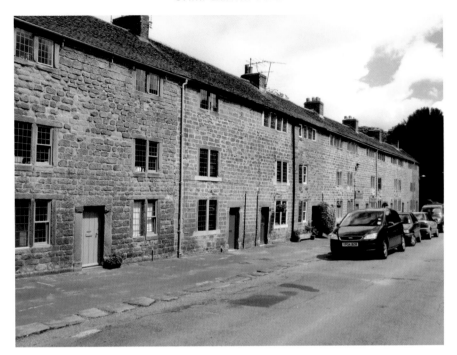

North Street

On the other side of the village, Cromford station is a splendid piece of railway architecture. The line from Derby to Matlock is considered to be one of the finest in the country. Further along the road, the bridge over the River Derwent is one of the oldest in England. Alongside are the remains of a bridge chapel and a fishing temple. The temple is built to the same design as the one in Beresford Dale frequented by Charles Cotton and Izaak Walton. St Mary's Church contains the tomb of Sir Richard Arkwright. Above stands impressive Willersley Castle, built by Sir Richard, but he died before it was fully completed.

The construction of Cromford Canal was completed in late 1794 to improve the speed of movement of heavy goods in and out of Cromford. Although it was opened after the death of Sir Richard Arkwright, he was a prime mover in the decision to construct the canal. It linked up with the Erewash Canal at Langley Mill, which ran into the River Trent.

Built in two gauges, the canal ran from Langley Mill to the eastern end of the Butterley Tunnel in broad gauge, with fourteen locks. From this point a narrow gauge system took over and there were no locks. The situation was further complicated by the fact that the Butterley Tunnel, 3,000 yards in length, did not have a towpath.

The canal soon became very busy, as apart from the benefits it brought to Arkwright's Cromford Mills, thousands of tonnes of stone were shipped all

Masson Mill

over the country from Cromford Wharf. Lead was taken the much shorter distance to the smelter at Lea, using the Nightingale Arm of the canal, a short branch line built by Florence Nightingale's uncle. One of the most unusual of shipments was two stone lions, which having been sculptured at Darley Dale were taken by canal to Liverpool, where they can still be seen standing by the entrance to St George's Hall.

The arrival of the railway era in the mid 1800s, gradually took most of the business away from the canal. Then disaster struck at the turn of the twentieth century with the collapse of the Butterley Tunnel, which was never rebuilt. However, the canal continued to be used on both sides, carrying mainly coal and limestone, until in 1944, it was finally abandoned as a commercial waterway.

Today, the section of the canal from Cromford to Ambergate has been developed for recreational purposes. It is very rich with wildlife and has been designated a Site of Special Scientific Interest, with the southern end from Ambergate to Whatstandwell being managed as a local nature reserve by Derbyshire Wildlife Trust.

Originally, it had been the intention to construct a canal to connect Cromford Canal with the Peak Forest Canal, but difficulties in ensuring an adequate water supply on the moors led to the scheme being dropped. Instead, the Cromford and High Peak Railway was built, which was considered to be an engineering masterpiece and has attracted the interest of railway enthusiasts from all over the world.

The line linked High Peak Junction at 277 feet above sea level with Whaley Bridge at 570 feet. In the middle it rose to over a 1,000 feet at Ladmanlow. This involved steep inclines, up and down which wagons were hauled by steam driven winding engines. A stretch of the line from High Peak Junction to Dowlow near Buxton has been converted into the High Peak Trail for horse riders, cyclists and walkers.

EDENSOR

(SK250698)

*On the B6012 through Chatsworth Park, a few yard to the
west of the drive up to Chatsworth House*

The small estate village of Edensor, pronounced 'Ensor', is set in one of the most beautiful locations in the country in parkland owned by the Devonshire family, whose stately home at Chatsworth House is only five minutes walk away. Often referred to as 'The Palace of the Peak,' Chatsworth House was named Britain's Best Stately Home in *Period Living and Traditional Homes* magazine's Best of British Awards 2004-2005. Today, Chatsworth is one of the Treasure Houses of England with fine furniture, sculpture, tapestry, paintings and other works of art.

Edensor is mentioned in the Domesday Book, but since then the village has been re-sited. Originally it lay between the river and the road through the Park, when the houses were set out in a straggling line down to the Derwent. This did not appeal to the fourth Duke of Devonshire, who having spent considerable money and effort improving the House, redesigning the gardens and building a grand new bridge over the river, decided to take down those houses visible from the House. The tenants were re-housed in the nearby estate villages of Pilsley and Beeley. The sixth Duke completed the dismantling of the old village and built the present one.

There still remains one house and garden on the riverside of the road, surrounded by a stone wall. Spared it is believed, because the tenant, an elderly man, did not want to move and the duke in an act of kindness allowed him to stay. Under the brow of the hill it was not visible from the House.

Joseph Paxton, who remodelled and landscaped the gardens at Chatsworth, chose the site for the new village, but it was John Robertson a relatively unknown architect from Derby who provided the designs. At that time aspiring young architects such as Robertson would prepare a book of house plans as part of their training.

It is thought that Robertson approached the Duke to show him the plans when he was busy with other matters and that after quickly looking through them he could not make up his mind and chose all the different styles in the

book. The designs ranging from Norman to Jacobean, Swiss-style to Italian villas are all here at Edensor. A few of the old houses remained virtually untouched, including parts of the old vicarage, two cottages overlooking the green and the old farmhouse which now houses the shop and tea rooms.

Robertson retained the fourteenth-century church, but only about thirty years after the completion of the model village it was replaced by a much larger one built by George Gilbert Scott. The new church with its graceful spire and spacious layout added to the status and importance of the village. A more recent addition that helps make the village more complete is the green, added in 1948 after the demolition of the school.

St Peter's Church contains one of the finest monuments in the county. This commemorates Henry and William Cavendish, the sons of Bess of Hardwick, the latter son being the First Earl. In the chancel is a brass plaque which records the death of John Beaton, the loyal servant of Mary, Queen of Scots, who was imprisoned at Chatsworth House during part of her period in captivity. Also in the church, in a glass case, is a wreath of everlasting flowers sent by Queen Victoria to the funeral of Lord Frederick Cavendish, tragically killed in Ireland while on a peace mission. Joseph Paxton is buried in the churchyard in a grave of much grander scale than that of his master, the sixth Duke.

Looking towards St Peter's Church

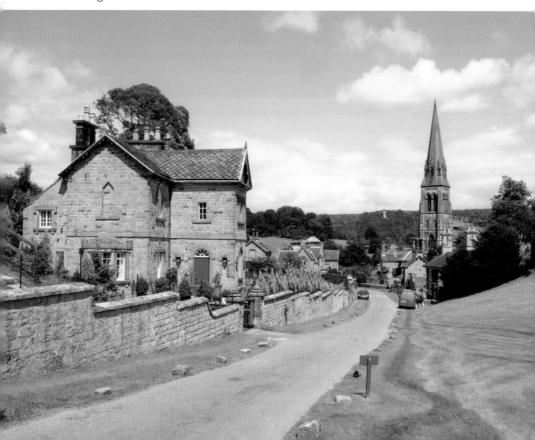

At the top of the churchyard is the grave of Kathleen Kennedy, the sister of the late President of the USA. She was the wife of the Duke's elder brother and heir to the Dukedom who was tragically killed in Belgium during the last war. Only four years later his wife was killed in an air crash.

In June, 1963, John F. Kennedy, the President of the United States visited the grave — five months before being assassinated — on the way by helicopter to a meeting with the Prime Minister. This event is recalled by the Duchess of Devonshire in her book, *The House: a Portrait of Chatsworth*, when she describes the reaction of one resident of the village, 'The wind from that machine blew my chickens away, and I haven't seen them since.'

The architect, Sir Jeffery Wyatville, was employed in designing the two gate lodges to mark the entrance to the park, one an Italianate villa, the other in complete contrast, an English Lodge. Through the park gates the lane into the village forks, Edensor Lane bearing right and Japp Lane to the left. The old coach house and stables near the estate entrance have been converted into comfortable flats for retired employees.

Edensor House, occupied for a time by the former Duke and Duchess, has been used to entertain royalty. Outside the park gates the handsome brick building was formerly an inn to serve travellers. This inn later became

House on Edensor Lane

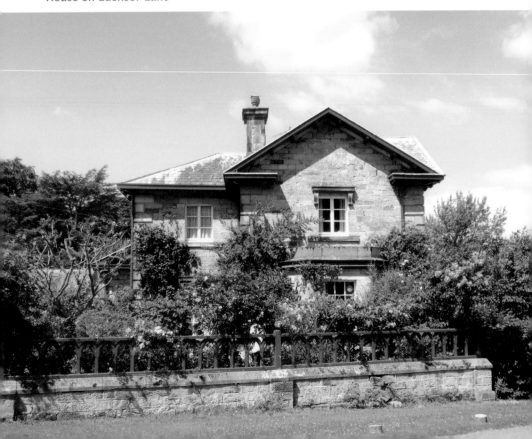

The gravestone of Kathleen Kennedy, sister of the late President of the USA

Chatsworth Institute and is now occupied by Chatsworth Estate Offices; in front is a bowling green and to the side a golf course. Villagers had to be content with a makeshift alehouse in one of the cottages; the cottage still exists, as do the iron staples from where the inn sign hung.

The 1,000 acre park is mostly open to the public free of charge throughout the year; not surprisingly it is a magnate for walkers. Sheep and cattle graze the rich pastureland, together with a large herd of deer which can usually be seen as you walk through the park. The road that winds its way through the park provides a magnificent view of Chatsworth House. Here you look across the River Derwent to the west and south front, with its neat lawns sloping up the bank to the woods that provide a superb backcloth. Unfortunately, it is only a fleeting view as vehicles are not allowed to stop on the road to allow their occupants to enjoy the view for longer.

ELTON

(SK223609)

Off the B5056 a linking road between A515
— Ashbourne and A6 — Bakewell

Elton is an unspoilt village, very popular with walkers and cyclists, who enjoy the beautiful countryside. There are also a few surprises nearby, with a hermit's cave and a very strange rock formation where Druids may once have worshipped.

Almost every reference about Elton mentions, at an early stage, that it is a cold place. This might seem a little unfair for somewhere close to the southern edge of the Peak District. But on closer examination, it becomes clear that the village, at an altitude of 900 feet, does not have any protection from the cold north and east winds. Even Alf Gregory, a former resident who was the photographer on the successful Mount Everest expedition in 1953, said it was 'a cold place' and like living 'on the top of a mountain'. The cottage where he lived for 21 years is identified by a small nameplate.

This must raise the inevitable question as to why the village was built in such an exposed position. The close proximity to the Portway, replaced in 1811 by a turnpike road, was the main road running from north to south through the area. In addition, the fact that lead was in plentiful supply, as was water, were probably the major factors behind the location of the village. The land was also suitable for sheep rearing to provide the lead miners with an additional income.

Elton's bracing climate seems to suit the inhabitants, many of whom have lived to a considerable age. Few including those who were not born in the village have moved away. There is a good community spirit and the people are warm and friendly. This was recognised in 2008, when Elton won the Communications category for the East England region of the Calor Village of the Year Award. The judges described the village as follows, 'Despite its small size, Elton has an extremely positive outlook and, while traditions run deep in this community, it is by no means content to rest on its laurels'. They also went on to say, 'Residents in Elton really know how to enjoy themselves, with

Elton Café

an impressive range of groups and activities on offer to satisfy the needs and interests of everyone in the community, from the very youngest villagers to the oldest.'

In the past after an appreciable fall of snow the villagers often added the additional sport of skiing to their repertoire. A drag lift was erected in the adjoining fields, but climate changes have meant that less snow has fallen in recent years, rather curtailing this activity.

The village is set on a division in the underlying rocks that runs along the main street. Limestone is on the north side and gritstone on the south. This produces an unusual effect with gritstone vegetation on one side and limestone on the other. The houses too reflect the division, with some built of gritstone and others limestone, or a mixture of both.

All Saints Church was built in 1811 and replaced an earlier church dedicated to St Margaret after its steeple had fallen a few years earlier. Illegal lead mining underneath the church caused the damage. Another misfortune befell the church when it was re-built; the font was thrown out and left to decay. Several years later it was removed by the vicar of Youlgreave and used as an ornamental water butt. His successor, aware of the value of the font, had

Elton Village Hall

it installed in Youlgreave Church. After realising their mistake, the people of Elton tried to get it returned, but without success and had to make do with a replica.

There is plenty of evidence in the fields of where the lead miners used to operate. On the eastern side of the village close to the Old Portway, now Dudwood Lane was the Portway Mine. This was the largest mine in the area, along with the Elton Cross a short distance further away to the north.

The Hermit's Cave at Cratcliffe Rocks, where under an overhang of rock a carved crucifix remains, was at one time home to a hermit. In the Middle Ages, hermits were looked on as holy men. Appointed to lonely places by a bishop, they rendered hospitality and assistance to travellers.

Behind Harthill Moor Farm is a perfect little Iron Age Fort, Castle Ring, possibly dating back over 300 years BC. At night, when the moon is full, fairies are supposed to emerge for music and dancing. The four great standing stones, near the Hermit's Cave, date back even further to over 1,000 years BC.

There are no shops in the village, but there is a pub and café. The Duke of York is an old-fashioned pub, but the welcome is warm as is the blazing coal fire in the lounge on a cold night. Apart from good food, nostalgia is on the menu at the Elton Café, with its large collection of advertising signs and memorabilia inside and an attractive old force pump outside. The café is now only open on Sundays.

Elton holds strong Nonconformist traditions, but only the Primitive Methodist Chapel remains open. The old Wesleyan Methodist Chapel is now the Village Hall and the former Wesleyan Ebenezer Chapel a private house.

Along the main street, there are a number of seventeenth-century stone houses. The oldest is The Old Hall, which for many years acted as a Youth Hostel before being put up for sale in 2002, but still offers accommodation. It is built of gritstone, part of which dates back to 1688. By contrast across the road, Greenacres Farm, is built of pure limestone.

The school stands on the south side of the main street. It was extended when the population increased in 1890. During Jubilee year, 1977, the villagers got together and raised the money to buy a field for sport and recreation for the young and not so young!

At the bottom of the hill on the western side of the village is the tiny hamlet of Gratton, which at one time was the home of a cheese factory operated by a consortium of local farmers. From there a narrow road leads to Middleton-by-Youlgreave.

MATLOCK

(SK300605)

On the A6 Derby to Buxton road — Matlock /Matlock Bath
Railway Stations

Scenically Matlock, or 'The Matlocks' as they should more correctly be called, is the most attractive town in Derbyshire. Much of it lies in a deep gorge with dramatic scenery in all directions, along which rushes the busy A6 with the River Derwent never far away. The railway is left to tunnel through the sheer limestone cliffs. Originally a string of small settlements, it is Matlock Bath that attracts most visitors.

It is a busy little place well stocked with gift shops, cafés and amusements. But its spectacular views are what are most admired, as anyone who has gazed at the view from a good vantage point on either side of the narrow gorge can confirm. It is a popular haunt for serious rock-climbers who test their ability against the sheer rock face of High Tor. A much easier way to climb is to take the cable car up to the Heights of Abraham, named after General Wolfe's famous assault on Quebec.

The fascinating Peak District Mining Museum is housed in The Pavilion and up on the hillside is the popular Guilliver's Kingdom, where children and their parents can spend many a happy hour in delightful wooded surroundings. The old Matlock Bath hydro now plays host to an Aquarium. Derwent Gardens are a great place to relax and there are lovely riverside walks to enjoy. But the highlights of the year are the Illuminations and Venetian Nights, when decorated boats amid a myriad of bright lights, ply their way slowly up and down the river.

It was not until the discovery of medicinal springs in Matlock Bath at the end of the seventeenth century that much attention was paid to the area. Matlock Bath gradually became fashionable with the wealthy in the eighteenth century, but its development was limited by its somewhat inaccessible location.

The arrival of the railway in 1849 with cheap fares changed its character, putting it within easy affordable reach for day-trippers who flocked there from Nottingham and Derby. The large crowds attracted touts, who hung

about the streets trying to persuade customers to see the sights and it was not long before the wealthy moved on in search of a more peaceful setting. Many of them only went the short distance to Matlock Bank, where John Smedley was just setting up his hydropathy. When in 1851 Ralph Davis opened a small hydropathy on Matlock Bank, Smedley acted as his medical adviser.

In 1853 he bought the business from Davis and immediately started to expand. He built the Hydro, commonly known as Smedley's Hydro, to his own design, which soon catered for more than 2,000 patrons per year. Victorian times were full of rich people prepared to pay two guineas a week to live austerely in gracious surroundings.

The treatment prescribed consisted of regular applications of water, by wet sheets, sponges, bath or douches. Diet was carefully controlled and alcohol and tobacco were forbidden. Exercise was carefully monitored to ensure over fatigue was not caused on long walks and other strenuous exercises.

Smedley died in 1874, but the business continued to prosper, as did a number of other similar establishments on Matlock Bank. As the number of visitors increased so did the demand for shops and services and Matlock Bridge became quite a lively shopping centre. Hydropathy continued to flourish and the town to grow until the First World War, but after that the number of

Matlock Bath

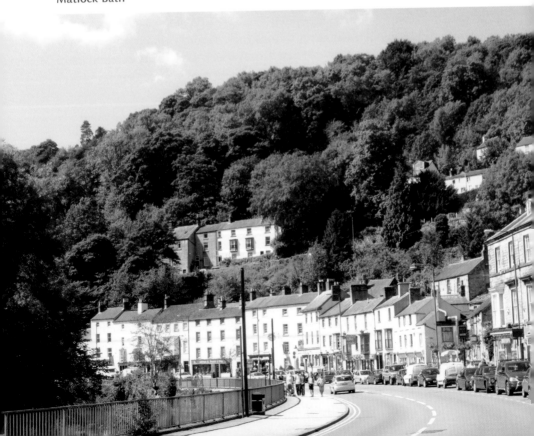

hydropathic establishments began to close. Smedley's Hydro is now the home of Derbyshire County Council.

The development of Matlock owed much to the fact that it was on the main railway line between London and Manchester. This came to an end in 1967, when the line north of the town was closed. Matlock though is famous for another line — a cable tramway line claimed to have the steepest gradient in the world for a public road at one in five and a half. It opened in 1893 and ran for nearly a mile from Crown Square up Bank Street to the top of Rutland Street. Job Smith, who was the owner of Malvern House Hydro on Smedley Street, was instrumental in bringing the tramway to Matlock. He had seen the steep tramway in San Francisco in operation and thought something similar would be ideal for Matlock, conveying visitors back and forth from the town centre.

Finance was raised principally through Sir George Newnes, who published *Tit Bits* and other magazines. When the company ran into financial difficulties, he bought the tramway and gave it to the town. It continued to carry passengers' uphill for two pence, and down for one penny until mounting costs caused it to close in 1927. The tram shelter from Crown Square has been re-located into Hall Leys Park, and the tram house still stands at the top of

Hall Leys Gardens

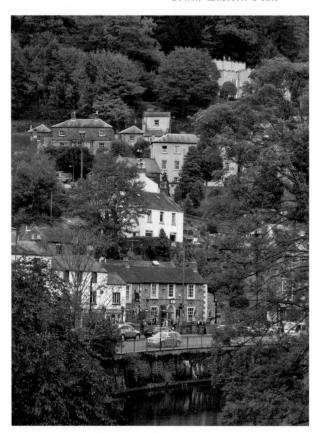

**Matlock Bath and the
River Derwent**

Rutland Street. Many must be the time in recent years, when toiling up Bank Street; people have wished the tramway still operated.

Matlock Bridge is the area where most of the shops are situated. The bridge itself started life as a packhorse crossing to replace the ford. Dale Road was once considered one of the most elegant shopping streets in the East Midlands. To the rear are pleasant riverside walks and Hall Leys Park where excellent recreational facilities for young and old are available.

At the head of the park is the ornate tram shelter; there is also a refreshment room and bandstand. From here are excellent views of the ruins of Riber Castle, built and lived in by John Smedley until his death. It was bought in 1962, by a group of zoologists who created a sixty-acre fauna reserve and rare breeds centre. Unfortunately, it closed in 2000.

The original settlement of Old Matlock sits on the hillside to the east of the Derwent. There has been a church here since the twelfth century, and a tablet in St Giles Church recalls a remarkable union between Adam and Grace Woolley, whose marriage lasted for nearly seventy-six years — surely a record for those days. At Matlock Green on the A515, a fortnightly cattle market used to be held, dating back to 1880.

OVER HADDON

(SK204664)

Off the B5055 Bakewell to Monyash road

Over Haddon sits perched on a ledge with glorious views over Lathkill Dale, one of the most beautiful dales in England, and the first to be designated as a National Nature Reserve in Derbyshire. The river, one of the purest in the country, rises in a cave near the top of the dale and sometimes disappears underground in its upper reaches before widening out below Over Haddon. It is for the sheer magnificence of the scenery, the wonderful walks and the natural beauty of its wildlife that visitors come to the village in droves at weekends and during the summer.

Archdeacon Noakes of Derby described Over Haddon as 'the most beautiful village in Derbyshire.' Many other villages will dispute that assertion, but it is Over Haddon's stunningly, beautiful location that sets it apart from the others. Charles Cotton, a friend of Izaak Walton, who wrote the best selling book *The Compleat Angler*, said of Lathkill Dale, 'It is by many degrees the purest and most transparent stream that I ever yet saw, either at home or abroad, and breeds it is said the reddest and the best trout in England.'

The reason for visitors flocking to the village in 1854 was quite different — a mini-Klondike Gold Rush took place, when gold was found in one of the lead mines. News spread fast and soon the little village was besieged with bounty hunters. A company was set up and hundreds of people invested money in the hope of a rich return; there was even talk of building a railway branch line to Bakewell. Unfortunately, the gold was so deep and in such small quantities that the venture proved unprofitable. The company was closed down and the investors lost all their money.

One commodity that was not in such short supply was lead, and there is evidence as far back as the Romans, of lead mining in Lathkill Dale. The Mandale Mine was one of the earliest recorded in Derbyshire. It became famous for producing large quantities of lead at prices that put some other mines in the dale out of business.

In 1825, Lathkill Dale Mine was reopened by John Alsop and Thomas

Bateman. They installed a revolutionary pumping engine that had been designed to pump water from the continuously flooding mine. It was installed underneath Bateman's House, in order to keep it hidden from prying eyes. Unfortunately the water eventually won the battle and they were unable to solve the flooding problem despite the new pump. Eleven years later the pair launched an even more ambitious plan, which saw the water discharged through Lathkill Sough, but despite all their efforts the mine only remained operational for a few years and work ceased altogether in 1842.

At that time, the pretty Lathkil Hotel (one 'l') with its outstanding view of the dale was called the Miner's Arms, where no doubt most of the lead miners invested their hard-earned money. Farming also was another very important industry, the rich pastureland around Over Haddon having been farmed since Neolithic times. During the Middle Ages, several Granges were established in the area where the monks farmed huge flocks of sheep, primarily for their valuable wool.

The Sundial on the south wall of the church of St Anne is a memorial to Janet Wadsworth, simply entitled 'Janet', whose grave lies a few feet away. The beautifully incised and gilded memorial on Welsh slate is the work of David Kindersley and associates and was presented to the church by her many

Footpath by the Lathkil Hotel

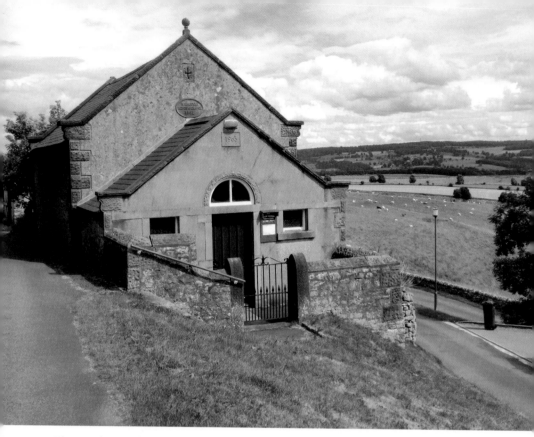

The Wesleyan Chapel

friends. David Kindersley is one of Britain's best known craftsmen, whose work can be seen in America and other parts of the world. Janet, the daughter of A. P. Wadsworth, the former editor of the *Manchester Guardian* played an important role in local affairs as well as being a regular worshipper at the church. In her working life, she was Education Officer for Granada Television and her job involved travelling around the country, but she never forgot her church and the village of Over Haddon.

Over Haddon seems an unlikely birthplace for a former head of MI6, a position Maurice Oldfield rose to when he was appointed Director of the Secret Intelligence Service, in 1973, by Edward Heath. He joined the army in 1939, volunteered for the Intelligence Corps and was posted to the Middle East, ending the war as a Lieutenant Colonel. After the war, he was awarded an MBE and joined the Foreign Office, where he gradually worked his way up to the top of the ladder. He was knighted in 1975, died six years later and is buried with his parents in the village churchyard.

Martha Taylor, who lived in a little cottage in Over Haddon, achieved fame as the 'Fasting Damsel'. Doctors of both medicine and theology made long journeys to visit her while she fasted. The longer the fast lasted the more she

was talked and written about — some accused her of being a fake, but could produce no evidence despite the fact that she was watched night and day. Martha survived her fast and all the interest it had created, dying a few years later, in 1684.

The Wesleyan Chapel was built in 1861, a few years before the church; the Village Hall came much later after a long wait and now plays an important part in community life as well as being available for hire for private events. The biggest event of the year is the village show held every September, when garden products, cookery, wine and handicrafts are all judged on a points system, the overall highest scorer being awarded the Joseph Oldfield Cup.

The former craft centre and café are sadly missed since their closure, replaced with cottages mainly to be used as second homes and for holiday accommodation. English Nature has also left and Manor Barn is no longer the home of the Exhibition Centre. There is a highly regarded Farm Butcher's Shop at New Close Farm, and at the junction of Main Street and Monyash Road is Haddon House Riding School.

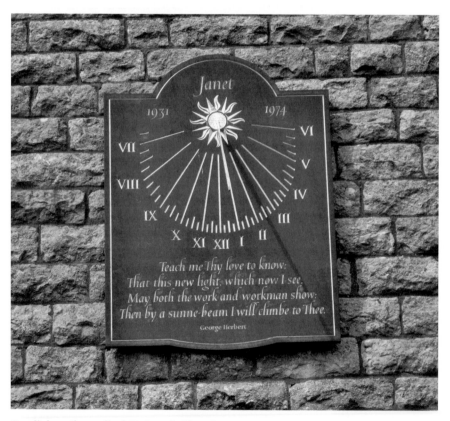

Sundial on the wall of St Anne's Church

PILSLEY

(SK240710)

On the B6012 through Chatsworth Park,
to the west of Chatsworth House

Most visitors to Pilsley visit the highly popular Chatsworth Farm Shop and hardly cast a passing glance at the village on the opposite side of the road. Those that do, find a pretty, unspoilt village with magnificent views over the Derwent Valley, its limestone cottages enriched during the summer by gardens full of colour. It lies about one mile east of Chatsworth House, and with Edensor and Beeley makes up the three Chatsworth Estate villages. They tend to share facilities; Pilsley has the school and a pub, Edensor a church and institute and Beeley a church and a pub. Both pubs are called the Devonshire Arms, which can cause confusion at times.

Chatsworth Farm Shop has been so successful that further expansion of the Farm Shop has taken place in the last few years, including an enlargement of the restaurant facilities. It occupies what was the Stud Farm, which was built in 1910 by the ninth Duke of Devonshire to house the stallions for breeding the Shire Horses that worked on the estate.

By the 1940s, tractors had replaced the horses, but before long animals once again held sway. A herd of pedigree Jersey cattle was moved in and a milking parlour set up. In 1977, a further transformation took place when the Duchess of Devonshire opened The Farm Shop in the former Tack Room, selling beef and lamb from the estate. As the shop has become more successful, it has expanded to include a whole range of products and other shops and a café were created in the courtyard. A further major refurbishment took place in the early years of the twenty-first century.

There are two Pilsleys in Derbyshire, the former mining village near to Clay Cross in North East Derbyshire and the Chatsworth Estate Village, so visitors using their satellite navigation systems to guide them, need to be careful not to end up at the wrong place. On arriving they will find it most rewarding to visit both the busy farm shop and to take a peaceful perambulation of the village.

Childrens' Well Dressing on Duck Row

In 1839, Paxton built the village school, which at first site appears surprisingly large for such a small place, but it was enlarged to accommodate more children when the village school at Beeley closed down. Paxton also built some of the other houses in the village, but not the group near to the Devonshire Arms that were erected more than a century earlier.

Many of the houses round the green were constructed during the period when the sixth Duke of Devonshire was knocking down and rebuilding Edensor, so that it was no longer in sight of Chatsworth House. The inhabitants were found temporary accommodation at Pilsley and Beeley.

At the time the Trustees of the Chatsworth Estate were looking for accommodation for eight employees of the estate. They selected a parcel of land on the west side of the village, where there were some derelict buildings. By using this site, they not only maintained the compactness of the village, but also took the opportunity to enclose the end of the green, thus improving its appearance. In order that the cottages would harmonise with the rest of the village they were built in two blocks of four.

The High Street climbs up gently from the Devonshire Arms, before suddenly and quite surprisingly it comes to an end by the accurately named Top House. It is replaced by a rough cart track and further on it divides into three pathways. The one going straight on is of the most historical significance, as this was the

The Devonshire Arms public house

route used by packhorses carrying lead from Monyash bound for the North Sea. In those days Pilsley was a stopping point, where the packhorses were changed for fresh animals for the next section of the journey. The view over the Derwent Valley from the trackway is particularly impressive.

Almost all Pilsley's population either works on, or used to work on the Chatsworth Estate — or holds a connection with the estate through a partner. The inhabitants have a wide range of skills as they have had the task of maintaining Chatsworth House and Gardens over the last 400 years.

One craftsmen, an upholsterer, set up business in the village and when he outgrew his premises, the estate knocked down an old barn and built a new one, calling it Broome's Barn after the tenant farmer who had farmed the land. The business still exists under the name of Penrose Sofa Company and although the manufacturing now takes place in Sheffield, the excellently presented showrooms remain in the village — hidden away discreetly behind the village public house.

The Devonshire Arms is a long narrow building with four distinctive gables and tall chimneys, set in the old part of the village. It faces up the main street into Pilsley and is of particularly pleasing appearance as it blends in perfectly with the street scene. A traditional country pub, it was built about 300 years ago, and is popular with local people and visitors alike.

A Pilsley cottage garden

Further up the street is the village post office and shop, the income from which is supplemented by the running of a bed and breakfast business, with the full approval of the Duke of Devonshire. The old chapel has been put to a variety of uses since services were discontinued, including acting as a Village Hall and school canteen.

Although it shares many social events with its neighbours, in mid July, Pilsley holds its own carnival and Well Dressings. Originally, Well Dressings were first started in the village in 1849, but were suspended by the Duke of Devonshire after a fight broke out between the men of the village and a gang of youths from Baslow. After a gap of about fifty years, the village's Well Dressings were revived in 1968. A rather unusual tradition is maintained by the young people of the village, who dress a board in the form of a windmill, which is placed on the small green facing Duck Row.

ROWSLEY

(SK256659)

On the A6 Matlock to Bakewell road

The village of Rowsley stands at the junction of two valleys of the Rivers Derwent and Wye, with wooded hills on either side. It was the beauty of its setting in the nineteenth century which attracted artists, poets and anglers. Though the wonderful scenery remains relatively unspoilt and still attracts scores of visitors, a new attraction has arrived in recent years. The stylish Peak Village Shopping Complex, which successfully blends into the landscape, draws visitors to the village who both want to shop and enjoy the lovely setting in which it stands.

There are two Rowsleys, not surprisingly called Great and Little, but perhaps more unexpectedly it is the latter that has the larger population. Little Rowsley on the eastern side of the River Derwent was in Bakewell Rural District Council, and Greater Rowsley on the other side was in Darley and Matlock Urban District Council. Now they are united as one parish in Derbyshire Dales. Greater Rowsley is much the older part of the village and has a number of handsome buildings. The arrival of the railway in 1849 brought about the development of Little Rowsley.

Paxton built an impressive Italianate Railway Station along with four stone cottages to house railway workers. The Station Hotel, now renamed the Grouse and Claret, was built nearby and everything was ready to extend the line through the valley. Unfortunately, there was a problem. The Duke of Devonshire was adamant that he would not allow the line across Chatsworth Park. If that was not bad enough, the Duke of Rutland also refused an alternative plan for the railway to run across his estate at Haddon. All the railway company could do at the time was to run trains between Rowsley and Ambergate.

The problem was solved when the Duke of Rutland agreed to the plans of the Midland Railway to build a track out of sight, in a cutting behind Haddon Hall. A new station was built a quarter of a mile south and instead of the line running up the Derwent Valley, it ran along the Wye Valley. Paxton's splendid

Paxton's old railway station

station was left isolated in the wrong valley. It was not until 1867 that the line finally reached Manchester.

Rowsley Station though was very popular with tourists and welcomed hundreds of visitors bound for Chatsworth. They usually completed their journeys by horse drawn carriage. Along Chatsworth Road are the Midland Cottages, where the railway workers lived, and the Methodist Chapel of 1910.

In 1967, when Dr Beeching closed the line, the extensive marshalling yard and locomotive shed were no longer required and Rowsley lost a major employer. For a few years, the yard was used by an engineering business. Transformation then took place into the Peak District's first and only Factory Outlet Shopping Centre. The complex also includes the popular tourist attraction 'Toys of Yesteryear', where many rare and unique exhibits are featured that will interest all the family. You can even have your picture taken with a life size model of Chitty Chitty Bang Bang.

Following the actions of a band of determined enthusiasts, who formed the Peak Railway Society, trains recommenced running from Matlock to Darley Dale Station in 1991. Six years later the line was extended to Rowsley South

The Peacock Hotel

Station. A journey on the train is an ideal way to see the best of the valley and beat the traffic jams and you can even extend your journey further. Indeed, only a short walk away from the Peak Railway Station at Matlock you can travel by rail from Matlock Station to London.

A mill has stood in the village since at least the sixteenth century. The latest, Caudwell's Mill, was founded in 1874 and continued to operate for

The Peak Well

104 years. When it closed a group of enthusiasts got together to save what was the only complete Victorian water turbine — powered roller mill in the country. They had a fight on their hands, as according to the Millers' Manual Association, milling machinery no longer needed must be destroyed to prevent re-use. After a lot of persuasive talk, agreement was reached to waive the ancient right and allow a small amount of flour to be produced and the mill used for exhibition purposes.

There is a busy Craft Centre at Caudwell's Mill, an excellent café, and well-stocked gift shop and picture gallery. There is also the shop on the ground floor of the mill, where flour may be purchased. But, if you just want to relax you can stand on the wooden footbridge and watch the ducks on the millpond, in idyllic surroundings.

The Duke of Rutland was Lord of the Manor of Rowsley and many of the properties are still in the family name. He built the school and teacher's house in 1840, and the church 14 years later. The Rutlands built the row of cottages in Wye Terrace for the workers at Caudwell Mill. There was a good supply of high quality building stone available from local quarries.

Almost certainly the best-known building in the village is the Peacock Hotel, with a stone peacock sitting above the door. It was built in 1652, in Jacobean style, by John Stevenson of Elton, agent to the Manners Family as a gentleman's residence. It later served as a farmhouse before it eventually became a hotel. In its time it has housed many famous residents including Royalty. The Peak Well opposite the hotel is the site of the main Well Dressing during the village festival that takes place on the last weekend of June each year. At the same time, down Church Lane, past the village shop and post office, the church holds a Flower Festival.

Rowsley Parish Church of St Katherine is relatively new and only dates from 1855; prior to that the inhabitants of the village had to use the churches at Bakewell or Beeley. Inside the church is the finally carved tomb of Lady Catherine Manners, the first wife of the 7th Duke of Rutland, who died shortly after it was built. The single bell came from Haddon Chapel. Two boys, while out swimming, discovered the Saxon Cross on the bed of the River Wye.

STANTON-IN-PEAK

(SK243643)

Off the B5056 a linking road between A515 — Ashbourne and A6 — Bakewell

Stanton-in-Peak is an attractive mainly gritstone built village, with fine views over the River Wye towards north Derbyshire. It is a little off the beaten track, about half a mile from the busy B5056, the road winding up the hillside to reach the edge of the village, marked by the high perimeter wall of Stanton Hall. The main street continues to wind its way steeply up the side of Stanton Moor, from where most of the stone used in construction of the village originated. The charm and character of the village may best be fully comprehended by a detailed exploration on foot, only then will Stanton be wholly appreciated. Its pretty little gardens, small courtyards, narrow alleyways and wonderful panoramic views reveal themselves for admiring inspection.

The village is very ancient, having been granted a Royal Charter in 968. Many of its houses date from the seventeenth and eighteenth centuries. The houses built in the early part of the nineteenth century, which carry the initials 'WPT', were built by William Pole Thornhill. The Thornhill family also built the tower on the eastern edge of Stanton Moor that bears the inscription 'Earl Grey 1832'. This commemorates Earl Grey's Reform Bill, which led eventually to every Englishman having the right to vote.

Stanton Hall hides behind a high wall along the village street, which runs alongside the road for about 300 yards. It was built early in the nineteenth century by Bache Thornhill to enclose a 130-acre deer park. The western side of the hall commands magnificent views. It was built in the late sixteenth century and was extensively re-built in 1693. A century later it was extended further by Bache Thornhill, although today it is reduced in size. For many generations, it was the home of the Thornhill family, who were responsible for the majority of buildings in the village.

The Parish Church of Holy Trinity was originally built by the Thornhill family in 1839, as a private church for their own use, but later that century became the parish church. It has a tall spire and, unusually, the nave lies from south to north. Inside there is a bronze Italian water stoup from the

workshop of Bellini. The church stands almost adjacent to Stanton Hall on the steeply climbing hillside, surrounded by immaculate green lawns and a well kept 'Garden of Remembrance'. Outside the church by the roadside is a pretty arbour with welcome benches on either side of the War Memorial for those toiling up the hill.

One of the earliest and the most unusual houses in the village is the three-storey Holly House, which stands facing the main street with eight of its fourteen windows remaining blocked to this day. Originally, the windows would have been blocked to avoid the dreaded window tax of 1697. Opposite is the award winning village pub with the strange sounding name of Flying Childers, which was converted from four cottages in the eighteenth century. It was named after a famous eighteenth-century racehorse owned by the fourth Duke of Devonshire and trained by Sir Hugh Childers. At the end of its racing days the Duke retired the horse to his stud at Chatsworth.

The reading room, now the Village Hall, was built by the Thornhill's, as was the 'The Stand'. Originally known as 'The Belvedere', it is a viewing platform with a stone seat, along the road to Rowsley. From here you get a magnificent panoramic view over the beautiful valley where the River Bradford joins the Wye at Fillyford Bridge. On the southern edge of the village, the well

View of the village

maintained local cricket ground on its sloping site must have one of the prettiest views for any cricket pitch in the country. It is a real pleasure for visiting teams to play in such a lovely location and might even make losing that little bit more bearable!

Towering above the village is Stanton Moor, which rises to 1,096 feet above sea level, and offers genuine moorland terrain. It is an isolated gritstone outcrop in the heart of limestone country and one of the richest prehistoric sites in Derbyshire. Although it is relatively small in size, it has a feeling of isolation despite its close proximity to Stanton-in-Peak in the north and Birchover in the south.

On the edge of the moor there are superb views of the surrounding countryside and, on the bracken clad moor, several impressive boulders and reminders of the past. It is easy to reach from the Birchover to Stanton road and provides easy, level walking.

Last century, the Heathcote family, father and son excavated in excess of 70 burial mounds on the moor. Both were noted amateur antiquarians and between them they excavated the tumuli on Stanton Moor and built up a fascinating private museum in the old village post office at Birchover. When Percy Heathcote died, the collection was transferred to Sheffield West Park Museum.

Millbank Cottage

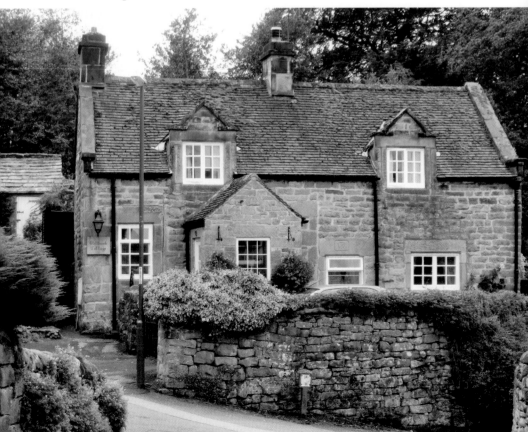

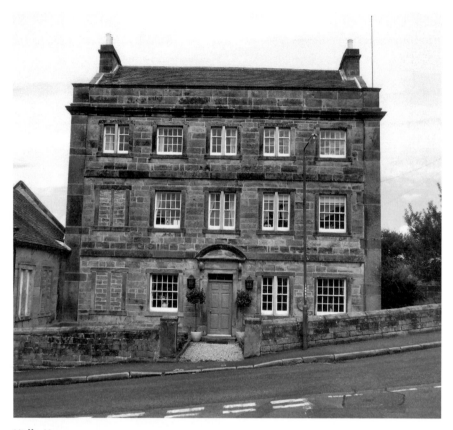

Holly House

The most famous of the Bronze Age relics on the moor are The Nine Ladies Stone Circle. The circle was probably the scene of Bronze Age ceremonies dating back to about 1,500 BC. But its name is based on the legend that nine ladies danced here on the Sabbath Day and were turned to stone as a punishment, along with the fiddler who stands nearby.

Stone quarrying has been an important industry in the area over a long period and provided employment for many Stanton people. Towards the end of the nineteenth century, out of a population of 717, 103 were quarry workers. The whole subject of quarrying in such a beautiful area has been a very contentious subject for a number of years.

The former village post office and general store is passed, now a private house, on the footpath to Congreave. This is where rabbits used to be kept for the Haddon Hall tables, the name Congreave meaning 'rabbit hole'. There are two other small hamlets in the parish, Pilhough and Stanton Lees. The former Methodist Chapel of 1829, used to stand near the top of the village, but is now closed.

WINSTER

(SK242603)

Off the B5056 a linking road between A515 — Ashbourne and A6 — Bakewell

Winster is a village that retains its eighteenth-century character, with over 60 listed buildings in its Conservation Area. The brightly painted houses, often with fascinating names, are set on the gently rising hillside alongside winding lanes and pathways. Little seems to have changed since the houses were built and in keeping with the village's traditional appearance many of its old customs have been retained.

Any newcomer to the area trying to make their way through the village on Shrove Tuesday might be rather surprised, and possibly a little startled, to see people young and old charging towards them, frying pan in hand, tossing pancakes. The Annual Shrove Tuesday Pancake Race has been in existence for over 100 years in the village.

Wakes Week, held in June every year is another tradition still followed in the village and gave rise to the amusing rhyme:

> *At Winster Wakes there's ale and cakes,*
> *At Elton Wakes there's quenchers,*
> *At Bircher Wakes there's knives and forks,*
> *At Wensley Wakes there's wenches*

Only Winster of the villages mentioned above retains so many of its old customs.

Morris Dancing is another longstanding tradition in the village; it takes place during Wakes Week, when the dancers perform the 'Winster Gallop' outside the Old Bowling Green public house. The great folk music pioneer, Cecil Sharp, first documented the dancing in the village early in the twentieth century. However, there have been some breaks in the custom, notably during wartime.

The Winster troupe is one of the oldest in the country and performs some of the most colourful dances. Morris Dancing is enjoyed not only by local

Looking down on the village

people, but also visitors from all over the world, and has been introduced to many other parts of the country. A team from the village were the first visitors to dance on the streets of Cambridge as well as many other places.

Winster is an ancient settlement mentioned in the Domesday Survey. But it was only when lead mining commenced in earnest that it came to prominence. At the height of the mining boom in the mid eighteenth century, it was considered to be the fourth largest town in the county with a population of around 2,000. There were a large number of alehouses and shops, but few survive today. The Miner's Standard public house on the western side of the village is a reminder of the past. A short distance further to the west runs the Portway, a very ancient highway that may date back before Roman times. By the side of the track, the remains of miners' huts are to be seen; the miners used to supplement their income by keeping milking cows.

The boom only lasted for about a century as the cost of draining the mines and competition from abroad reduced profitability — mines began to close and the population of the village declined. With little work in the village many of the men from Winster worked at the Mill Close Mine, near to Stanton-in-Peak, until disastrous flooding in 1938, ended mining.

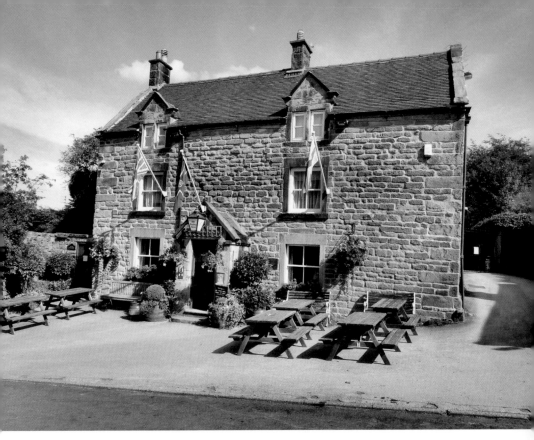

The Bowling Green public house

In the centre of the village, almost blocking the roadway, is the ancient Market House, now in the care of the National Trust. It was the first property acquired by the Trust in Derbyshire in 1906, and is now open to the public as an Information Centre. The base of the property is stone and the upper part brick built, but it was probably originally timber framed. Initially, the whole of the ground floor between the arches would have been open to allow trading to take place and only blocked up when business declined.

The former prosperity of Winster is evidenced by the fine three-storey houses that line the main street. Private houses have replaced most of the shops and businesses, but a shop and a post office remain. The grandest of the houses is Winster Hall. It was built for Francis Moore, who was a local solicitor and mine owner. Unfortunately, it has a sad tale to tell of the tragic love affair of the daughter of the house and the coachman. Her parents did not approve and arranged what they believed to be a more suitable match. However, before the wedding could take place the young couple climbed to the top of the parapet and jumped hand in hand to their deaths.

Situated on the western edge of the village is the Miner's Standard public house. The name is derived from the dish that local lead miners used for

measuring ore — the miner's standard. A small sign inside proclaims 'pub of the year 1653', the year that it was built. A short distance up the hill from the pub is the Ore House. Here lead miners deposited ore down a chute for safekeeping overnight, in a somewhat similar manner to the present bank night safe system. Nevertheless, despite its prosperity, Winster did have a Parish Poor House on Bank Top.

The Dower House, which currently provides accommodation, was probably built on the site of the original Manor House. It stands at the side of the Parish Church of St John the Baptist, where the nave and the chancel have been enlarged twice, the last time in 1883. Further up West Bank is the Burton Institute, refurbished a century ago by Joseph Burton as a Reading Room for the residents and now used as the Village Hall.

The Oddo House came into the possession of the Brittlebank family, in about 1700, but it was a later member of the family who brought notoriety to the name. A fatal duel was fought on the lawn of the Bank House, in 1821 between William Cuddie, the village doctor and the victor, William Brittlebank, who fled abroad to escape the consequences.

A cattle market was once held opposite the Bowling Green public house, which dates back to the fourteenth century, at East Bank. The Wesleyan Reform Chapel stands further up the gently rising bank. The Primitive Methodist Chapel is situated near to the top of the village and is approached by flights of steps on both sides. The busy, little village shop on Main Street is now run by the community.

Winster Market Hall

WIRKSWORTH

(SK286540)

The small market town of Wirksworth does not perhaps make much impact on the busy traveller driving through. All those visitors, however, with time to explore the narrow streets and maze of interesting alleyways, to admire the old buildings and lovely views, to visit the ancient church and the cathedral-like close, will soon find themselves falling in love with this fascinating old town. Standing as it does virtually at the centre of Derbyshire, about two miles to the south of the Peak District National Park boundary, Wirksworth was the centre of the English lead mining industry when it was at its height.

Lead was the basis of Wirksworth's past prosperity and lead mining in the area goes back to at least Roman times. The Barmote Court was set up in 1288 to enforce lead mining laws, which it was said even at that time were of great antiquity. It is almost certainly the oldest industrial court in Britain, and possibly in the world; it still sits twice a year at Moot Hall in Chapel Lane.

Between 1600 and 1780 lead mining reached a peak, before finally declining during the latter part of the nineteenth century. When miners were forced deeper and deeper for the ore, flooding problems became even more severe and made extraction uneconomic. The discovery of rich deposits of easily accessible lead ore at Broken Hill in Australia forced prices down even further, resulting in the closure of many mines.

As lead mining declined, the limestone quarries provided work for people who lived in the area. The arrival of the railway in Wirksworth, in 1867, which linked the town with Derby and the rapidly expanding railway network beyond, opened the way for the easy distribution of limestone which was in great demand. The situation was improved still further twelve years later when a railway tunnel was built below the town centre linking Dale Quarry, known locally as the 'Big Hole' with the station.

The great upheaval came in 1925-26 with the re-opening of Dale Quarry, when mechanisation was introduced and a stone crusher installed in a hole between 200 and 300 feet deep. Inevitably the whole of this densely populated

Looking over Wirksworth

area declined and the town was badly affected by dust, dirt and noise. Many of the people who could afford to do so reluctantly left, along with business and commerce. Buildings fell into disrepair, frequently being left empty to decay, and what had been one of Derbyshire's most important towns was left blighted, with the residents who remained, in despair that improvements would ever take place.

Help was at hand when Derbyshire Historic Buildings Trust discovered an anonymous charity, which after a lengthy process of selection and negotiation chose Wirksworth for financial support. In November 1978, a public meeting was called at Wirksworth Town Hall to discuss the proposals for the regeneration of the town. The meeting was overwhelmingly in favour of the proposals and the Wirksworth Project was launched.

At first progress was slow, but after what seemed almost insurmountable problems were overcome, the realisation of the dramatic progress that had been made became fully apparent when national and international recognition was achieved. In June 1983, Wirksworth was presented with the prestigious Europa Nostra Award for architectural conservation.

This was the only award made to a United Kingdom project at that time. It was given for its 'exemplary regeneration of a small county town, through

The Market Place

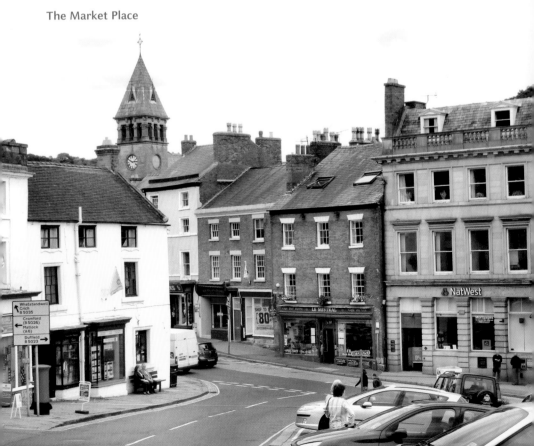

a broad programme of self-help and innovative features'. Praise came from many other quarters and HRH Prince Charles referred to the project as 'brilliantly imaginative'.

The Heritage Centre is housed in what once was a Silk and Velvet Mill where the 'Wirksworth Story' is explained on three floors. This takes you on a fascinating journey through time from pre-historic days, when the bones of a Woolly Rhino were found, through the lead mining era to the present day. Excellent views over the town are obtained from the windows.

The Parish Church of St Mary the Virgin stands on a site at the junction of at least five ancient trackways. It was one of the first centres of Christian teaching and may well have been built on the site of a prehistoric stone circle. The church dates back to about 653, and a path completely encircles the churchyard giving it a cathedral-like appearance.

Adam Bede cottage stands at the southern end of Wirksworth, where Samuel Evans and his wife Elizabeth once lived and were portrayed as Adam Bede and Dinah Morris in George Eliot's famous novel *Adam Bede*. George Eliot loosely based her novel *Mill on the Floss* on Haarlem Mill that stands on the other side of the road from the cottage.

The limestone cottages of The Dale and Green Hill cling to the hillside, as if Wirksworth was some little Cornish fishing village with nothing but the sea missing. In places it is possible to walk from the garden of one house onto the roof of another below. This is the area where the lead miners used to live, the jumble of small cottages having been built mostly of random stone extracted from nearby quarries. Nowhere is the lack of planning more apparent than in the area between the remains of Dale Quarry and Middle Peak Quarry, know locally as Puzzle Gardens.

The cottages are linked by a maze of 'ginnels' or 'jitties', there is no room for vehicular access and it is a nightmare for any new postman. Halfway up Green Hill is Babington House, at one time used as a hospital, which is an excellent example of the old builders' rule, 'Always use local products if they are available' the builder having quarried the stone from the back garden. At the foot of Green Hill stands Hopkinson's House, restored from dereliction by the 'Wirksworth Project'.

Every year at Spring Bank holiday, Wirksworth holds its annual Well Dressing ceremonies and carnival. In September the town celebrates the talents of local, national and international artists, along with performers of all descriptions, when it holds its prestigious annual festival. Ecclesbourne Valley Railway is based at the immaculately re-furbished Wirksworth Railway Station.

ALSTONEFIELD

(SK131556)

Off the A515 Ashbourne to Buxton road

Alstonefield is a handsome, unspoilt upland village standing on a limestone plateau at an altitude of 900 feet above sea level, just over the Derbyshire border in Staffordshire. It was built on an ancient site where several trackways once crossed, later to become packhorse routes. Today, it is a village of attractive houses and gardens with plenty of open space, often covered with a triangle of grass rather than a square. The number of awards received in the Best Kept Village Competition endorses the pride shown by local people in the village.

During the Middle Ages it was a thriving market town, having been granted a market charter in 1308. At the height of its importance, it covered an area of nearly 24,000 acres with a population in excess of 4,500. However, as packhorse trade declined and transportation by canal and then rail predominated, so Alstonefield's location came to be more of a hindrance than an asset. For obvious geographical reasons, canal and railway engineers ignored the village, leaving it somewhat isolated.

The George, a popular coaching inn, was the centre of activity in the village. A wool market was held in the yard and up until about 100 years ago an annual livestock sale. There was a button factory in Church Street, which made silk covered buttons probably for the flourishing silk manufacturing industry in Macclesfield. At nearby Hopedale, there was a cheese factory, but both this and button factory long since went out of production. The village now provides very little employment apart from for a few skilled crafts people.

Hidden from view on the south side of the village is St Peter's Church. There has been a church at Alstonefield since at least 892, when a pastoral visit is on record, by the Archbishop of York, to dedicate the church. Parts of the present building date back to about 1100, but most of the church was re-built in 1590 and restored nearly 300 years later.

St Peter's Church is particularly noted for its fine woodwork, especially the rather grand Cotton family pew, with the Cotton coat of arms on the back.

The triangle of grass at the centre of the village

This was made for Charles Cotton senior, the owner of Beresford Hall. He was the father of Charles Cotton junior, a friend of Izaak Walton, a devout Christian who no doubt worshipped at the church. Walton wrote the best selling book *The Compleat Angler*; both he and Cotton were well known for their love of fishing and the River Dove.

The single benches in the church were presumably for the poor people and

The George public house

contrast strikingly with the much more ornate Cotton family pew. But judging by the huge chest inside the church, which measures approximately ten feet in length, the church had considerable wealth. The chest has three locks and required the vicar and the two churchwardens all to be present when it was opened.

In 1989 four bells were rescued from a church in Stoke on Trent, which was being demolished. These together with three of the original bells, which had not been heard for eighty years, were re-hung. Now the church has a peal of six bells — one of the original bells remaining 'dead'.

The churchyard contains two particularly interesting gravestones situated a few yards from the south wall, in line with the porch. Weathered with age, the round topped tombstone commemorates Anne Green, who died in 1518, which makes it about the oldest memorial to be seen in a graveyard in this country. The other tombstone, rectangular in shape, records the death in 1731 of Mary Barclay, aged 107!

A workhouse was built in the village in 1790, where about fifty paupers were housed in accordance with their age, sex, physical and mental ability. It was a hard life. The Rising Bell tolled at 5 am in the morning but, thankfully,

The village pump

two hours later in the winter. The able-bodied men polished limestone and many of the houses in the locality have fireplaces built of this material. Women did housework and helped look after the young. After a day taken up with work, prayers were said at 8 pm and they all retired to tightly packed beds. No fixed lights were allowed after 9 pm. Following the dissolution of the workhouse in 1868, the premises have changed quite radically and now consist of three private dwellings.

Alstonefield Hall, with its tall chimneys, faces across the green towards the George. It used to be the rectory and behind it is a tithe barn with an exposed wattle and daub wall. The former café and post office are now closed, but the 'J. Hambleton … Mercer and Grocer' sign remains, as does the long established Cottage Studio next door, but now visitors need to make an appointment to view. As do visitors to Hope House Costume Museum and Restoration Workshop that has its home in the village. A limited post office service is currently available in the Village Hall.

The village pump on Hartington Road, at one time had a thatched roof, but is now exposed to the elements! On the corner opposite, next to Rose Cottage, is the former reading room, which apparently used to be very much of a male preserve not just for reading, but also for playing games. Further along the road to Hartington Road, on a triangle of grass, a tree has been planted to commemorate winning the Best Kept Village Competition in 1966. A few extra yards on, at the back of a cottage, is a sign indicating where the Crewe and Harpur Inn used to stand, the village having been part of that estate for many years. The Harpur family, whose home was at Calke Abbey in the southern part of the county, were one of the wealthiest in the country and during the eighteenth century owned vast tracts of land in Derbyshire.

Standing at the top of Lode Lane, is the former Wesleyan Chapel, where Michael Griffin now operates a hand-made furniture business, in what was once the Sunday School room. A short distance away is Fynderne House, now a private residence. It was at one time the Red Lion public house, in stark contrast, it later became a Temperance Hotel.

ASHBOURNE

(SK180468)

On A52 between Stoke-on-Trent and Derby

The historic market town of Ashbourne with its many fine buildings, bustling market and busy shops is frequently referred to as the 'Gateway to Dovedale', which may not be quite true. As there is so much to see in the town, generally visitors to the Peak District do not just pass through, but wisely take time to explore and enjoy the many surprises they find. Most of this ancient town has been protected since 1968, by Conservation Area status.

Originally, the town lay only to the north of the Henmore Brook, with the tiny hamlet of Compton to the south. However, by the thirteenth century trade prospered in Compton as taxes could be avoided by trading on that side of the Henmore. Ashbourne itself being Crown Property had to pay dues to the King. Both are now joined together, though the old village street name of 'Compton' has been retained.

A further most important distinction remains in that those who live north of the Henmore Brook are referred to as the 'Up'ards', and those to the south as the 'Down'ards'. This decides the sides for the famous Royal Shrovetide football games, which take place on Shrove Tuesday and Ash Wednesday every year. The goals are three miles apart and traditionally the game is played without rules, although one ancient rule is that you must not murder your opponent, to which one or two others have been added.

The game starts at 2 pm at Shaw Croft, after the singing of the National Anthem. The ball is 'turned up', usually by some well known celebrity who throws the ball to the assembled crowd. In 1928, HRH the Prince of Wales turned up the ball and ever since then the title of the game has had the 'Royal' prefix. The game used to start in the market place, but was moved to try to avoid unnecessary damage from the roughhouse that follows.

Almost certainly the game has been played since medieval times by rival villages. There are even claims that it has pagan origins when a human head was substituted for the ball. And although several attempts have been made to stop it, because of the trouble it has created, it still survives in Ashbourne.

The town grew as a market centre at the junction of a number of roads, the most important the old main road linking London and Manchester. This passes through Macclesfield and Leek before reaching Ashbourne and heading off to Derby. Stagecoaches regularly used the route in the eighteenth century and Ashbourne was an important stopping off place. Now the town is bypassed from the west, but the streets are still busy with traffic and the pavements with shoppers.

The town has managed over the centuries to preserve much of its architectural character. The medieval layout with a long straight main street and a large triangular market place has remained intact. The market place, though, has been encroached by buildings, and is now much smaller than the original design.

When horse drawn transport began to be replaced by the railway, Ashbourne failed to get main line status, only being allowed a branch line to Uttoxeter. This restricted the development of the town as a major industrial centre, but did have the effect of enabling it to preserve its identity.

St Oswald's Church is one of the most beautiful churches in the county, with a lovely slender spire, 212 feet in height. Inside there is a large collection of impressive statues, the sculpture of Penelope Boothby, in pure white carrara,

The former Queen Elizabeth Grammar School

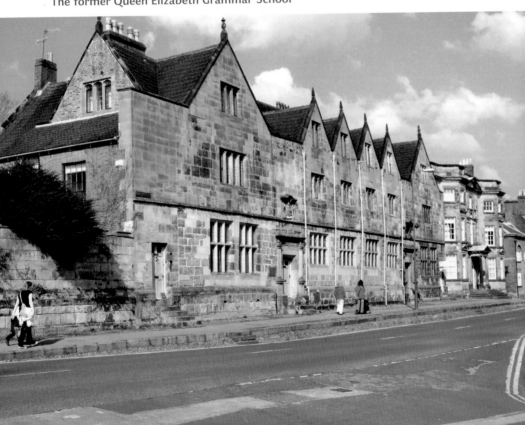

being nationally famous. The present church stands on the site of the church mentioned in the Domesday Book and largely rebuilt in the thirteenth century.

The Old Grammar School was founded in 1585 by the Royal Charter of Queen Elizabeth. Four hundred years later, another Queen Elizabeth, the Second this time, visited Ashbourne to celebrate the 400th anniversary of the

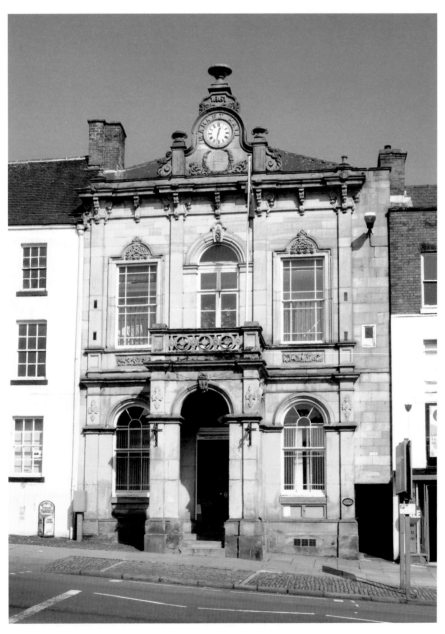

The Town Hall

St Oswald's Church

school. Over the years the school had become too small to meet the needs of the twentieth century and a new school was built on Green Road. The old school continued in use for many years after that, but in 1997, the decision to sell the Grade I listed building was taken.

Opposite the Old Grammar School is the Mansion House, the former home of Dr John Taylor a livelong friend of Dr Samuel Johnson, whom he regularly entertained, along with James Boswell, Johnson's biographer. In 1764, Dr Taylor engaged Robert Adam, who was working on Kedleston Hall, to re-design his house. The work was actually completed by the Derby architect, James Pickford, who turned the house into a miniature mansion. Amongst the many notable features is an octagonal drawing room beneath a copper dome.

Across St John's Street hangs one of only a small number of gallows signs that remain. It came about through the amalgamation of two former coaching inns, which were re-named, as the 'Green Man and Black's Head Royal Hotel'. Above the sign, the Blackamoor's Head smiles as you arrive and frowns as you depart.

Bull bating at one time took place in Ashbourne's handsome, cobbled market place and just in front of the Wright Memorial was the ring to which the unfortunate beast was tethered. The memorial was erected in memory of Francis Wright a benefactor to the town, but not universally popular. His action in putting a stop to the annual fair, of which he disapproved, and his efforts to stop Shrovetide football did not go down well with many of the inhabitants.

George Brittlebank, a lawyer, lived at Monument House. When in 1864 the police banned Shrovetide football he threw the ball to the angry crowd, after it had been smuggled to him across the market place in a shopping basket carried by a local woman. He promised to defend, at no cost, anyone arrested playing the game.

In December 1745, Bonnie Prince Charlie proclaimed his father as King James III, in Ashbourne Market Place. He stayed the night at Ashbourne Hall; the little that remains forms part of the town's library. He did not get much further. Without the expected support of the English Jacobites and the French, he turned back after reaching Derby, although a small advance party did reach Swarkestone Bridge.

BUTTERTON AND GRINDON

(SK075566 & SK085545)

Off the B5053 Bottom House (A523) to Warslow road

Butterton is situated on the edge of the Staffordshire Moorlands, and commands an elevated location overlooking the beautifully wooded **Manifold Valley**. Like Grindon, a near neighbour, it is a rather isolated and picturesque village. For visitors entering Butterton by car for the first time along the Grindon road, a shock awaits, as coming into the village, after passing a sign for a 'Ford,' you have to drive along the bed of a stream to reach the centre. For a small out-of-the-way village, it is fortunate to still have a small general store, a butcher's shop and the Black Lion public house.

Human habitation has been present in the area from a very early stage as prehistoric barrows, known locally as lows, have revealed spearheads and articles of adornment buried with the owners. There are numerous packhorse routes around Butterton which were used to transport copper and lead ore from Ecton, on the opposite side of the Manifold Valley, to various smelting works. Ecton Hill rises to a height of 1,212 feet above sea level, and was first worked commercially in the mid seventeenth century. Archaeological finds show that minerals have been mined there for many centuries previously.

There are some very attractive stone houses with pretty gardens in Butterton, built of local sandstone, but it is St Bartholomew's Church with its lofty spire that dominates the landscape. The spire is one of the newest in the Peak having only been built in the late nineteenth century. It certainly rivals that of All Saints' Church at Grindon in dominating the surrounding countryside and can be seen for miles around.

The present St Bartholomew's Church is built in Gothic style and dates back to the 1870s, when it was rebuilt. It has a register, used since 1670, and a fourteenth-century font. Previous churches on the site can be traced back to the thirteenth century. Inside the church is a memorial plaque to Joseph Wood, Rowland Cantrell, William Hambleton and Joseph Shenton together with the following inscription: 'The three first of whom gave their lives in an unsuccessful but heroic attempt to rescue from death the last named, a youth

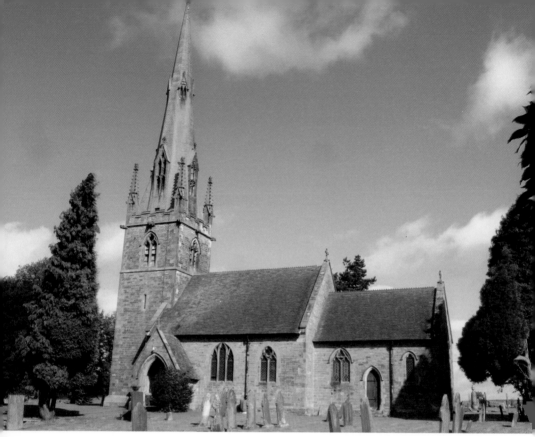

St Bartholomew's Church, Butterton

who had descended an un-used shaft on August 30th 1842. This tablet was placed here by an eye-witness of this noble Christian deed.'

Following the suggestions of Butterton residents, a War Memorial was designed on the 26 October 2006. It was billed at the time as 'North Staffordshire's newest War Memorial'. The memorial is set in the wall of St Bartholomew's Church, and takes the form of a single poppy with the word 'Remembrance' underneath. Although the village does not have any recorded casualties, the memorial serves as a reminder of the men and women from Butterton who served their country during wartime.

Grindon is another small, isolated village, overlooking the Manifold Valley, amidst magnificent Peak District scenery. The needle-like spire of its church acts as a landmark for miles across the lonely hills. The remoteness of the village is put into perspective, by an inscription in the church to six airmen, including two press reporters, whose plane crashed, while bringing relief to stricken villages cut off by blizzards in 1947. The plane crashed on Grindon Moor, when parachuting food supplies to the villages of Butterton, Grindon, Onecote and Wetton.

The descent to the Manifold is very steep on both sides of the valley, with several hairpin-bends on the road. On reaching the foot of the

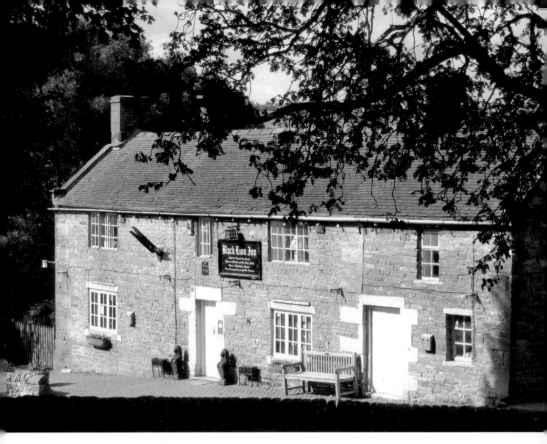

The Black Lion public house, Butterton

hill, the river is crossed at Weags Bridge and the road follows another tortuous route up the other side of the valley to Wetton. On 27 June 1904, a railway line ran through the valley. It was opened by the Leek and Manifold Valley Light Railway, and operated by the North Staffordshire Railway. The problem was the line followed the valley bottom, but Grindon and the other settlements it served were mostly on the top of hills. As a result it was not convenient and proved unpopular with the locals. The consequence was lack of profit, and the line only had a short life, closing in 1934.

Following the line closure, the track bed was removed and resurfaced, and opened up as the Manifold Way in 1937. It is eight miles in length and runs from Hulme End in the north, where there is an information centre, to Waterhouses on the A523/A52 Leek to Ashbourne road. The trail is suitable for walkers and cyclists, and has proved very popular with visitors.

All Saints' Church is referred to as the 'Cathedral of the Moors'. It stands at a height of 1,050 feet above sea level with its elegant spire towering above the sycamore trees round the churchyard. The church was rebuilt in the mid 1800s, but there has been a church on the site since at least the eleventh

Pinfold Grindon

century. Inside, two coffins and a battered Norman font remain from the previous church and there is a sundial above the front porch.

The War Memorial is the church clock high on the south face of the tower. It keeps 'Grindon time', since its ebony pendulum causes it to speed up in wet weather and as the reverse effect in dry. Now there is an excuse for being late!

An unusual sight near the church entrance is a Rindle Stone, which records that: 'The Lord of the Manor of Grindon established his right to this rindle at Stafford Assizes on March 17th 1872'. Exactly why the Lord of the Manor should want to assert his right to the rindle is uncertain, as a rindle is a stream which runs only in wet weather.

The Cavalier, around 400 years old and originally the smithy, for many years was the only pub in the village, but is now closed. It was previously called the Shoulder of Mutton and some historians think it was renamed in honour of Bonnie Prince Charlie, who once stayed in the village. Opposite is the former village pinfold, where stray animals were kept until claimed by their owner who was required to pay a fee for the service.

FLASH

(SK025672)

Off the A53 Leek to Buxton road

Flash, surrounded by magnificent moorland scenery stands at a height of 1,525 feet above sea level, and is claimed to be the highest village in England. It is an isolated place, the main part of which consists of well weathered cottages and a small church, all clustered together seemingly to keep warm on the side of Oliver Hill. There is also a pub called the New Inn and a village school. Just outside the village at Flash Bar on the A53 is another pub, the Traveller's Rest, although its future seems uncertain at the time of writing, and the stylish Flash Bar Stores, possibly the highest shop and café in England.

On a sunny day when the sky is clear you can see for miles over the surrounding countryside, and as you walk across the moors, listening to the birds singing and keeping a watch out for wildlife, it is easy to imagine you are in Paradise. At another time, on a different day, the picture may be quite the reverse.

The A53 runs only a very short distance to the east of Flash and is frequently closed by heavy snow in winter. But things are no where near as serious nowadays as they used to be, due to our milder climate and improved snow clearing methods. The harsh winter of 1947, still lives in the minds of many of the older inhabitants, when the Peak was in the grip of violent blizzards. Telephone lines were brought down and hundreds of vehicles were abandoned as the roads round Flash came to a complete standstill. The situation was desperate as people became short of food and fuel and the village lost contact with the outside world.

Only a short distance from the village is Three Shires Head, where a bridge crosses the River Dane at a point where the borders of Derbyshire, Staffordshire and Cheshire meet. Many years ago illegal prizefights used to take place there, as at that time the police were not allowed to cross county borders, and it was easy for the wrong doers to flee into another county. For the very same reason, counterfeiters choose the spot for their unlawful trade, the village giving its name to the term 'flash' to the illegal money. The word

flash has since become associated with being dishonest or for goods that are not of genuine quality.

In the days before sick pay was introduced, in order to protect themselves if the main bread winner in the household was unable to work, families often got together to form Benefit Clubs. Members would pay subscriptions, in return for which they got a weekly pay out from the fund when they were sick. This is where the old expression of 'On the Club' originated.

The village had its own benefit society to support those most in need, the Flash Loyal Union Society, established in 1846, nicknamed the 'Teapot Club' presumably because many members saved the money in a teapot. Attendance once a year at an annual feast was compulsory for members, when the money was placed in the fund. Feast Day was an important day in the villager's social calendar and when in 1995 the benefit club had to be disbanded due to new Government regulations, the event was retained.

As one recent visitor who just happened to visit Flash on the day of the village parade recounts, she was astonished to see a procession march all the way to the Traveller's Rest carrying a large model teapot. Even more as the marchers also carried banners referring to the teapot and were accompanied by a brass band. On the same day there is a service in the church and also a

St Paul's Church

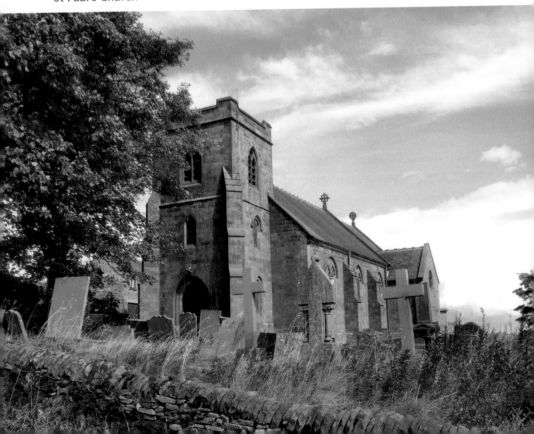

Well Dressing and Flower Festival take place, and refreshments are provided in the Village Hall.

On one Feast Day competition, the first prize was a reputedly a teapot. The contestants had to pull as uglier face as possible, which at the time was identified as 'pullin yer roggin', now known as 'gurning'. A problem occurred one year when a Longnor man, much to his indignation, won the teapot. He protested furiously saying that he had not started to pull his face yet, but still won the prize. As insults to a visitor go they do not get much worse!

St Paul's Church was founded in 1744, but the original building fell into disrepair at the end of the 1800s and a replacement was built early the following century. In a window of the church are the coat of arms of the Harpur-Crewe family, who at one time held vast tracts of land in the area. The Flash Loyal Union Society banner is stored in the church for safekeeping.

To the north is Axe Edge where both the Dove and Manifold rivers rise. To the west is the lovely river valley of the River Dane. Further along the road towards Leek are the Roaches, the French name for rocks. Together with Hen Cloud and Ramshaw Rocks, they are a gritstone escarpment, which marks the south-western edge of the Peak District. Rising to almost 1,700 feet in

A house on the outskirts of the village

Flash Bar Stores and Café

height, some of the rock faces are particularly severe and have attracted world famous climbers to test their skills.

The rock and bracken clad hillside affords stunning views, which have been enhanced even further by the construction of Tittesworth Reservoir. The land round the Roaches once belonged to the Swythamley Estate, but following its break up in 1980, an area of 975 acres was purchased by the Peak District National Park Authority.

Ramshaw Rocks are particularly impressive as they tower above the busy Buxton to Leek road. Most noticeable of all is an unusual rock formation known as the 'Winking Eye', a combination of upright stones, which seem to wink at passers by on the A53. The Roaches used to be home to a herd of Wallabies released during the Second World War from a private zoo at Swythamley Hall. They continued to breed for a number of years, but are thought to have died out near the end of last century.

HARTINGTON

(SK129604)

On the B5054 about two miles to the west of the A515
Ashbourne to Buxton road

The picturesque village of Hartington with its spacious market place, village green, its delightful duck pond and limestone houses, which sparkle in the bright sunlight, make it one of the major tourist centres in the Peak District. It has more the air of a prosperous market town than a village.

Hartington was the first in the Peak District to be granted a charter to hold weekly markets and an annual fair, but these have long since ceased with the moving away of commercial activity. However, even today the village has a range of services equivalent to those of a small town, but the population is only about 400 — apart from the tourists of course! Many of these are attracted by the excellent walking facilities available.

The size and stature of St Giles Church provides further evidence of the former status of the village. Standing on rising ground with an impressive battlemented west tower the church presents an imposing sight. It is somewhat unusual in construction as both Staffordshire redstone and Derbyshire limestone have been used with gritstone detailing to produce a pleasing result.

Hartington's main industry apart from tourism is cheese making. The cheese factory, opened in the 1870s, is the only survivor of seven that at one time operated in the area. It closed after about twenty years but was soon back in action and had the distinction of achieving a Royal Warrant to supply Stilton to George V in the 1920s and 1930s.

The factory now produces no less than a quarter of the world's supply of Stilton. Legally the cheese can only be made in the three shire counties of Derby, Nottingham and Leicester — had the factory been built a quarter mile to the west it would not have qualified, being outside the county boundary in Staffordshire! Cheese can be purchased from the busy factory shop opposite the duck pond. Sadly, the factory closed recently, but the shop remains open.

Since 1934, Hartington Hall has been a Youth Hostel. It was the home of the Bateman family for over four hundred years and is a very fine example of

Hartington Hall

a yeoman farmer's house. The room Bonnie Prince Charlie is said to have slept in on his ill-fated journey to London, however, seems small and dark.

Charles Cotton who lived at Beresford Hall, now demolished, wrote, with his great friend Izaak Walton, a remarkable book about seventeenth-century rural England called *The Compleat Angler*. No other English language book, other than the Bible and Book of Common Prayer, has been reprinted more times. He shared his time between an extravagant life style in London society with the quieter pleasures of his home and the Peak District. That is when his creditors were not chasing him — then it is said he hid in a cave in Beresford Dale. The fishing lodge he built still remains on private land in Beresford Dale, but can be seen from a distance when approaching the dale.

Hartington has produced some notable craftsmen; William Smith made the W. G. Grace Memorial Gates at Lord's, the Spa bandstand at Scarborough and, locally, the lamp hanging for St Giles Church. James Redfern, Smith's uncle and a talented sculptor, whose work appears in churches and cathedrals all over the world including Westminster Abbey, was brought up in the village.

A craftsman of a different kind, John Oliver, the son of a lead miner, left England to work on the Canadian Pacific Railway before eventually becoming the Prime Minister of British Columbia in 1921. Prince Obolenski, a Russian nobleman, who lived at Dove Cottage for a time, having fled the revolution

The Market Hall

in his country, achieved immortality in Rugby circles by scoring two tries for England in a match against the formidable New Zealand All Blacks.

Once an important stopping place for pack horses and drovers and then for stagecoaches, both The Charles Cotton and The Devonshire Arms are former coaching inns. Now the village provides for tourists as well as local people and there are several tempting cafés, quality gift and craft shops and a newsagent.

Most noticeable of all is the small supermarket housed in the rather grand old Market Hall, built in 1836, with three arches of rusticated stone. On the green is the village pump, which was in regular use before piped water arrived. The old Victorian letterbox that used to stand outside the Dauphin, a quality

The War Memorial

art and crafts shop, was relocated at the same time as the Post Office, further up the road. Regular craft fairs and an annual book fair are held in the Village Hall, which started life in 1926 as a silent picture house. Hartington Well Dressings are held during September.

At the bottom of Hall Bank there is a most unusual War Memorial in the form of a collage of pure limestone rocks. Just off the market place, in what used to be the village garage, is Rooke's pottery, which specialises in making terracotta garden pots.

The railway signal box at Hartington, a short distance up the hill from the village, has been preserved. It operates as a small kiosk selling refreshments at busy times of the year. The late Victorian railway that it served came into service in 1899. Originally the line was the trackbed of the Buxton to Ashbourne railway line, built by the LNWR. In its heyday, it carried express trains from Manchester to London and until after the Second World War a daily train delivered milk from Peak District farms to Finsbury Park, London. Also several quarries were opened along the track from where limestone was extracted and then sent by rail to industrial areas.

The line was converted into a pathway, known as the Tissington Trail after the railway closed in 1967. It runs along a 13 mile route from Ashbourne to Parsley Hay. At this point it joins up with the High Peak Trail, which runs from High Peak Junction to Dowlow near to Buxton. Surrounded by beautiful countryside the traffic-free trail is ideal for horse riders, cyclists, naturalists and walkers. It is suitable for wheel chairs and pushchairs along the flat sections.

ILAM

(SK134508)

Between the A515 Ashbourne to Buxton road and the
A52 Ashbourne to Stoke-on-Trent road

Alpine-style cottages, a Tudor Gothic Hall, an eccentric river and a wonderful background of soft green hills make Ilam a very popular place with visitors. It is situated in one of the most spectacular locations in the Peak District, with magnificent views towards Thorpe Cloud and the entrance to Dovedale. Only a short walk away to the east is the nationally famous, frequently painted and photographed Dovedale Stepping Stones, which must have appeared on more calendar covers than almost any other view in the country.

Ilam Park is free for all to walk round. The aptly named Paradise Walk, by the River Manifold, fringed with woodland, planted as a pleasure ground for the hall, is a favourite with most people. The river disappears for most of its four or five mile route from Wetton Mill, flowing underground before emerging at the Boil Holes, in the grounds of Ilam Hall. Only in the rainy season does it behave like an ordinary river and flow above ground. Not to be out done by this strange practice, the River Hamps also flows underground and emerges from a cave a few yards up river. Together they create the largest such rising in the country, the water bubbling up as if it was boiling.

Half way along the path is the Battlestone, thought to be the shaft of a Saxon Cross made to commemorate a battle between the Saxons and Danes. The return journey is through Ilam Park, where it is still easy to identify the 'ridge and furrow' pattern in the fields, a consequence of ancient farming practices. The track that runs across the fields was once used by servants and trades people who were not allowed to use the main drive to the hall. Close by the entrance to the car park, is the Pepperpot, a very ornate and rather unusual looking dovecote.

The Italian Gardens, although much changed from the days when the Watts-Russell family lived at the hall, provide excellent views and the chance to relax. Tucked away in the gardens is the grotto where William Congreve wrote his first play while recuperating from illness. Samuel Johnson also visited Ilam and it is said that Happy Valley, in his book *Rasselas* was based on Paradise Walk.

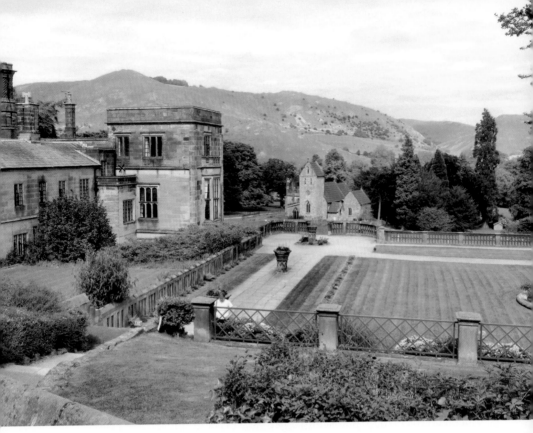

Ilam Hall Gardens

A short distance further to the east is St Bertram's Bridge, which carried the old road across the River Manifold before the present bridge was built. Bertram, who had connections with the Royal family of Mercia, was returning from Ireland with his wife and newborn child. He left them briefly to look for food, only to find on his return that wolves had savaged them both. At once he denounced his heritage and spent the rest of his life as a hermit preaching the gospel.

After the Dissolution of the Monasteries, John Port acquired the estate and built a house on the site of the present Ilam Hall. In 1809, David Pike Watts became the owner and on his death, it passed to his daughter. Her husband, Jesse Watts-Russell a wealthy industrialist, had a rather grand hall built. It had battlemented towers, ornamental chimneys and a flag tower. The architect, who designed the hall, was also engaged in the building of Alton Towers and there were some similarities between the two.

The former estate village was mostly demolished and replaced by alpine style cottages, which provided a marked contrast alongside some of the older more traditional buildings. Watts-Russell built the school and provided it with an endowment. It fits in so beautifully with the other alpine style cottages in the village that one cannot imagine any child not wanting to go to school!

Ilam School

Jesse Watts-Russell's wife was noted for the help and support she gave to villagers and when she died he had a 30-foot mock-Eleanor memorial cross, erected in her memory, in the middle of the village close by the bridge. Six water troughs were placed round the base to provide drinking water for thirsty animals. The cross gave Sir Gilbert Scott inspiration for the Martyrs' Memorial at Oxford.

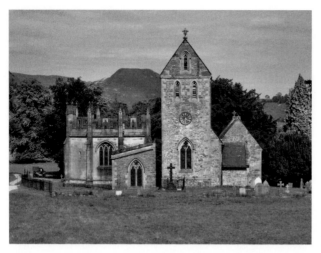

The Church of the Holy Cross

Following Watts-Russell's death, the hall was in the hands of the Hanbury family for a time, before being tried unsuccessfully as a restaurant, then sold, and partly demolished. In 1934, Sir Robert MacDougal was persuaded to buy it for the nation and give it to the Youth Hostels Association 'for the perpetual use of the youth of the world'. As the YHA did not have a trust body, it gave the building to the National Trust. What remains today are the old entrance hall, armoury and servants' quarters, which have been converted into a Youth Hostel. There are tea rooms, a National Trust shop, information facilities and a car park available for the use of the general public.

In the church of the Holy Cross, the chapel of St Bertram contains a shrine that became a place of pilgrimage in the Middle Ages and the scene of many miraculous cures. The Chantrey Chapel holds a finely carved memorial to David Pike Watts. Dovedale House, which stands near the end of the church path was once the vicarage, but because of its size proved costly to run. It is now a Residential Youth Centre, accommodating groups of young people for recreational and training purposes.

Only a short walk away is Dovedale, described by Ruskin as 'An alluring first lesson in all that is beautiful'. The building of the Midland Railway in 1863 made the Peak only three hours from London. Many were the thousands who got off the train at Alsop-en-le-Dale Station and walked the length of Dovedale before catching a train home at Thorpe Station. The railway is no more, but cars still bring thousands of visitors to what is one of England's most famous beauty spots. The Dovedale Sheepdog Trials also attract big crowds every August.

Let us leave the last words with Byron, who wrote with Dovedale in mind, to his friend the Irish poet Tom Moore, 'I can assure you there are things in Derbyshire as noble as Greece or Switzerland.'

LONGNOR

(SK090650)

On B5053, off the A515 Buxton to Ashbourne road,
6 miles to the south-east of Buxton

Set in lonely moorland countryside, six miles to the southeast of Buxton and close to the Derbyshire border, is the ancient village of Longnor. It sits astride a narrow ridge of gritstone where the River Dove flows to the north and the River Manifold to the south. It attracts large numbers of visitors who come to explore the upper reaches of these two famous river valleys and the rugged scenery that surrounds them.

Little was heard of Longnor, in what was a wild and rugged area at the northern most boundary of Staffordshire, before the first written reference to the founding of St Bartholomew's Church in 1223. According to tradition however a church was built in the village in about 700 AD, following the formation of a Christian community.

In the early days, agriculture was the main pre-occupation of the few people who lived here, but by the mid-1600s, there were four annual fairs and two weekly markets. The opportunities to trade had the effect of attracting more and more people to Longnor and as a consequence its importance rapidly increased. Local farms provided food for the table and new trades sprang up. On market days, the streets were thronging with people buying and selling goods.

The population continued to rise and by the mid nineteenth century, Longnor was referred to as a market town. But it was not without its problems despite the increase in trade. Rowdiness and criminality were quite common, no doubt fuelled by the dozen busy alehouses in the town. A cell at the local police station provided a place for some of the wrong doers to take a more sober view of the reasons behind their incarceration. All though was not doom and gloom; the establishment of schools and with the church and chapel thriving, the community had good reason to be proud of the progress achieved. The Methodist chapel, built in 1780, was expanded to incorporate a gallery and organ and the church rebuilt and extended to cater for increased numbers.

The Market Place

Longnor held its position as a small market town until the disappearance of the coaching age. When gradually easier access to other towns and cities improved, businesses moved away to Buxton and Leek. By the onset of the twentieth century, although agriculture still retained its importance, increasing mechanisation meant a smaller labour force was required, and workers migrated to newer industries. Despite losing its status as a market town, it still has the presence of a small town with facilities that are the envy of many other villages in the area. In 2009, two pubs, a fish and chip shop, a general store and a post office, a deli, an agricultural merchant and a combined coffee and craft shop still remained. The market place however is now much smaller than it was originally.

At the upper end of the steeply cobbled market place, the market hall dates back to 1873. At that time it was rebuilt at the direction of the Harpur-Crewe family, Longnor was a prosperous market town and on the board outside the market hall the scale of charges are listed. The Harpur-Crewe family were lords of the manor; an association which began in the fifteenth century and lasted for many years. A reminder of which is the Crewe and Harpur Arms, which stands on the opposite side of the road facing the market place, which is now only available for self catering accommodation and private functions.

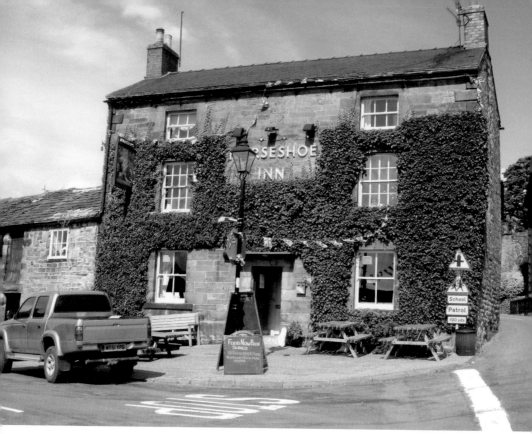

The Horseshoe Inn public house

There are many quaint epitaphs in the churchyard, which was closed for burials in 1888, and a new cemetery opened. The one most quoted is that for William Billinge, born in a cornfield in 1679, who died 106 years later only a stone's throw away. He lived through seven reigns, and fought in countless battles and was still soldiering at the ripe old age of 66.

In 1977, Longor became a conservation area and attracted European and Rural Regeneration money to develop the community, which led to a Europa Nostra award being made to the village, for which a plaque is displayed in the market place. The Honeycomb Centre was set up for people with educational disabilities, producing garden furniture, re-cycling household furniture and craft goods. The centre was been highly acclaimed in a government report and attracted visitors from abroad on fact-finding missions. There is also an Internet Café where visitors can send their post cards home by e-mail.

Opposite the Honycomb Centre is Upper Limits, the only indoor climbing wall in the Staffordshire Moorlands, where courses are run for all abilities in the daytime or at weekends. There are also facilities for archery and other team building activities.

As part of the National Park Authority's Integrated Rural Development experiments, local farmers have been encouraged to retain and promote herb rich meadows and some were paid for the number of different wild flowers in their fields. Payment was also made for the upkeep of dry-stone walls, which helped keep this old craft alive. Small businesses were established and repairs undertaken.

Longnor Craft Centre occupies the market hall, where you can also sit and have a cup of coffee and a rest from browsing. Close by is the Horseshoe Inn, the oldest surviving pub in the village, dating back to 1609. A few yards along the road to Crowdecote is the Cheshire Cheese, the inn's name referring to its origin in 1621 as a local cheese store. The former Red Bull, in cobbled Chapel Street, was once a public house, and it is thought its name is derived form the local practice of bull baiting.

Longnor Races are a very colourful event, said to have resulted from a meeting of local farmers who decided to put up a wager to decide the winner by racing their mounts round the village. The original race followed a course from the village around Mill Lane and back. This popular event is continued to this day, but in a somewhat different format with cross country racing, horse racing, trotting, motorbike and sidecar racing and a gymkhana. Longnor Races take place on the Thursday after the first Sunday in September.

The entrance to the former Market Hall

MIDDLETON-BY-YOULGREAVE

(SK195632)

*Off the B5056 a linking road between A515 — Ashbourne and
A6 — Bakewell, then follow signs from Youlgreave*

It is hard to find a more attractive, less spoilt village in the whole of the Peak District. It also is surprisingly quiet as it is situated on an unclassified loop road and at weekends walkers often out number motorists. The spaciously laid out main street is lined by pretty limestone cottages, the gardens bursting with colour in the summer. Many of the houses were re-built in the 1820s by Thomas Bateman.

The village is only a short distance from one of Peak District's loveliest dales and is surrounded by excellent walking country. A track leads from the village down to Bradford Dale with its six pools of crystal clear water, which reflect the shadows of the mature trees along the steep sided dale. A view of which J. B. Frith described as 'for peaceful loveliness and sheer prettiness nothing in Derbyshire excels it.'

At the top of the dale, Sir Christopher Fulwood was shot, later dying from his injuries, after his attempt to hide in a crevice in the cliff was discovered by Roundhead soldiers. An ardent Royalist, Sir Christopher, had raised an army of lead miners to fight in the Civil War, when he was surprised by the soldiers and fled from his home. His fortified manor house, known as Middleton Castle, which had been built by his father Sir George Fulwood, was never again occupied. It was eventually knocked down and much of the stone used in the construction of Castle Farm and other buildings around the village. All that remains is a mound in the field opposite Chapel House.

At the end of the eighteenth century, Thomas Bateman, whose main family home was at Hartington Hall, acquired Middleton Hall and the accompanying estate. He was a merchant during the American War and attended a meeting in Manchester to discuss the shortage of cotton. He reputedly overheard someone say that four ships laden with cotton were due in the Mersey. Leaving his hat behind to avert suspicion, he left the meeting and hurried to Liverpool and bought the complete cargo, making himself a rich man.

Bateman rebuilt Middleton Hall and the rest of the village, and being a staunch non-conformist had the Congregational Chapel erected in 1826. It is now a private house, past which a footpath leads to the elaborate tomb of his grandson who bears the same name. He was buried there at his own request rather than close to the family's main home, Hartington Hall. The stone tomb is surrounded by iron railings and surmounted by a stone model of a Bronze Age cinerary urn.

Following the early death of his parents, the younger Bateman was brought up by his grandfather at Middleton Hall. He later became a famous archaeologist, who together with his son, William, excavated numerous barrows mainly in Derbyshire and above the Manifold Valley, in Staffordshire. On its completion in 1844, he moved to Lomberdale Hall, which stands well outside the village on the left hand side of the road to Youlgreave.

It was Bateman's stated intention to house his ever growing collection of antiquities at Lomberdale Hall, but his hard drinking son, put an end to that vision. He sold the collection in two large sales at Sotheby's then sold the hall. Fortunately, the archaeological collection was on loan at West Park Museum in Sheffield and was purchased by them.

The former chapel

In total, Bateman excavated over 500 barrows in 20 years, the most prolific year of which was 1845, when 38 barrows were dug. By this time he was living at Lomberdale Hall and had acquired a large collection of artefacts. He died prematurely at the age of 39, in 1861. A fortnight prior to his death, he had published *Ten Years Digging*, containing detailed notes on some of the excavations. Considering that due to a serious illness, he only dug 22 barrows in the last seven years of his life his efforts are a quite remarkable achievement.

There used to be both a shop and pub in the village. The shop closed over 50 years ago and Bateman's Arms, now the Square House, closed nearly a century ago. It only had a six day licence and was seen open one Sunday, apparently by Mrs Waterhouse, returning from the church to the hall. Shortly afterwards it lost its licence. Although you cannot buy food or refreshment in Middleton, you can purchase a landscape painting from Diane Kettle's Backyard, Working Fine Art Studio, where walkers are welcome to call in to view and enroll for an art course if they have time!

The parish church and the Village Hall are at opposite ends of the village and in the middle by the small recreation ground is an unusual War Memorial.

Elton Road

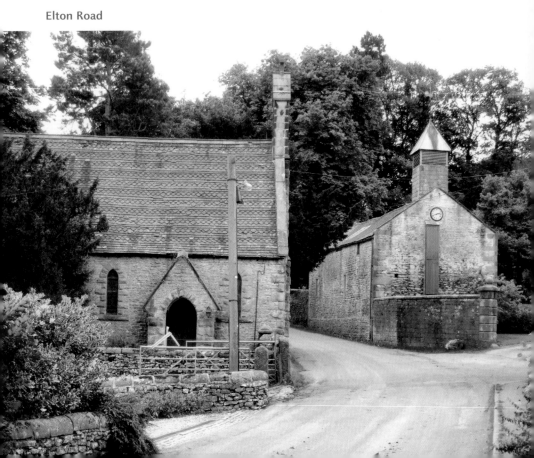

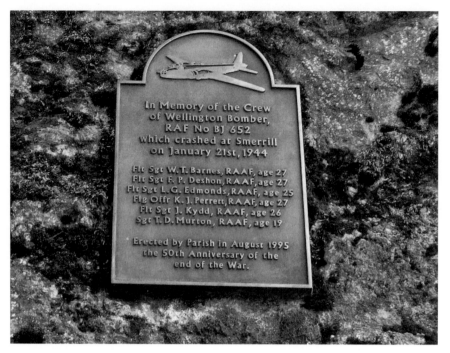

In Memory of the Crew
of Wellington Bomber,
RAF No BJ 652
which crashed at Smerrill
on January 21st, 1944

Flt Sgt W.T. Barnes, RAAF, age 27
Flt Sgt F. P. Deshon, RAAF, age 27
Flt Sgt L.G. Edmonds, RAAF, age 25
Flg Offr K. J. Perrett, RAAF, age 27
Flt Sgt J. Kydd, RAAF, age 26
Sgt T. D. Murton, RAAF, age 19

Erected by Parish in August 1995
the 50th Anniversary of the
end of the War.

The Aircraft Memorial

It takes the form of a bronze plaque, which was erected in 1995 on the 50th anniversary of the end of the Second World War. It depicts a Wellington Bomber, which crashed at nearby Smerrill on 21 January 1944, killing six Royal Australian Air Force crew members.

In 1977, Middleton-by-Youlgreave produced its first Well Dressing in living memory, in honour of the Queen's Silver Jubilee. Since then annual Well Dressings have become established on the last Saturday in May before the Spring Bank Holiday, when other supporting events also take place. Three wells are traditionally dressed, all rather unusually fitted with taps, fed from a pumping station in Bradford Dale. The dressings remain on view the following week for the enjoyment of visitors.

The Millennium Project undertaken by Middleton and Smerrill, started in 1999 and finished seven years later, was called Sights of Meaning and marks the seventeen entrances to what is a large parish with boundary stones. Over 200 people took part in the project, which may still be identifiable in another 1,000 years. All the boundary stones have been inscribed with text chosen by members of the parish. An eighteenth stone is situated in the village square, which contains a combination of the text from all the other boundary stones.

MILLDALE

(SK139548)

Off A515 Ashbourne to Buxton road, take the Alstonefield road and then turn left for Milldale

Milldale is a delightfully positioned hamlet at the northern end of Dovedale. It attracts walkers like few other places of its size in Britain. Most come to explore the beautiful Dove Valley, with its steep-sided limestone sides and tree-covered slopes along the stretch that runs from Milldale, down to the large car park close to the road linking Ilam and Thorpe. In some places the water has eroded the limestone into spectacular rock formations, like the Lion's Head and the natural archway in front of Reynard's Cave. For the more energetic who climb Thorpe Cloud or Bunster, there are fine views across the valley. But there are many other excellent walks in the area that either start or pass through Milldale.

The building of the Midland Railway in 1863 made the Peak only three hours from London and thousands flocked to Dovedale to enjoy the magnificent scenery and breathe the pure fresh air. The railway is now gone, but cars still bring scores of visitors to what is one of England's most famous beauty spots. A high proportion of the 22 million people who visit the Peak District National Park, include the Dove Valley in their itineraries. According to a footpath count in Dovedale on a typical August Sunday in 1990, a figure of 4,421 walkers was recorded on the Staffordshire bank of the river and 3,597 on the Derbyshire side.

There was a mill in Alstonefield manor in the thirteenth century. It was presumably situated in the hamlet of Milldale, where records show that there was a mill to the north of Viator's Bridge by 1775. The mill ceased to operate in the late 1870s, but 50 years later it was still standing, although derelict by that time. The buildings to the left of what used to be part of the mill have been converted into a National Trust Information Barn.

The mill processed and crushed calamine, mined at Chrome Hill and Parkhouse Hill, near Glutton, south of Buxton. Drug firms used the higher quality calamine and lower grades were used in brass making. In the nineteenth

221

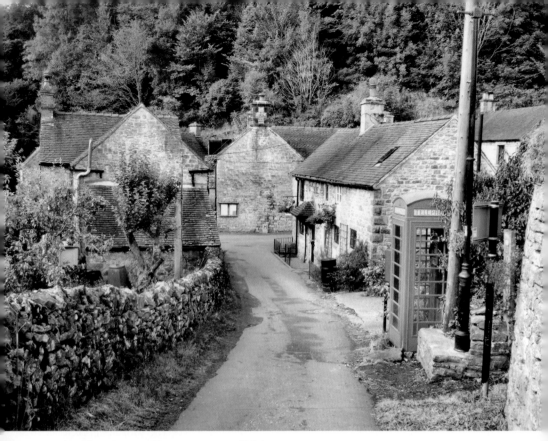

Looking down Millway Lane to Milldale

century it was utilised to grind colours for paints. The remaining millstone wheel is still to be seen lying by the riverbank.

The ancient packhorse bridge, over the River Dove, crossed by hundreds of walkers on a fine weekend at any time of the year, is the most renowned of all in the Peak District. It is known as the Viator's Bridge, and was made famous in the English classic *The Compleat Angler* by Izaak Walton. In the fifth edition, published in 1676, Charles Cotton of nearby Beresford Hall wrote an addendum about fishing, introducing the reader to two travellers — Charles Cotton (Piscator) and Izaak Walton (Viator).

In the days when the two travellers would have approached the narrow bridge at Milldale, it would not have had any walls and must have looked quite frightening to cross. Bridges then were designed with low parapets to allow horses carrying panniers to cross without obstruction. Viator commented on seeing the bridge: 'Why! A mouse can hardly go over it: 'tis not twelve fingers broad.' Milldale Bridge is now known as Viator's Bridge and its name is clearly in view for all that cross to see.

A familiar figure by the bridge used to be Nancy Bennington who set up a stall selling mineral waters, sweets and postcards. When she saw walkers

approaching the bridge, she would hurry across to open the gate and hold out her hand for a tip. In her younger days, she had operated her business from Reynard's Cave a three-mile round trip and a steep climb away. Nancy was a great character, known by the rich and famous that had visited the valley, and in 1937, she was described by the *Manchester Evening News* as 'The grand old woman of Dovedale.'

Viator's Bridge

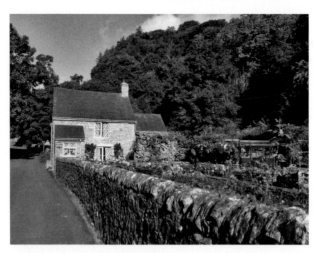

A Milldale cottage

Milldale consists of only a dozen or so cottages, the oldest of which date back to the seventeenth century, and the others probably the eighteenth century. There is no public house in the village, but only a short distance away at Hopedale is the Watts Russell Inn. It is an attractive old pub that dates back over 250 years and is named after the wealthy businessman James Watts Russell who lived at Ilam Hall.

The other alternative for Milldale residents, in pre-car days, would be to go up Millway Lane, the old road to Alstonefield, for liquid refreshment. Things could have been different if an application in 1898 by William Hambleton for a drinks licence had not been declined. However, all was not lost and Milldale did have its hotel, but of the temperance variety!

Mr and Mrs Bailey, who lived at Dove Mount, served refreshments to ramblers for 48 years. In 1966, about 150 members of the Manchester Ramblers Association held a special ceremony to thank them for their services. Nowadays, welcome refreshments can be obtained from a small shop window at Polly's Cottage, named after a former occupant.

The Primitive Methodist Chapel was built in 1835 and occasional services are still held there. On Christmas Eve 1998, sixty-two people squeezed into the tiny chapel, but in the year 2000 numbers were even greater and eighteen had to stand outside. The notice outside reads 'Methodist Chapel — Look Around You — Come Inside — Give Thanks.'

A short distance upstream, at the entry to Wolfscote Dale, is Lode Mill, where a one-arch stone bridge crosses the river. The bridge is of nineteenth-century construction. Previously the river was forded at this point and, in 1658, a woman was drowned there. The mill, built in 1814, continued in operation until 1929, grinding corn for local farmers. The miller's son then transformed it into a joinery business. He converted the drive shaft from the mill to belt drive a circular saw, using waterpower from the river. On the opposite side looking down over the Wolfscote Dale path, is Dove Cottage.

PARWICH

(SK187544)

Situated between the A515 Ashbourne to Buxton road and the B5056

Apart from walkers who come to explore the network of footpaths that pass through Parwich, not many visitors to Derbyshire discover one of the prettiest villages in the county. Situated on the edge of the Peak District, Parwich is not on any of the main routes through the area and as a result does not suffer from excessive traffic noise, as do so many other villages. Its neat limestone houses of various shapes and sizes stand in picture postcard fashion along winding lanes and narrow ginnels. In the summer, the cottages with their attractive gardens, window boxes and hanging baskets provide a vivid splash of colour against the green background of the steeply rising hillside.

Nowadays, visitors often remark how quiet and peaceful and unspoilt the village is, but this was not the case one hundred years ago. At that time it was a busy bustling little village, with the noise of people at work. Animals too were a common sight in the streets, with cows being driven through the village for milking and then being returned to the fields later. This led to the roads becoming rather muddy, particularly in the winter and wet weather, when the animals carried mud from the fields, depositing most of it on the roads.

Parwich is mentioned in the Domesday Book of 1086, but it goes back much further. The Romans had a presence in the area, attracted by the mineral deposits and probably settled in the village, whose name appears to have Roman origins. The discovery of pottery fragments adding substance to the argument.

The hills rise above Parwich to over 1,000 feet to form a rough uneven plateau. Here a considerable number of pre-historic remains have been found. There is evidence of some medieval lead mining in the locality, but the village escaped the worst ravages of the lead mining boom. Farming has been very important to the village's prosperity, but it is now in decline, with small farms almost disappearing. People of working age mainly travel to neighbouring towns and cites, or to one of the large quarries in the area.

St Peter's Church was built in 1873, but the style is from a much earlier period, which can be rather confusing. The previous church stood on the same site for

over 800 years, before it was replaced. A carved Saxon tympanum over the west door creates much interest; it depicts the Lamb of God with a cross, a stag trampling on a serpent, a wolf and other strange animals. A replica of the carving has been made for preservation purposes and can be seen inside the church.

Parwich Hall, which is three storeys high, overlooks the village from a commanding position on the hillside. Unusually, for an area where stone is plentiful and inexpensive, it has a mainly brick façade. Sir Richard Levinge built it on top of the foundations of a previous property in 1747. Later the Evans family acquired the hall; they were rich industrialists from Darley Abbey near to Derby, but they did not take up residence. During the nineteenth century it was used as a vicarage, but the vicar was so unpopular with his parishioners that when he moved away after they burned an effigy of him on the village green.

High up on the hillside is the former Parwich Hospital, now a private house called Rathbone Hall. It is named after Florence Rathbone who helped finance it, when it was built in 1912, as a convalescent home. It stands impressively apart from any other dwellings and would seem ideally fitted to its original purpose. During the Second World War, the Red Cross used it and after that it was in the hands of the NHS for a time before serving as the Parwich Care Centre — closing in 2000 due to falling demand.

'The Dam'

Further down the hillside on the eastern side of Rathbone Hall, stands the stone built Orchard Farm. Interestingly, it contains a surprising number of different styles some dating back to at least the seventeenth century. On the western side, Knob Hall was set up in the early 1900s as a cheese factory, when it was known as Parwich Creamery. It was supplied with water from the nearby well; at first, the water was hand drawn before a pump was installed. However, after about 25 years the creamery closed and it reverted to a private residence.

Parwich's pleasant little cricket ground on Parson's Croft, also provides facilities for tennis and bowls. The land was sold to the village by Parwich Oddfellows, and apparently got its name because the rental income was originally used for charity. A modern house known as Bear Stake Croft obtained its name in even more unusual circumstances. The field in which it was built has the same name as the house, where it is believed bear baiting once took place.

The Sycamore Inn dates back to the seventeenth century, the brick extension at the rear two centuries later. The pub stands close to the Village Green, once much larger, which is now split into sections. Ducks swim on 'The Dam', where sheep were once dipped. The whole area has an air of peaceful spaciousness. The Sycamore also doubles as the village shop, following the closure of the last shop in Parwich. In 2008, the pub was declared National British Pub Champion for its community involvement.

St Peter's Church

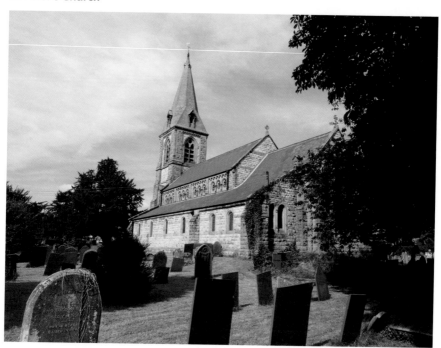

The school still survives, numbers boosted subsequent to the closure of nearby Bradbourne School. It is housed in an impressive limestone building with gritstone quoins.

Parwich is a village with a great community spirit and the Memorial Hall, built in 1963, has been the venue for many pantomimes, meetings and celebrations. The hall replaced a corrugated iron structure and was built to commemorate the dead of both World Wars. It is scheduled for replacement in 2010.

To the north, top class grass Harness Racing was introduced in 1998 at Pikehall. Since then, it has gone from strength to strength to become a major Peak District attraction. There are two meetings a year in June and July.

Parwich village

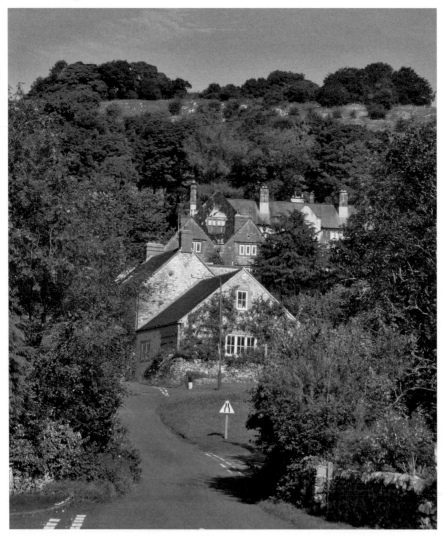

THORPE

(SK157503)

Off the A515 Ashbourne to Buxton road

The pretty village of Thorpe is little noticed by many of the thousands of visitors who pass through on their way to explore the beautiful valleys of the Dove and Manifold, which lie just beyond. Many more walkers and cyclists also pass it by on the Tissington Trail, a short distance to the east of the village, but Thorpe unlike Tissington, does not attract large numbers of admirers. Even the walkers, who pass through the centre of the village, anxious to reach the next beauty spot on their itineraries, rarely seem to slacken pace to fully comprehend what the village has to offer.

Approaching the River Dove from Thorpe, the distinctive cone like hill, known as Thorpe Cloud, guards the entrance to Dovedale. The summit is a short stiff climb from Thorpe village or along the path from The Peveril of the Peak Hotel, both somewhat easier than the longer climb up from the River Dove. Whatever route you choose, the panoramic views from the top are fantastic and well worth the effort.

It was the arrival of LNERs Ashbourne to Buxton line that really started the tourist boom. Many were the thousands who alighted from the train at Alsop-en-le-Dale Station and walked the length of Dovedale before catching a train home at Thorpe Station. Nowadays it is mainly cars which bring thousands of visitors to one of England's most famous beauty spots. They are, no doubt enticed by the beautiful pictures they have seen of Dovedale, in guidebooks, in the press and on television. The railway is long since gone, the station having closed to passengers on 1 November 1954 and for goods on the 7 October 1963. It has now been demolished and the disused track converted into the hugely popular Tissington Trail.

The trail runs along a thirteen mile route from Ashbourne to Parsley Hay. At this point it joins up with the High Peak Trail, which runs from High Peak Junction to Dowlow near to Buxton. Surrounded by beautiful countryside, the traffic-free trail is ideal for horse riders, cyclists, naturalists and walkers. It is suitable for wheel chairs and pushchairs along the flat sections. Since

View of Thorpe Cloud from Thorpe

opening to the public in June 1971, it has been a great success. Large numbers of people are attracted at weekends throughout the year and every day during peak holiday periods. Many walkers leave the trail at Thorpe to visit Dovedale. Some continue up the valley to Milldale, before eventually rejoining the trail at Alsop-en-le-Dale.

As more visitors began to arrive, so the demand for accommodation grew. The Dog and Partridge, which at one time stood at the junction of two turnpikes, offered limited space. Also the Dovedale Inn, a nineteenth-century coaching inn, provided lodging, refreshments and a change of horses for the coaches. It is now a private family run guest house. In addition there are a number of other guest houses and bed and breakfast establishments.

There are also two large popular hotels offering accommodation, the Peveril of the Peak and the Izaak Walton, on the Staffordshire side of the River Dove. The Peveril of the Peak takes its name from an historical novel by Sir Walter Scott and dates back to the 1830s. It hosted the German national football team for the 1966 World Cup, who practised between matches on the Recreation Ground at Ashbourne.

Thorpe cottage

Only a short distance from Thorpe, Coldwall Bridge crosses the River Dove. This long, wide grass covered bridge arouses quite a lot of curiosity amongst visitors, until maybe they notice the milestone 'Cheadle 11 miles' that dates back to the days when the coach-road ran between Ashbourne and Cheadle. Built in 1726, the bridge fell into disuse at the start of the motoring age, the gradients proving too steep for the cars of that era.

St Leonard's Church has a stocky little Norman tower and a tub font, one of only three in Derbyshire, a fine Elizabethan altar rail and a tomb to John Milward who died in 1632. The marks made by arrows being sharpened remain on the outside of the south porch. After the Black Death the number of available archers needed to protect king and country had been seriously reduced. Edward III, finding archery was being neglected, ordered men to stop playing football and other games to practice archery instead. The people kept their arrows at home, but living in wooden houses had no means of sharpening them and found the stone porch at the church the most convenient place. Shooting at butts took place after the Sunday service, usually at the bottom of the churchyard.

The sundial in the churchyard appears to be exceptionally high and cannot be properly viewed on foot; this seems unusual until it is realised that it was

put there for the benefit of horse-riders. It was made by the distinguished craftsman, John Whitehurst of Derby, so it is inconceivable that such an elementary error was made in the design. The clock in the church tower was made by Whitehurst's business successors, John Smith and Sons. The Old Rectory stands next to the churchyard.

The school closed a number of years ago and has been converted into the Village Hall. On the Green stands a fine Wellingtonia tree, planted in the middle of the nineteenth century by Sir William FitzHerbert of Tissington, in celebration of his purchase of the estate. A more recent tree planting exercise took place to mark the millennium and children born in the village that year. The Manor House stands on Digmire Lane, near the end of which is the village pump.

A short distance from St Mary's Bridge, which is crossed on the way to Ilam, the name of the farm reminds us of the corn mill that once stood by the River Dove. The mill has been completely demolished except for a short section of walling. Sheep were formerly washed at the Stepping Stones and below Coldwall Bridge, but this practice was discontinued in the 1950s.

The Village Hall

TISSINGTON

(SK175524)

Off A515 from Ashbourne (3.5 miles) to Buxton road

Tissington is one of the prettiest and most unspoilt villages in the country and a sense of something rather special fills the minds of visitors, who enter the village off the main Ashbourne to Buxton road. First you pass through large rusticated lodge gates and then along an avenue of fine-looking 200 year old lime trees. Surprisingly the village is reached before the hall. Its pretty limestone cottages and well-tended gardens behind wide grass verges and backed by mature trees, give a feeling of peace and tranquillity. No planner designed it; the beauty of the village is the result of evolution.

Further up the main village road is Tissington Hall, a fine Jacobean Manor House, standing in a slightly elevated position above the road behind a walled garden. The wall is broken only by a handsome seventeenth-century gateway with wrought iron gates by the famous Derbyshire blacksmith, Robert Bakewell. The house was built in 1609 by Francis FitzHerbert, but has been much extended by his descendants. It replaced an earlier hall, which stood on the opposite side of the road within the confines of an ancient Derbyshire hill fort.

The hall is occupied by Sir Richard FitzHerbert, the 9th Baronet, and Lady Caroline FitzHerbert and their children. It has been altered considerably over the years. In the early eighteenth century the west front was given a face-lift in the fashionable Palladian style of the early Georgian period and most of the mullions on the east front were replaced by sash windows. The process was reversed early in the twentieth century, when the house was enlarged by the addition of a mock Jacobean wing with a library and billiard room overlooking the garden. At the same time the original oak panelling was uncovered, the mullion windows replaced and the estate administration block enlarged. The hall is open to the public at certain times during the summer months.

In 1997, Sir Richard converted the Old Coach House into a most attractive and popular tea room, which offers morning coffee, lunches and teas in delightful surroundings. Lady FitzHerbert founded a pre-school kindergarten in the old school in 1995 to educate the very young.

Further along the road a surprise awaits at Yew Tree Cottage where part of the building has been turned into a small candle workshop. Formerly a Blacksmith's house, which is decorated with motifs of the trade — the Wright family were blacksmiths in the village for 90 years. In front of the cottage is Yew Tree Well.

Facing the green is the pond where the ducks swim in timeless fashion and you might just see the Well Dressing boards floating in the water if you visit in May. Tucked in the corner by the pond are the Old Kitchen Gardens where shrubs and other perennial garden plants are grown.

Tissington is known as the mother place of Well Dressing and people come from all over the world to witness the Annual Well Dressing ceremony. This takes place on Ascension Day, when five attractive wells are dressed together with a children's well. Dressing consists of erecting boards covered in clay, into which thousands of flower petals are pressed to create an elaborate tableaux of some biblical or topographical scene. It is probable that Well Dressing took place in 1350, in thanksgiving for the village's escape from the Black Death, which was attributed to the purity of its water. Wells have been dressed ever since but not in unbroken succession. The precise origins of Well Dressing are unknown but may date from before the Romans.

Tissington Pond

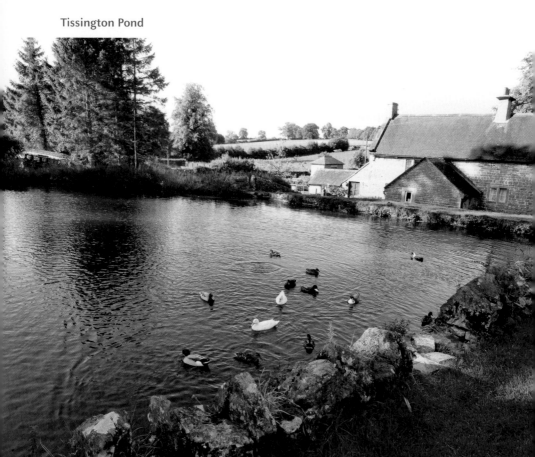

St Mary's Church rises steeply above the main road through the village with a sparkling stream flowing close to the entrance to the churchyard. Built early in the twelfth century, but heavily restored 700 years later, it has a massive Norman tower, with four foot thick walls and a well-preserved Norman doorway. Inside there is a baroque style seventeenth-century memorial to the FitzHerbert family, a finely carved communion rail and an early Norman font, which bears crude symbolic carvings.

It has not always been peaceful in Tissington, as during the Civil War it was the site of a skirmish between Royalists and Parliamentarians. The FitzHerberts supported the Royalist cause and the family were lucky to escape the destruction of their home, the punishment meted out to many royalists by the supporters of Oliver Cromwell. The pillars of the church doorway are worth close inspection, the grooves having been worn by archers sharpening their arrows in readiness for archery practice. This skill was much encouraged after the Black Death, which had left the country short of experienced bowmen.

When the railway came to the village Sir Richard insisted that the line should be placed in a cutting. The Railway Company, it is said, built the cottages adjacent to the station in red brick in retaliation for the inconvenience. The

Tissington Hall

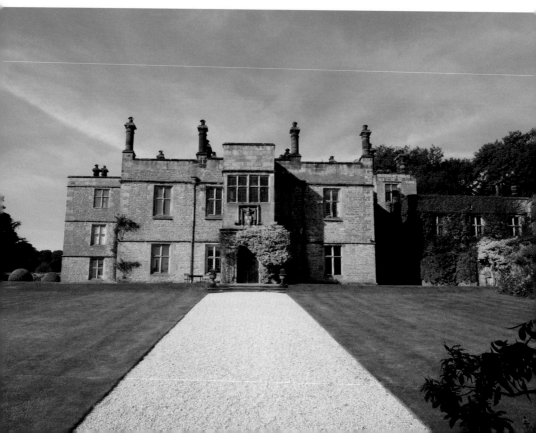

The entrance to Tissington Hall

LNWR built the line and it was opened in 1899. In its heyday, it carried express trains from Manchester to London and until after the Second World War a daily train delivered milk from Peak District farms to Finsbury Park, London.

Following the closure of the line in the 1960s, it was decided to remove the trackbed and turn the line into a trail for the benefit of walkers, cyclists and horse riders. This experimental scheme was one of the first of its type in the country. It has been a great success, since opening to the public in June 1971. Large numbers of people are attracted at weekends throughout the year and every day during peak holiday periods.

The Tissington Trail runs along a 13 mile route from Ashbourne to Parsley Hay. At this point it joins up with the High Peak Trail, which runs from High Peak Junction to Dowlow near to Buxton. Surrounded by beautiful countryside the traffic-free trail is ideal for horse riders, cyclists, naturalists and walkers. It is suitable for wheel chairs and pushchairs along the flat sections. In the village there is a gift shop and butchers. Periodic events take place at the Village Hall, including regular craft shows.

WARSLOW
AND HULME END
(SK087587 & SK105594)

Between the A523 Ashbourne to Leek road and the A515 Ashbourne to Buxton road

Warslow standing at almost 1,000 feet is a surprisingly large village for what is a fairly remote part of Staffordshire. Formerly an estate village of the Harpur-Crewe family of Calke Abbey in South Derbyshire, it is composed mainly of pleasant stone built properties with a church provided by Sir George Crewe.

The village lies to the west of beautiful, wild moorland country, but to the east the countryside is far less forbidding. Visitors are most attracted to the gloriously rugged Manifold Valley, which stretches from Hulme End in a southerly direction to Waterhouses.

A spectacular limestone gorge, the Manifold Valley once had one of Britain's more unusual narrow gauge railway lines running along the valley floor. This venture was made possible by the passing of the Light Railways Act in 1896. The act gave much greater flexibility regarding the construction of minor railways and it was under these new regulations that the building of the Leek to Hulme End line took place. The section from Leek to Waterhouses was standard gauge and from Waterhouses to Hulme End narrow gauge. The 2ft 6in single track railway, which ran through the Manifold Valley, had its official opening on Monday 27 June 1904 and became known as The Leek and Manifold Light Railway.

Principal Engineer for the line was E. R. Calthorp, who previously had been involved with the construction of the Barsi Light Railway in India. He brought with him many of the designs that had been used in the building of the Indian railway. The rolling stock bore many similar features; the coaches had colonial-type end platforms and were fitted with large side windows so that passengers could enjoy the scenic splendour of the valley.

Unfortunately, the enterprise was seriously flawed and over optimistic. Most of the villages it hoped to serve were some distance away on high ground above the Manifold Valley making the journey to and from the line difficult. This meant local passenger demand was insufficient and the line was left to

Church of St Lawrence

rely too much on tourism. In addition, the hoped for extension to Buxton never took place and the improvement and increasing competition from road haulage led to the loss of freight business. Although for a time though, during the First World War, the line played an important role with the carriage of large quantities of milk in 17 gallon churns.

Inevitably with the line losing money, the LMS announced the railway would close on Monday 12 March 1934. The track bed has been taken up and replaced by a footpath, known as the Manifold Way. Today the track bed is mainly footpath and for most of the way it is car free, apart from a narrow road leading through the Swainsley Tunnel, past Wetton Mill, to the turn off for Wetton village.

Warslow is recorded in the Domesday Book, under an entry for Alstonefield Manor, which may indicate it had been a separate estate before the Norman Conquest. Signs of habitation in the area though go back much further, a Bronze Age barrow having been discovered on the north eastern side of Warslow. In addition, two further barrows have been revealed on the eastern side of the village, and one at Brownlow to the south west. Three Bronze Age barrows also stand on top of the hill south west of nearby Upper Elkstone village.

The Manifold Inn

There may have been a church in Warslow as early as the thirteenth century, judging by the font on display in the present church and part of the shaft and base of a late medieval cross in the churchyard. The current church of St Lawrence was rebuilt in 1820, and contains a number of relics from time past. Most notable is a box pew belonging to the Harpur-Crewe family who owned the estate. Sir Thomas Wardle, a silk mill owner from Leek who built Swainsley Hall in the Manifold Valley, is also commemorated by a window in the church.

There are several fresh water springs in the village and at one time water from them was bottled and sold. Now it is only the Greyhound Inn where liquid refreshment is regularly retailed. The 250 years old former coaching inn was originally called the Greyhound and Hare, referring to the days when coursing was a popular sport.

Originally, hill farming was the main industry in the area, until mining started to flourish. Lead mining became important early in the nineteenth century. A century earlier considerable quantities of copper ore started to be produced at Ecton, on the others side of the Manifold Valley. The main mine reached a depth of over 1,400 feet, which was the deepest in Britain at the

time. A Boulton and Watt steam engine, an underground canal for haulage purposes and several other unusual features were used in production.

The fifth Duke of Devonshire, using the profits he had made from his copper mines at Ecton in the Manifold Valley, embarked on a costly campaign to attract and accommodate more visitors to Buxton. Then only a tiny Peakland village, it resulted in the 1780s Buxton really coming to prominence as a spa.

Hulme End is the former terminus of the Leek and Manifold Light Railway, and items of railway memorabilia still remain. It is now the starting point of many walks in the Manifold Valley, where a large car park and a Visitor Centre and café are also located. The village is quite small; with a busy little shop which serves the needs of local people and visitors.

The Manifold Inn, a 200 year old coaching inn, formerly called The Light Railway is on the eastern side of the village. Opposite the pub is the Old Toll House, which at one time served the turnpike and river ford. The bridge that the Toll House sits on was first built in 1790, but most of the original bridge has subsequently been replaced due to damage and collapse. The current bridge has been there since 1819.

The War Memorial

WETTON

(SK108555)

Off the Ilam to Alstonefield road

Wetton is a compact little village of limestone cottages, the gardens a riot of colour in the summer. It is in an exposed position against the cold at an altitude of about 1,000 feet and the little cottages seem to huddle together for protection. Winters are now much milder, but some of the older residents still recall the times the village has been cut off from the outside world.

At Grindon, on the other side of the Manifold Valley that divides the two villages, is a memorial to six men. They died when their aircraft crashed while 'bringing relief to the stricken villages during the great blizzard of 1947'. Two press photographers died with the RAF men, shortly after parachuting food supplies to the people of Wetton, Onecote, Butterton and Grindon.

In the summer, Wetton is a picture with its pretty cottages and lovely gardens and it is not surprising that so many people decide to take their holidays in the village. For the more adventurous there is the campsite behind the pub, but for those who prefer four walls there is plenty of choice. The very tidy village notice board even provides a map, showing precisely where holiday accommodation is located.

In 1993, when the first World Toe Wrestling Championship was introduced in the village, a great deal of interest was generated both locally and nationally. During the years it operated, a lot of money was raised for charity and it kept the pumps at the Royal Oak busy. Unfortunately, for the Royal Oak it no longer takes place in Wetton and has moved to another pub near to Ashbourne,

A much gentler pursuit than toe wrestling has been recently introduced and while it might not attract the attention of the national media, it is certainly enjoyed by the local people. It takes the form of growing sunflowers; villagers are provided with the seed and pot and have to use their skills to try to win a prize for growing the best sunflower in Wetton. For those wanting something a little more strenuous there is the annual Wetton and Manifold Valley 10 Kilometre Road Race.

Wetton is a very active village and recent projects include the restoration of two wells, the erection of an information board and provision of a seat for rest

The former Methodist Chapel

and reflection. Another project completed a short time ago at St Margaret's Church, resulted in the bells ringing again, having not been heard within living memory. The five existing bells were recast at the beginning of this century and a sixth added in 2001. Surprisingly, all are from different centuries.

During restoration work early this century, on the leaded roof of the ancient tower at St Margaret's Church, 219 footprints and hand impressions were

St Margaret's Church

discovered in the existing lead work. They covered a period from 1781-1913 and have been surveyed and preserved. It shows that graffiti is not a new phenomenon; some of the earliest examples can be seen at Stonehenge and Pompeii.

In the graveyard is the last resting place of Samuel Carrington. He was the village schoolmaster for 50 years, but is better known as a nationally recognized archaeologist. His tomb is carved with shells and fossils. Together with Thomas Bateman of Middleton-by-Youlgreave, he excavated sizeable Romano-British settlements at Borough Fields and Long Low. Half a mile south west at Thor's Cave, overlooking the Manifold Valley, they found evidence of occupation in Iron Age and Romano-British times.

Until 1947, Wetton was an estate village belonging to the Duke of Devonshire. Faced by crippling death duties the land was sold and offered initially to the sitting tenants. The Chatsworth Holiday Cottages in the village are just one reminder of the Devonshire's involvement with Wetton.

The main industries at present are agriculture and tourism; the latter attracted by some of the most spectacular scenery in the Peak District, rich with wildflowers, butterflies and birds. The Manifold Valley is a very popular visitor attraction. Surprisingly, the river beds of the Manifold and Hamps that flow through the valley are frequently dry, as the waters soak away into the porous limestone rocks below and only reappear in wet weather. During

The Old Policehouse with stocks in the foreground

dry weather the Manifold disappears at Wetton Mill and re-emerges from its underground journey from a boil hole at Ilam.

The Leek and Manifold Light Railway used to run through the valley. Lack of sufficient business forced the closure of the line and it has subsequently been converted into a trail for walkers and cyclists, only two miles of which is not car-free. Ossum's Cave at Wetton Mill is known to have been used in the Stone Age, where flints were fashioned. Thor's Cave rises 350 feet above the Manifold Valley; its 60-foot entrance is very imposing but the cave inside is comparatively small. The climb up to the cave is steep and can be quite treacherous in wet weather, but is worth the effort for the excellent view.

Wetton Mill was established in the valley by William Cavendish, second son of Bess of Hardwick. It was finally abandoned in 1857, is now in the ownership of the National Trust and is the starting point of many walks. There is a tearoom, housed in one of the former grist buildings at the mill, which provides most welcome refreshments. These can be partaken either inside, or at one of the picnic tables outside.

In the past, mining used to be an important employment provider for the villagers. The building of the Crescent at Buxton is said to have been funded by the Duke of Devonshire out of the profits of his copper mine at nearby Ecton. Stone from a quarry to the north west of Wetton was used for making paving setts, which paved the streets of Stoke-on-Trent.

Many of the properties in the village date back two or three hundred years; the Manor Farm House is sixteenth century and Hallows Grange is dated 1675. Falling numbers led to the closure of the school, which has been converted into the Village Hall. The Methodist Chapel is no more, but now a smart B&B establishment. Stocks are on display in the garden of the Old Policehouse.

YOULGREAVE

(SK210642)

*Off the B5056 a linking road
between A515 — Ashbourne and A6 — Bakewell*

Surrounded by glorious countryside, the ancient village of Youlgreave winds its way carefully along a narrow limestone shelf, between two of the area's loveliest valleys. Bradford Dale to the south drops sharply down with pretty little cottages and their gardens clinging to the side of the valley; a little further away to the north on the other side of the hill is Lathkill Dale, considered by some to be Derbyshire's finest dale.

The long, narrow village street runs for about one and a half miles along almost the only level ground available; the footpath being lost altogether by the church, where pedestrians, who do not want to run the risk of getting run over, walk through the churchyard. On the eastern side of Youlgreave is the tiny olde-worlde settlement of Alport, which marks the southern entrance to Lathkill Dale at the confluence of the rivers Bradford and Lathkill. At the other end of Bradford Dale is the charming little village of Middleton-by-Youlgreave. The walk along Bradford Dale from Alport not only provides an opportunity to admire the scenery, but also to note the varying styles of bridges across the river. A steep climb up Hollywell Lane and back to the centre of the village completes the walk.

Apart from the narrow road, one problem visitors have is knowing how to spell the name. The sign on the western entrance to the village says 'Youlgreave'. A quick check on the Ordnance Survey agrees, so does the guide book for the church, but local people call it 'Youlgrave', which is how the name is pronounced. It was recorded in the Domesday Book of 1086 as 'Giolgrave' and according to research there are over sixty different spellings of the name!

The precise origin of the village's unusual nickname of 'Pommy' is not certain either, but is probably connected with the local band. When the instruments were first purchased, it is said only a few members of the band knew any music, so parades were not particularly tuneful, but more of a repetitious

'Pom, pom, pom'. Another version of 'Pommy' is of a pig resting on a wall serenading the band as it passed by!

An important centre for lead mining, the Mawstone Mine even re-opened after the First World War in anticipation of increased demand, only to cease production permanently in 1932. An explosion in that year killed five of the six miners working underground and three of the rescue party were killed by carbon monoxide poisoning.

In the centre of the market place is a huge circular water tank or conduit head, known locally as 'The Fountain', which since 1829 has supplied soft water to the villagers, initially at an annual charge of 6d. It was built following a campaign by the 'Friendly Society of Women', who demanded a cleaner, healthier and more efficient supply of water. It certainly was more efficient than carrying the water up the steep path from Bradford Dale and healthier, as many deaths had been caused amongst children by drinking contaminated water.

In 1829, the laying of 1,106 yards of iron pipes was completed from Mawstone Spring on the hillside across the dale, just 25 feet higher than the conduit. At a given time every day the 'Waterkeeper' unlocked the tap and allowed the water to be drawn. By this time a queue of people had gathered with their pails and whilst they waited no doubt took the opportunity to share

The Fountain

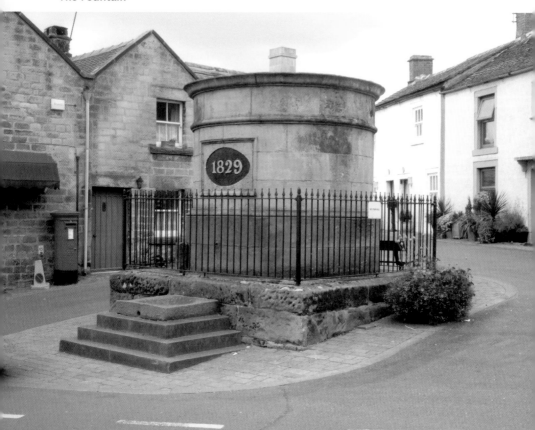

All Saint's Church

the latest gossip. A further improvement took place in 1869, when the water was fed to various stand pipes dotted round the village.

Well Dressing, or 'tap dressing' as it is sometimes called was first introduced when water was piped to The Fountain, and it was decorated in thanksgiving for the improved water supply. On the Saturday nearest St John the Baptist's Day in June every year five wells are dressed to a very high standard and are

The Bull's Head

amongst the most widely admired in the county.

A water project of a different type took place at neighbouring Alport, when in 2009, a hydroelectric installation was completed designed to provide 'clean' renewable energy for up to thirty-five homes in the village. This brought the former water powered corn mill back to life again after lying idle for many years.

The parish church of All Saint's is a magnificent structure, second only in size to Tideswell in the Peak District. Norman in origin, the font with its projecting stoop is unique in this country. Do not miss the small intriguing figure of a pilgrim with staff and wallet, reputedly carved by a travelling friar in return for hospitality. The stained glass east window was made by William Morris to a design by Edward Burne-Jones. An interesting entry in the churchwarden's accounts for 1799 reads 'Dog whippers had to be paid', for whipping dogs out of church during divine service.

Near the church are some rather grand Georgian houses. Further west is The Old Hall, a distinctive looking Manor House, said to be haunted, dated 1656 according to the datestone but may be earlier. At the rear is Old Hall Farm another charming stone built house of about 1630.

Tiny Thimble Hall, 'one up and one down', situated in the market place is the smallest hall in the country; it attracted considerable interest when sold in 1999. Nearby, a three-storey Victorian building used to be the Co-operative stores and still carries the advertising, but is now a thriving youth hostel, which in 2009 also operated as a teashop at busy times. As keen cinema fans will know, the store was featured in the film *The Virgin and the Gypsy*, along with much of the rest of the village, which was referred to as Congreave in the novel written by D. H. Lawrence.

There are three pubs, The Bull's Head, with a superb carving over the courtyard entrance, The George and the Farmyard Inn. The village is well served with a variety of shops including a post office and gift shop. Football and cricket are played at the Recreation Ground, where county cricketers have played benefit matches in recent times.

PLACES OF SPECIAL INTEREST

NORTHERN PEAK

1. *Castleton Museum and Information Centre,* state-of-the-art building features a range of exhibitions and provides visitor information
2. *Moorland Visitor Centre,* superbly designed, ultra modern information and exhibition centre at Edale
3. *Dams and Dambusters Museum* in the West Tower of Derwent Dam, open most Sundays and Bank Holidays
4. *The Upper Derwent Valley Visitor Centre* located at Fairholmes, close to the Derwent Dam — information and exhibitions
5. *David Mellor Cutlery,* Hathersage, a widely acclaimed Cutlery Factory, Design Museum and café in superbly designed buildings
6. *New Mills Heritage Centre* tells the story of New Mills from the medieval period — scale model of the Torrs Industrial site
7. *Longdendale Trail* follows the former Manchester to Sheffield railway line for six miles, from Hadfield to the Woodhead Tunnel
8. *Thornhill Trail* was formerly a specially built narrow-gauge line from Bamford, which was used for reservoir construction
9. *Trespass Trail* opened on the 75th anniversary of the Mass Trespass of Kinder Scout, follows the route of the trespass
10. *Sett Valley Trail* follows a former railway line along a scenic route from Hayfield to New Mills
11. *Peveril Castle,* perched high above Castleton with inspiring views of the surrounding countryside, an English Heritage property
12. *Castleton Caverns,* all within easy walking distance of the village — Speedwell, Blue John, Treak and Peak Cavern
13. *Chestnut Centre,* near Chapel-en-le-Frith, houses Europe's largest collection of multi-specied otters and owls
14. *Freshfields Donkey Sanctuary,* near Buxton, is known as 'The Actors' village, where donkeys are given a caring home

15. *Torrs Riverside Park*, New Mills, stretches for two miles along a spectacular river gorge of great historical importance
16. *Lyme Park*, Disley, the former home of the Legh family, now under the control of the National Trust and open to the public
17. *Bugsworth Canal Basin*, near Whaley Bridge, is a fascinating restored relic of the Industrial Revolution
18. *Longshaw Visitor Centre*, near Grindleford, in excellent walking country — National Trust shop and refreshments with lovely views
19. *Dunge Valley Gardens*, Kettleshulme, near Whaley Bridge, a beautiful garden with rhododendrons, azaleas, flowers and streams
20. *Abbeydale Industrial Hamlet*, near Sheffield, is a unique eighteenth-century industrial site

More Information: Castleton Visitor Centre (Tel. 01629 816558)

CENTRAL PEAK

1. *Buxton Museum and Art Gallery*, where you can visit the Wonders of the Peak exhibition
2. *Eyam Museum* tells the heartbreaking story of the Bubonic Plague and also covers other aspects of local history
3. *Revolution House*, near Chesterfield, where the successful plot to overthrow King James II was hatched
4. *Chesterfield Museum and Art Gallery* traces the story of Chesterfield from the Romans to the building of the 'Crooked Spire' church
5. *Eyam Hall*, a handsome stone manor house, with a Jacobean staircase — Courtyard contains craft shops and a café
6. *Poole's Cavern*, a natural show cave, in the Buxton and Grin Low Country Park, with a visitor centre
7. *Buxton and Grin Low Country Park, lovely* woodland and moorland walks with magnificent views from the top of Solomon's Temple
8. *Go Ape*, high-wire adventures in the Buxton and Grin Low Country Park
9. *Buxton Pavilion Gardens*, a listed building with 23 acres of landscaped gardens — exhibitions, entertainment and refreshments
10. *Queen's Park*, Chesterfield, an attractive park with a miniature railway, lake and an internationally famous cricket ground
11. *Magpie Mine*, Sheldon, the surface remains are the best example in Britain of a nineteenth-century lead mine
12. *Buxton Opera House*, designed in grand Edwardian style; it holds one of this country's largest opera-based festivals

13. *Renishaw Hall,* near Sheffield, with beautiful gardens, woodland walks, nature trails and sculpture garden — museum and galleries
14. *Barrow Hill Roundhouse Railway Centre,* Chesterfield, the last working roundhouse in Britain, also exhibits other railway memorabilia
15. *Monsal Trail,* a former railway line, 8.5 miles long running from one mile south east of Bakewell, to the head of Chee Dale
16. *Arbor Low Stone Circle,* near Monyash, a huge stone circle consisting of a ring of stones surrounded by a grass bank and a ditch
17. *Tegg's Nose Country Park,* near Macclesfield, walks with superb views, overlooking Macclesfield Forest and Langley Reservoirs
18. *Goyt Valley,* near Buxton, amidst glorious scenery, with two reservoirs, an old packhorse bridge and the ruins of Errwood Hall

More Information: Buxton Tourist Information Centre (Tel. 01298 25106)
Chesterfield TIC (Tel. 01246 345777/8)

SOUTH EAST PEAK

1. *Old House Museum,* Bakewell, an award winning museum in Bakewell's oldest house, which traces five centuries of history
2. *M & C Collection of Historic Motorcycles,* Bakewell, a fine collection of vintage and classic motorcycles and memorabilia
3. *Old Market Hall,* Bakewell, a seventeenth-century structure, now used as an information and exhibition centre
4. *Haddon Hall,* near Bakewell, a beautifully preserved medieval Tudor manor house, in a lovely setting
5. *Chatsworth House and Gardens,* near Bakewell, one of Britain's best loved houses, with magnificent gardens
6. *Chatsworth Farmyard and Adventure Playground,* near Bakewell, where all the family can enjoy a good day out
7. *Chatsworth Farm Shop,* Pilsley, near Bakewell, extensive and highly acclaimed farm shop with a restaurant
8. *Matlock Bath Aquarium,* formerly Victorian Thermal Baths — Aquarium, Hollograms, Petrifying Well, Gemstone and Fossil Collection
9. *Gullivers Kingdom,* Matlock Bath, family theme park in lovely woodland setting aimed at younger children
10. *Heights of Abraham,* Matlock Bath, a spectacular cable car ride takes you to show caverns, exhibitions, café and a gift shop
11. *Peak District Mining Museum,* Matlock Bath, 'hands on' experience of the story of lead mining — also visit Temple Mine

12. *Peak Village*, Rowsley, shopping complex with refreshments, a fitness and beauty centre and Toys of Yesteryear Museum

13. *Market House*, Winster, a sixteenth-century building, purchased by the National Trust and now used in part as an information centre

14. *Caudwell's Mill and Craft Centre*, Rowsley, the only complete Victorian water turbine powered roller mill in the country

15. *Wirksworth* Heritage Centre tells the intriguing story of the town from early times to the present day — also Art Gallery

16. *Steeple Grange Light Railway*, Wirksworth, delightful little railway on a branch line of the former Cromford and High Peak Railway

17. *High Peak Trail* follows the line of the former High Peak Railway from High Peak Junction (Cromford) to Dowlow (south of Buxton)

18. *Sir Richard Arkwright's Mills*, Cromford, forms part of the prestigious Derwent Valley Mills World Heritage Site

19. *National Stone Centre*, Wirksworth, a dramatic 50 acre geological site with a visitor centre, which tells the story of stone

20. *Peak Railway*, Matlock takes you on a relaxing journey by steam train, between Matlock and Rowsley South

21. *Matlock Farm Park* provides a great day out for all the family on a 600 acre working farm — Riding and Trekking Centre

22. *Red House Stables and Carriage Museum*, Darley Abbey, one of the finest collections of original horse drawn vehicles/equipment

23. *Ecclesbourne Valley Railway* is based at the immaculately restored Wirksworth Railway Station, steam trips available

More Information: Bakewell Visitor Centre (Tel. 01629 816558)
Matlock Tourist Information Centre (Tel. 01629 583388)

SOUTH WEST PEAK

1. *Hope House Costume Museum and Restoration Workshop*, Alstonefield can only be visited by appointment

2. *Tissington Trail* runs from Ashbourne to Parsley Hay, for 13 miles along the former Ashbourne to Buxton railway line

3. *Tissington Hall,* near Ashbourne, stunning Jacobean Manor House, situated in a picture postcard village

4. *Upper Limits*, Longnor, the centre offers a wide range of courses both inside and out, an indoor climbing wall is a special feature

5. *Longnor Craft Shop* in the Old Market Hall, showroom for Fox Country Furniture, also Art Gallery, craft displays and refreshments

6. *Roystone Grange, Pikehall*, where evidence has been found of occupation in Roman times by native hill farmers
7. *Dovedale*, Ilam, is one of the most visited places in the UK, with famous steeping stones and lovely walks
8. *Rookes Pottery*, Hartington, established in 1977, by makers and designers David and Catherine Rooke
9. *Ilam Hall*, near Ashbourne, is not open to the public, but there is a National Trust Information Centre, Shop and Café and walks
10. *Ilam Park*, near Ashbourne, is an attractive area of ancient semi-natural woodland and parkland, in idyllic surroundings
11. *Manifold Trail* runs from Waterhouses to Hulme End, along the mainly traffic free track of the former Manifold Light Railway
13. *Manifold Visitor Centre*, Hulme End is housed in former ticket office of the Manifold Light Railway, historical displays and info
14. *Alton Towers*, near Cheadle, is one of Europe's top theme parks, with rides and entertainment, in a glorious garden setting
15. *Blackbrook Zoological Park*, Winkhill, near Leek, with rare birds, unusual animals, reptiles, insects and aquatics
16. *Rudyard Lake and Steam Railway*, near Leek, miniature railway and Activity/Information Centre in a lovely lakeside setting
17. *Tittesworth Reservoir and Visitor Centre*, near Leek, a great family attraction overlooked by the Roaches and impressive scenery
18. *Churnet Valley Railway*, near Leek, runs through outstandingly scenic countryside from Cheddleton to Froghall and back
19. *Northfield Farm*, Flash, runs Riding and Trekking courses suitable for all standards
20. *Wetton Mill* (National Trust), Manifold Valley, a teashop and Ossum's Cave are located at Wetton Mill — Thor's Cave is nearby

More Information: Ashbourne Tourist Information Centre
(Tel. 01335 343666)

Note: Further information may be obtained from various Information Points in the area, other Tourist Information Centres, Council Offices and miscellaneous sources.
 A Well Dressing leaflet containing a diary of events is normally available from early spring.